Artists' Techniques and Materials

Antonella Fuga

Artists' Techniques and Materials

Translated by Rosanna M. Giammanco Frongia

The J. Paul Getty Museum
Los Angeles

A Guide to Imagery

Italian edition © 2004 Mondadori Electa S.p.A., Milan
All rights reserved. www.electaweb.it

Series Editor: Stefano Zuffi
Original Graphic Coordinator: Dario Tagliabue
Original Graphic Designer: Anna Piccarreta
Original Layout: Claudia Brambilla
Original Editorial Coordinator: Caterina Giavotto
Original Editor: Carla Ferrucci
Original Photographic Researcher: Elisa Dal Canto
Original Technical Coordinator: Andrea Panozzo
Original Quality Control: Giancarlo Berti

English translation © 2006 J. Paul Getty Trust

First published in the United States of America in 2006 by
Getty Publications
1200 Getty Center Drive, Suite 500
Los Angeles, California 90049-1682
www.getty.edu

Mark Greenberg, *Editor in Chief*

Ann Lucke, *Managing Editor*
Mollie Holtman, *Editor*
Sharon R. Herson, *Copy Editor*
Rosanna M. Giammanco Frongia, *Translator*
Pamela Heath, *Production Coordinator*
Michael Shaw, *Designer and Typesetter*
Translation, copyediting, design, and typesetting coordinated by LibriSource Inc.

Library of Congress Cataloging-in-Publication Data
Fuga, Antonella.
 [Tecniche e materiali delle arti. English]
 Artists' techniques and materials / Antonella Fuga ; translated by Rosanna M. Giammanco Frongia.
 p. cm. — (A guide to imagery)
 Includes bibliographical references and indexes.
 ISBN-13: 978-0-89236-860-0 (pbk.)
 ISBN-10: 0-89236-860-8 (pbk.)
 1. Art—Technique. 2. Artists' materials. I. Title. II. Series.
 N7430.F8413 2006
 702'.8—dc22
 2006006951
Printed in Hong Kong

On the opposite page: Cristoforo de Predis, *The Children of Mercury,* ca. 1460.
Illuminated page from the *De Sphaera* codex. Modena, Biblioteca Estense.

On page 6: Petrus Christus, *Saint Eligius* (detail), 1449.
New York, Metropolitan Museum of Art, Robert Lehman Collection.

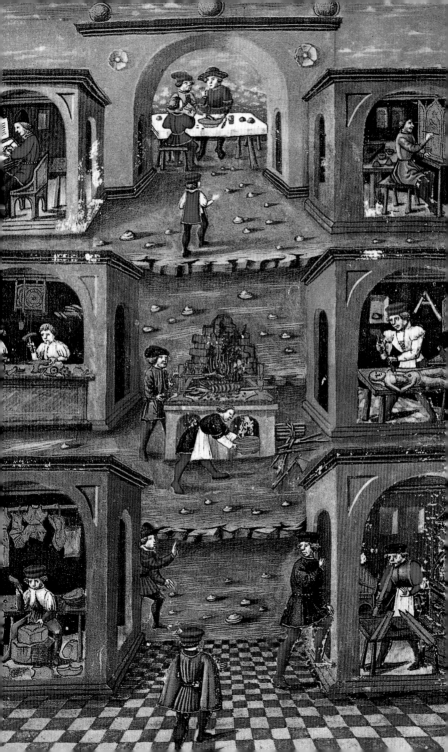

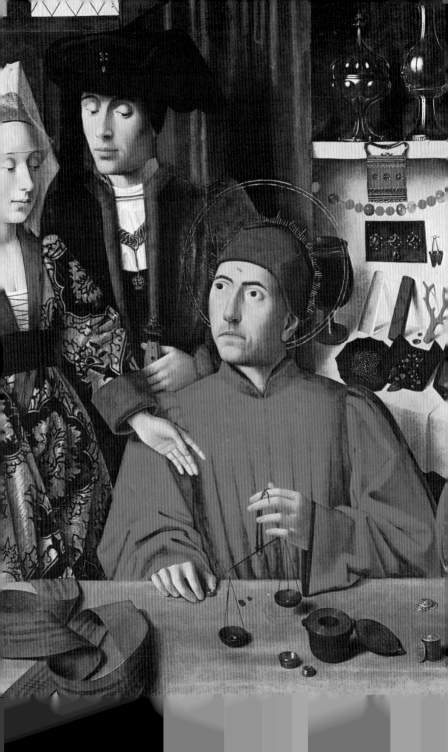

Contents

Introduction

In Paris, on April 15, 1875, a group of young artists that included Claude Monet, Camille Pissarro, Edgar Degas, and Auguste Renoir first exhibited paintings that were to radically alter the course of the history of art: their everyday images and landscapes, painted with strokes of oil color that were at once short, thick, and airy, transposed to canvas the sensations of air, movement, and light. The revolutionary role of these Impressionist works, painted in accordance with a precise theory of light, is well known and recognized by all. Not everyone, however, knows that this radical change in artistic language was also made possible by a simple technical innovation, namely, the invention of ready-made oil colors available in small tubes. Prepared pigments of this kind simplified the artist's equipment, making it lighter and therefore easier to carry—ideal for painting outdoors; in addition, colors in a tube are easier to use and give the artist more expressive freedom. This is just one example of how a technical detail, even a

very simple one, can be fundamental to understanding an artist's work.

Visitors to an art gallery or a church come into direct contact with work that is laden with history and symbolism; they also experience firsthand the materials that went into making the work of art, such as the gold leaf embedded in the glass tiles of Byzantine mosaics; the lustrous, tight polychromy of a Flemish wooden altar; or the enchanting blue made from lapis lazuli that Lorenzo Lotto prepared following a unique method. These elements, intriguing in and of themselves, are not just accessory moments in the making of a work of art; rather, they are part and parcel of the historical context and the artist's personality, and as such become material bearers of the symbolic language of images.

The technology of methods and materials is more readily visible in the so-called applied, or decorative, arts—sometimes improperly called "minor arts." These have always been important, especially in the art of the 15th and 16th centuries,

nd also in that of the 18th century, even
lazing the trail for painting, sculpture,
nd architecture. Pollaiuolo and
'errocchio, for example, began their
rtistic careers as goldsmiths, and many
Mannerist and Baroque artists loved to
Jan and even execute decorative bronzes,
s well as figured glass and crystal. In the
8th century, Johann Friedrich Böttger's
discovery of the formula for porcelain
terally revolutionized the art world: this
ragile material, first invented in China,
ecame very important during that century,
nfluencing taste in painting and sculpture
nd playing a major role in furnishings
nd architecture; examples include the
orcelain parlors of the royal palaces in
Naples (Capodimonte) and Madrid.

Behind every great or small work of art
s an endless trail of research and innumer-
ble "alchemical" experiments. At times,
hance and lucky "mistakes" led to the
discovery of formulas and processes that
vere perfected over time by artists and
'experimental masters" who handed them

down through the centuries. This guide
illustrates fundamental artistic techniques
together with the origin and use of the
most popular materials employed in draw-
ing, printmaking, painting, and sculpture.
The applied arts are included as well, and
a good part of this book is dedicated to
them: from their vast array, I have chosen
to illustrate the techniques of mosaic and
intarsia (inlay work), ceramic, glass, metal-
work, and jewelry. The last chapter is a
brief excursion into techniques used in
contemporary art, those that, in my
opinion, best represent the vast, irreversible
change characteristic of artistic expression
in modern times. I did not include textile
and tapestry terminology because these
arts require a different, more complex
technical approach.

The aim of this book, within the
context of the Guide to Imagery series, is
to provide a unique approach for reading
works of art by explaining how they were
made and putting the reader in touch with
some of their hidden aspects.

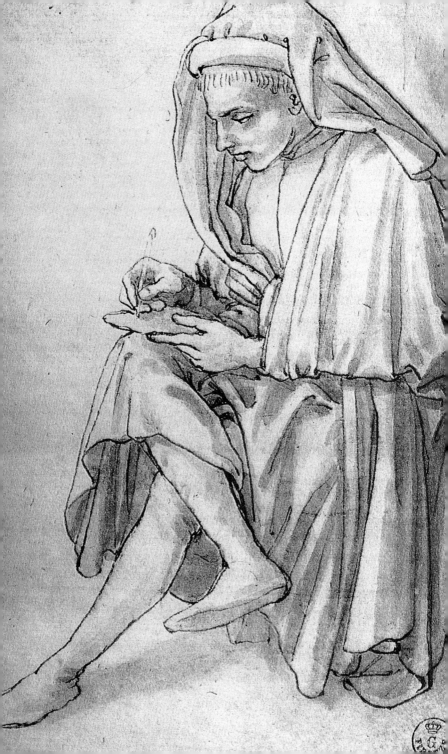

DRAWING

Charcoal
Brush
Pen
Metalpoint
Red Chalk
Chalk
Pencil
Watercolor
Pastel
Graphite
Mixed Media
Preparatory Drawing and Cartoon

"Small willow twigs baked in the oven in a new, carefully sealed pot are good material for drawing on paper and cardboard" (Filippo Baldinucci, 1681).

Charcoal

Raw Materials
Willow or other plant twigs

Tools and Supports
Oven, airtight container, reed or metal tube, paper, parchment, wood board, eraser made with the soft part of the bread

Diffusion
Used since the Neolithic period, charcoal is the most common drawing medium of all times.

Related Materials or Techniques
Pen, brush, chalk, watercolor, pastel, pencil, red chalk

Notes of Interest
To char the weeping-willow sticks, Cennino Cennini suggested the use of the baker's oven at night, after it was turned off but still warm.

Charcoal, the most ancient of drawing materials, has been used since prehistory. Easy to make and use, it is suitable for all kinds of drawings. In his handbook *Il Libro dell'arte* (1437), Cennino Cennini carefully described the traditional technique for making good drawing charcoal. Small twigs of soft willow-wood should be left to dry, then cut into sticks the length of one's palm, tied into small bundles, and placed in a pot covered with an airtight lid that was in turn sealed with a layer of clay. The sealed pot cooked at a low temperature overnight. Once the twigs were charred, they were left to cool slowly. After their tip was sharpened, the twigs were inserted into a reed or tied to a larger stick to avoid soiling the hands. Charcoal's highly friable nature gives its easily erasable line an unusually soft and pictorial quality but also tends to smear the paper and leave blackish rings. Even more problematic is the risk that the lines will pulverize. This is the main cause behind the loss of many older charcoal drawings. Charcoal is especially suitable for making practice drawings and studies, for sketching figures that will be finished in other media (e.g., pen or brush), and for prodcuing cartoons of large compositions that will become paintings or frescoes.

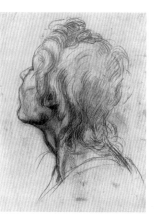

▶ Andrea del Sarto, *Study of a Male Head*, ca. 1518. Charcoal on paper. Rome, Gabinetto Disegni e Stampe.

This type of charcoal leaves black, velvety marks, though over time the oily component can separate from the solids, creating oily smears along the outlines of the drawing that often seep through the back of the paper, in some cases ruining the work. This problem is caused by an excess of oil absorbed by the charcoal.

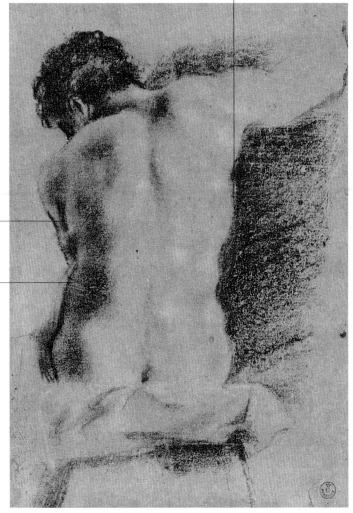

*...aking the charcoal
...cks in linseed oil
... shorter or longer
...riods produces a
...easy charcoal
...hose marks are
...delible and do not
...ed fixing.*

*...e marks from oiled
...arcoal are very simi-
... to pastel marks and
...n easily be mistaken
... them.*

Guercino, *Male Nude, Seated,*
...20–30. Oiled charcoal on paper.
...orence, Galleria degli Uffizi,
...abinetto Disegni e Stampe.

Charcoal

Thicker marks can be easily blurred with the fingers; they have a tendency, however, to smear the sheet with blackish rings.

Charcoal is a soft, crumbly material that allows great fluidity. The thickness of the marks varies according to the pressure applied with the tip to the paper.

Lighter marks erase easily; this is one of the main reasons why charcoal drawings do not conserve well. Various methods have been used to fix the charcoal powder to paper, including quickly placing the front of the sheet on the surface of a basin filled with water and glue, or spraying the drawing with a solution made of water and gum arabic.

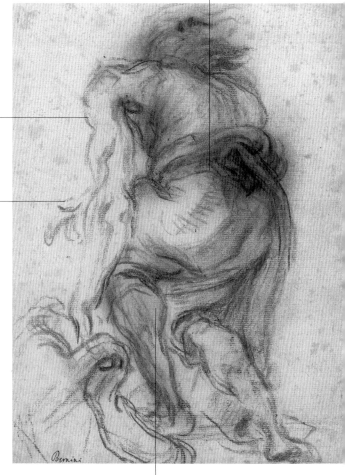

▲ Gianlorenzo Bernini, *Figure Seen from the Back*, ca. 1677. Charcoal on paper. Rome, Gabinetto Disegni e Stampe.

The thick, soft marks of the charcoal allow for a rapid style, fast and incisive, like that of Bernini, who focused on the salient traits of his compositions without defining their outlines, thus very effectively creating a sense of movement through space.

*ushes are made "of two kinds of hair: vair [squirrel] and hog. . . .
aftsmen who make them are rare, though one can find the sellers
stores and apothecaries" (Gian Battista Armenini, 1587).*

Brush

he brush, the painting tool par excellence, is also a drawing
ol. It was often used as such in the Middle Ages, whether
tists wanted to draw powerful images with broad, simplified
rokes or render more accurate descriptions with very fine-
ped brushes. Cennini suggested brushes made of squirrel
ir (vair), though brushes made of polecat, dog, ox, or other
imal hair or bristles were also common. The brush can be
ed by itself or in conjunction with pen, metalpoint, or pencil,
parchment or on paper. It is particularly useful for rendering
anges in light that modulate volume and movement. Inks of
rying degrees of transparency may be used, and several light
ats may be applied because an artist can shade large areas
ickly and effectively with a brush. The latter is also suitable
r adding high-
hts. In this case,
d white is used
stead of ink;
uted in water
d gum arabic, it
applied to bring
t the portions of
e composition
at are closest to
e picture plane.

Raw Materials
Wood, hair or bristles
from various animals

Tools and Supports
Ink, lead white (also
known as *bianco di
piombo* or ceruse), water-
color, paper, parchment,
wood board

Diffusion
Brushes have been used
to make drawings since
the earliest times.

**Related Materials
or Techniques**
Pen, metalpoint,
watercolor, pastel,
pencil, red chalk

Notes of Interest
In rare cases, artists
applied gold and silver
in addition to lead
white for highlights; in
such instances, they used
a method proper to the
technique of illumination.

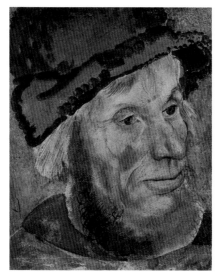

◄ Lucas Cranach the Elder,
*Head of a Man with a Fur
Cap*, 1505–6. Brush and
watercolor traced over with
pen, on paper. Basel,
Öffentliche Kunstsammlung.

Brush

Ink is made from a mixture of lampblack and the gallnuts of oak trees macerated in iron salts (iron gallate and tannate), which is then diluted in water. This type of ink, which contains iron and tannic acid, tends to oxidize over time, and if used on paper, it causes corrosion.

The contours of the drawing were outlined with a very fine brush dipped in slightly diluted ink.

The painter produced shadows by applying short strokes with a thin brush dipped in pure ink.

Sturdier and longer lasting than paper, parchment was the support of choice for important drawings. Parchment was made from the skin of calves, goats, or sheep: the skin was steeped in lime, then pulled taut on a frame and left to dry. Finally, it was thinned by scraping it with knives.

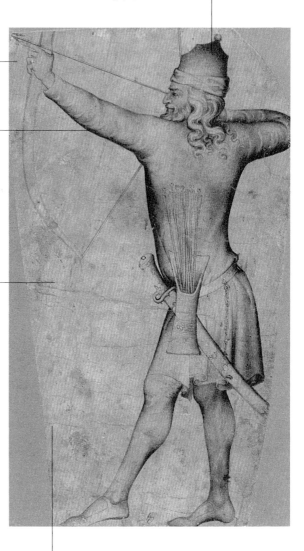

The visible tears on this sheet of paper were caused by excess dryness, the work having been stored under very dry conditions.

The face of the pasha and the shaded parts are rendered effectively by the contrast of black ink and white paper, which creates highly expressive "patches."

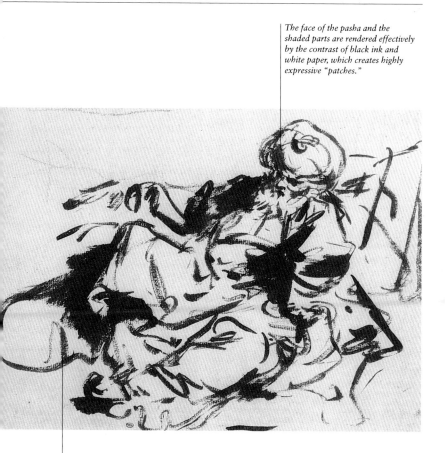

In this drawing, Fragonard used a quick, flowing, almost calligraphic line that highlights the folds of the fabric, stylizing it in just a few strokes.

Master of the Narbonne Vestment, *her*, 1370–80. Brush and black on parchment. Oxford, Christ irch.

▲ Jean-Honoré Fragonard, *The Pasha*, 1750–75. Brush and ink on white paper. Paris, Musée du Louvre, Cabinet des Dessins.

Pen

Raw Materials
Reeds, goose feathers

Tools and Supports
Ink of various kinds, paper, parchment

Diffusion
Known in classical antiquity, the pen was used by all great artists, including Ghiberti, Leonardo, Bosch, Brueghel, and Rembrandt.

Related Materials or Techniques
Brush, watercolor, pencil

Notes of Interest
The feathers from the right wing of the goose were preferred since their curve better fit the movement of the hand.

In addition to being a writing implement, the pen has always been considered the "graphic" tool par excellence. The earliest pens, used in classical antiquity, were made by sharpening reed sticks; dipping the tip in ink produced marks for writing and drawing. This type of pen, however, left harsh lines that were difficult to soften since the tip was made of wood, a hard material. For this reason, the wing feathers of the goose—longer and stronger, softer and more flexible—began to be used in

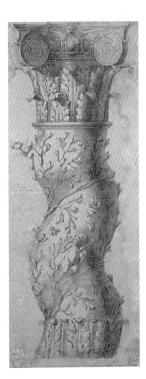

the Middle Ages. Drawing with the pen is structurally demanding because pen marks cannot be erased, and a pen drawing allows only a few expressive elements: the thickness and number of lines, and the contrast between the colors of the ink and that of the support. The artist must have great technical skill to fully exploit these features. The pen is used with inks of various kinds, such as those made from gallnuts, bistre, or cuttlefish, and, starting in the 15th century, China ink. Colored inks—blue, green, red—are used more rarely, and usually on prepared paper.

▶ Francesco Borromini, *Column*, 1626–27. Presentation sketch of the upper part of the columns for the baldachin in St. Peter's in the Vatican. Pen and brown ink wash. Windsor Castle, Royal Library.

The extremely fine tip of the pen becomes the privileged medium for an accurate rendition of Bosch's fantastic landscapes; each minute detail is drawn painstakingly with tiny bistre strokes.

The artist creates a chiaroscuro effect with curving, delicate cross-hatching. The final effect is that this pen drawing resembles an etching.

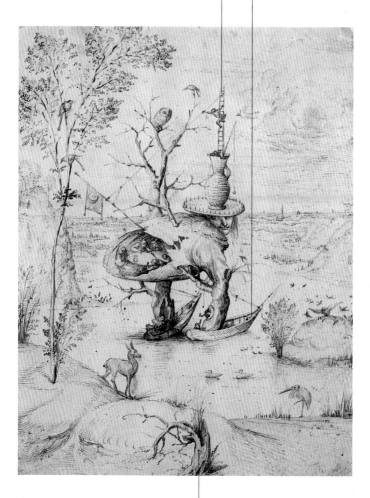

Hieronymus Bosch, *The Tree Man*, 15th–early 16th century. Pen and [bistre] on paper. Vienna, Graphische [Sam]mlung Albertina.

Bistre is a pigment derived from tarry soot made by burning beech wood. The resulting ash is worked into a paste with water and gum arabic (the latter is extracted from exuded matter of the acacia tree).

The ink is sepia brown, extracted from cuttlefish secretions, which are then filtered, dried, and diluted with water and gum arabic. Sepia brown resembles bistre in color but is warmer and redder; it becomes unstable when exposed to light. Sepia brown is often used as watercolor.

The goose quill was cut to make a flat tip that allowed the artist to adjust the thickness of the lines, here soft and modulated. The varying thickness of the lines effectively renders the movement of the figures and confers on the work an apparently casual "sketchy" effect.

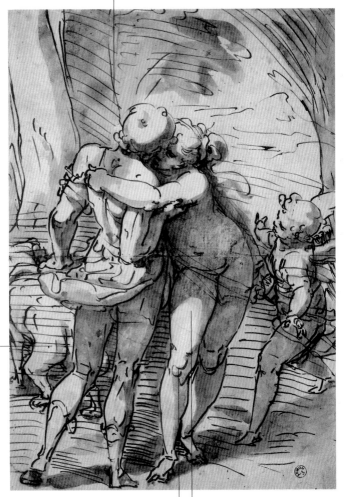

For shadows, the artist used highly diluted sepia brown applied with quick brushstrokes that overlap in the darker areas.

The white ground of the paper was left untouched for highlights.

▲ Luca Cambiaso, *Venus Embracing Adonis*, 1570–80. Pen and sepia ink on paper. Florence, Horne Collection.

"A thin rod of two-thirds lead and one-third tin, useful for underdrawing for those interested in drawing with the pen"
(Filippo Baldinucci, 1681).

Metalpoint

The metalpoint, or stylus, has undoubtedly been used since antiquity. Depending on the metal, the rod leaves either a groove or a colored mark. Giovanni Boccaccio refers to it in the fifth tale of the sixth day of the *Decameron* (1353); there, speaking of Giotto, he mentions the stylus alongside the pen and the brush. Lead, the earliest metal used for this implement, leaves a strong, dark gray line on paper or parchment. The lines are easily erased with soft bread. The main problem with a lead point is that it quickly loses its shape. To reinforce the tips, tin was added to the alloy, but by doing so the marks became a lighter gray, visible only on primed paper. Therefore, the tin metalpoint is rarely used for final drawings: its slender, transparent line is used mostly for practice sketches, which are often finished in other media. Throughout the 15th century and the first decades of the 16th, silverpoint was used for final drawings, as this metal traces a light gray, compact, luminous mark of great richness and elegance on primed paper. Very hard metalpoints are used primarily for scientific drawings.

Raw Materials
Lead, tin, silver

Tools and Supports
White and primed paper, parchment, wood board

Diffusion
Metal styluses were used during Roman times; metalpoints were in common use from the end of the 14th to the beginning of the 16th century.

Related Materials or Techniques
Pen, pencil, brush and pen with ink, lead white, red chalk, watercolor

Notes of Interest
In the past, artists also experimented with metals such as gold, tin, and brass. Over time, metalpoint drawings oxidize and change color.

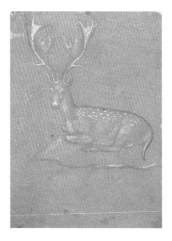

◄ Lombard artist, *Crouching Deer*, 1400–1415. Silverpoint and lead white on paper. Venice, Gallerie dell'Accademia.

Metalpoint

The lead point traces a very pale, barely visible line.

In the chiaroscuro, shadows are few and summarily drawn, and concentrated on the lower part of the composition; the artist has been more careful in applying lead white to the highlights, which follow the shape of the figure with great delicacy, defining some of the figure's details as well.

The paper has be colored on t reverse as well, w a pale blue tint ma of lead white a indigo (a natur coloring substan extracted from t Indigofera tinctor plant) mixed in glu the same prepar tion used for t rose col

Paper can be tinted rose by using a mixture made with glue extracted from boiled and filtered parchment scraps to which lead white and cinnabar red (vermilion) are added in the final step. Paper coated with this color is much stronger, ensuring that the drawing will be long-lasting. In addition, the delicate contours of the lead point (with tin added to the alloy, since the lines here are a pale gray) are more visible.

The artist clearly changed his mind here.

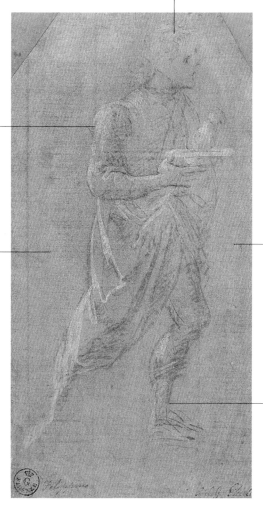

▲ Filippino Lippi, *Young Man Advancing*, ca. 1465. Lead point and lead white on partially tinted white paper: rose-colored on the front and light blue on the back. Florence, Galleria degli Uffizi, Gabinetto Disegni e Stampe.

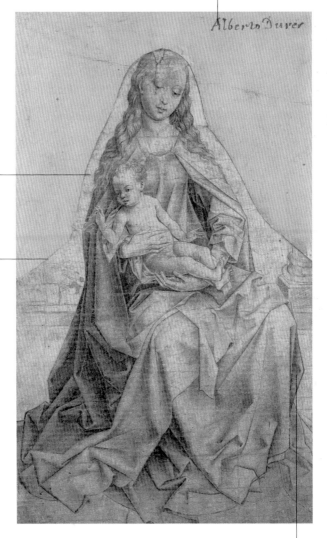

This drawing has been cut out and glued to a supporting sheet of paper. The signature is counterfeit.

*e silverpoint leaves
lear and elegant
*rk on the prepared
*per; thus it is ideal
* delineating con-
*rs and outlining
* tiniest details.

*e silverpoint strokes
* visible only on the
*med paper. The
*und has been
*ated with powders
*h in phosphate or
*cium carbonate,
*h as bone dust or
*ely ground eggshells
*seashells diluted
*th animal glue and
*seed oil or water.
*is preparation was
*plied to the ground
*several layers, with
*rush. Horn powder,
*rticularly the kind
*ade from deer horn,
*s prized for this
*rpose.

Rogier van der Weyden, *Madonna
d Child*, ca. 1450. Silverpoint on
*med white paper. Rotterdam,
*seum Boijmans-Van Beuningen.

*The stiff, sculpture-like drapery, typical of Van der Weyden's
images, has been rendered by the precise interplay of light
and shade—nearly invisible silverpoint strokes were drawn
in varying degrees of proximity to each other, a difficult
technique because once drawn, the strokes cannot be erased.*

23

This drawing is part of a very rare notebook made of supremely thin boxwood tablets bound together with leather bands. The tablets were coated with a mixture of calcined chicken-bone powder (calx) and saliva. Once dry, the support was ready for drawing with metalpoint. Once all the tablets were used, they could be erased and reused by removing the priming.

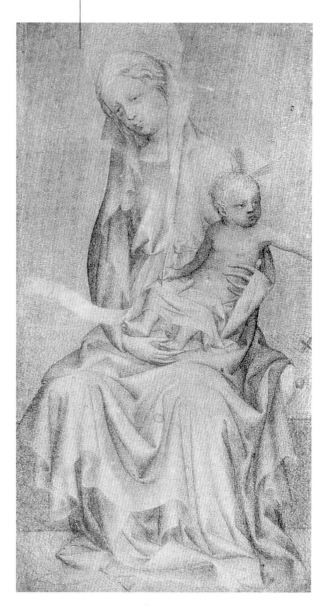

▶ Circle of Jacquemart de Hesdin, *Madonna and Child*, ca. 1485. Metalpoint on boxwood tablet primed with gesso. New York, Pierpont Morgan Library.

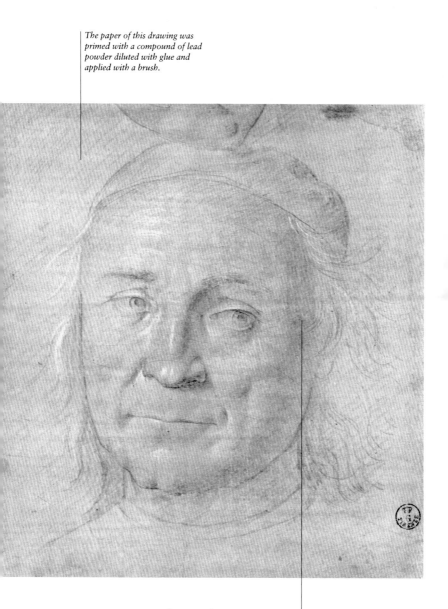

The paper of this drawing was primed with a compound of lead powder diluted with glue and applied with a brush.

Lorenzo di Credi, *Portrait of Man*, ca. 1485. Silverpoint and d white on primed gray paper. rence, Galleria degli Uffizi, binetto Disegni e Stampe.

In this portrait by Lorenzo di Credi, the face displays all the expressive possibilities of silverpoint, whose delicacy, coupled with touches of lead white, yields highly realistic, elegant results.

"Red pencil. A sort of soft stone, available in small pieces . . . sawed and broken down into small pointed pieces, it can be used for drawing" (Filippo Baldinucci, 1681).

Red Chalk

Raw Materials
Iron-bearing clay

Tools and Supports
Pencil holder, paper,
parchment, wood board

Diffusion
Leonardo, Michelangelo,
Pontormo, Parmigianino.
In the 17th century, a
watercolor of the same
tint was used with red
chalk, thus expanding
possibilities in expressing
the modulation of light;
the French school reached
high levels of virtuosity
with this technique,
especially in the 18th
century, with Fragonard
and Hubert Robert.

**Related Materials
or Techniques**
Black pencil, brush with
watercolor or ink, chalk,
pastel

The term "sanguine" refers to a type of pencil with a warm brick-red color that is made from iron-bearing clay known as hematite. The history of the red pencil, which from the 19th century was commonly referred to simply as sanguine (literally, blood-red) or red chalk, thus belongs to the tradition of drawings made with pointed pieces of natural stone. It is used alone or, more often, with black pencil. Red chalk drawings became very common during the 16th century, especially in Florence, although it was Leonardo da Vinci and his followers in Lombardy who first used the medium systematically. To make these crumbly sticks easy to use and prevent them from smearing hands and paper, they are placed in a pencil holder of metal or reed that leaves only the tip of the pencil free. The clay, found in different degrees of hardness, produces strokes of varying thickness and intensity: the harder the clay, the lighter and more delicate the stroke; softer clay yields warmer and more intensely colored marks. These differences are heightened by the pressure that the artist applies while drawing. Red chalk is water soluble: in fact, artists will sometimes dilute a stroke by going over it with a wet brush, which results in a softer, more nuanced appearance.

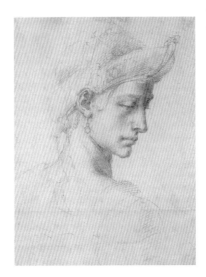

▶ Michelangelo, *Head in Profile*, ca. 1522. Red chalk on paper. Oxford, Ashmolean Museum.

26

Using only red chalk, Leonardo da Vinci
applied fine, light strokes in soft, painterly
fashion in this celebrated portrait.

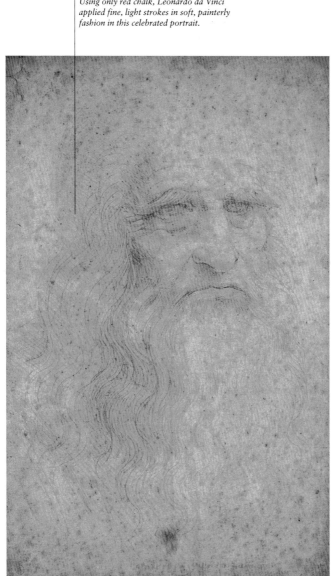

Leonardo da Vinci, *Self-portrait*,
12. Red chalk on paper. Turin,
blioteca Reale.

Chalk

Raw Materials
Various minerals including calcite, clay, coal, water and glue, colored pigments

Tools and Supports
Primed and unprimed paper

Diffusion
Commonly used for drawing, starting in the Renaissance

Related Materials or Techniques
Pen, brush, charcoal, pastel, pencil, red chalk

Chalk, or hydrated calcium sulfate, is a very important material in the history of art. Used as a pigment in tempera painting, it also serves as an ingredient in priming wood panels and canvases, and has many other applications from sculpture to inlay it is even used in some lacquers. Chalk has been, and still is today, a popular drawing medium. Starting in the Renaissance artists began to use minerals that are easily found in nature, cut into sticks, such as calcite for white chalk, raw clay for gray, and natural coal for black. Today, these drawing materials are manufactured industrially in many colors by mixing chalk powder with mineral pigments, water, and glue. Successful attempts were made at the end of the 15th century to give chalk a more painterly consistency by replacing glue with olive oil and beeswax. In the early 19th century, these sticks, or *crayons*, were "rediscovered" in connection with the invention of lithography; their use became widespread, especially among French artists.

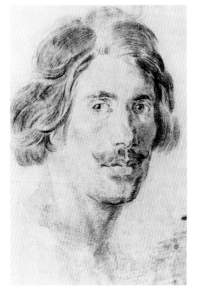

▶ Gianlorenzo Bernini, *Self-portrait*, ca. 1627. Chalk on paper. Rome, Biblioteca Corsiniana.

Although the stroke of the chalk stick is "dry" and not very painterly, it is nonetheless quite versatile: here it was used to sketch the head of Hercules with just a few strokes.

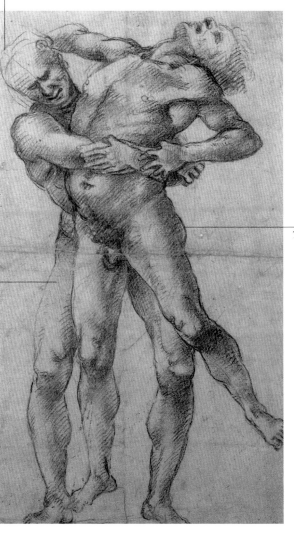

alk marks
se easily but
also very
ile. The draw-
s made with
s medium
st be coated
th a fixative,
ually a solu-
n of water
d gum arabic.

The strong defini-
tion of volumes,
characteristic of
Luca Signorelli's
style, is achieved
by quick strokes
shaded off with
the fingers in
contrast to the
natural white of
the paper.

Luca Signorelli, *Hercules and
taeus*, 1499–1502. Black chalk on
per. Windsor Castle, Royal Library.

"Lead pencil . . . a sort of manufactured pencil that tints with the color of lead and is used for drawing" (Filippo Baldinucci, 1681).

Pencil

Raw Materials
Natural stone, graphite, pencil holder made of metal or wood

Tools and Supports
Paper, eraser

Diffusion
Used since the second half of the 15th century until today, with industrially manufactured wood and graphite pencils

Related Materials or Techniques
Pen, brush, crayon, watercolor, pastel, red chalk

Notes of Interest
For the restoration of painted murals, a glass-fiber pencil is used today; consisting of a bundle of glass fibers held together by a small cord, it is used as a very precise abrasive.

The word "pencil" today denotes the most common medium for writing and drawing; made of wood with a graphite core, it has served as a popular tool since the 19th century. The progenitor of the pencil is surely the implement that Cennini, in his *Libro dell'arte* (1437), described as a "black stone originating from Piedmont, a soft stone that can be sharpened with a small knife; it is soft and deeply black . . . and draws as you like." Use of this material, also known as "Italian stone," became widespread in artists' workshops, especially from the late 15th century on. These small "sticks" occur in nature in different degrees of hardness, which allows the artist to vary the brightness, moving from an intense, creamy black similar to that produced by natural coal, to a very light, almost pearly, gray. To make them easy to use, the sticks were placed in a metal pencil holder. From the end of the 16th century, the use of the graphite pencil increased; graphite, a soft mineral of uniform grain, makes sharp marks that are resistant yet easy to erase. This "lead," sold in small metal or wood cylinders, creates marks whose color is very close to that of lead point; for this reason, it is called "lead pencil." This medium could replace the difficult, time-consuming metalpoint; thanks to its precision and easy erasability, it is ideal for architectural drawings that are later finished with the pen. Sometimes, drawings made with red chalk, colored pastels, or industrially made crayons are included in the broad class of "pencil drawings."

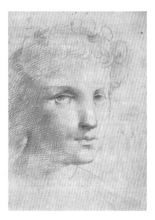

► Domenico Beccafumi, *Head of Young Woman*, 1510–20. Black pencil on paper. Private collection.

In this work, the combination of red
pencil and black pencil allows the
artist to enhance the atmospheric
vibrations of the light.

The pencil used here is a
soft, well-sharpened stone:
the lines are broader and
more densely cross-hatched
in the darker areas.

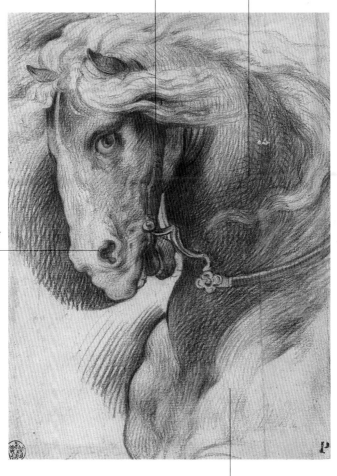

*ghlights are
ated by using the
ite of the paper.*

Lighter areas have
thinner, lighter lines
with less cross-hatching.

Cavalier d'Arpino, *Head of a Horse*,
96–97. Black and reddish-brown pencil
paper. Berlin, Kupferstichkabinett.

Pencil

Lead pencil is used often in architectural drawings
that are then finished by tracing the lines with pen
and ink. In the final step, the original pencil markings
are easily erased with a bread eraser.

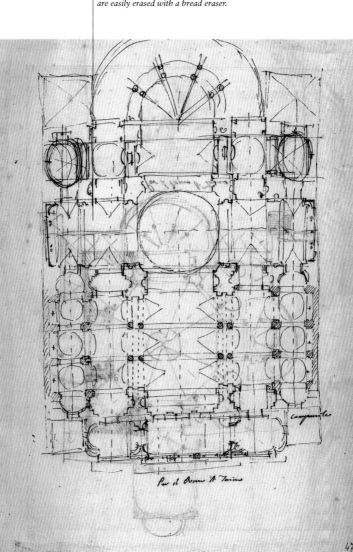

▲ Filippo Juvarra, *Studies for the
New Cathedral in Turin*, 1715–21.
Pencil and pen on paper. Turin,
Museo Civico d'Arte Antica.

The pencils used by Van Gogh were industrial products, almost of the same kind as the pencils of today. This drawing has the quality of a quick sketch drawn outdoors.

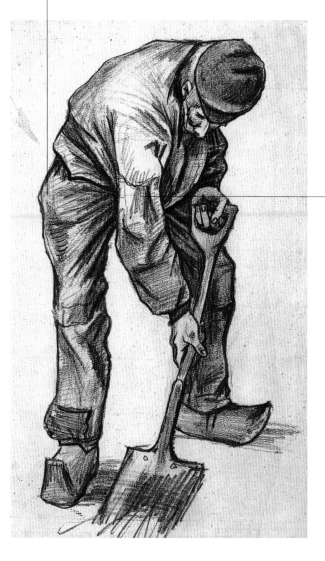

The artist uses a soft lead that leaves quick, sharp marks that render the subtleties of chiaroscuro with just a few strokes.

incent van Gogh, *A Digger*, 1882.
cil and ink on watercolor paper.
sterdam, Van Gogh Museum.

"A type of color that serves to color drawings; it is made by mixing two small drops of ink in as much water as would fit into a nutshell" (Filippo Baldinucci, 1681).

Watercolor

In watercolor, finely ground, colored pigments are mixed with water before being applied to parchment or paper. The water however, does not completely dissolve the powdered colors or fix them permanently to the support. Therefore, to avoid pulverization and loss, agglutinant substances must be added, such as gum arabic or honey. Different types of ink, such as sepia brown, or powders from metallic oxides, colored earth or stones, were used in the past for watercolors. The use of colors dissolved in water was known in many ancient cultures including Egypt, China, and Japan. In Europe, watercolor is used to complete chiaroscuro effects or to add color to drawings made with other media. It also serves as the first medium in preparatory drawings of important works, in architectural drawings, and also in books on botany or zoological subjects where color illustrations often reach high artistic levels.

Albrecht Dürer was the first to use watercolor in the modern manner; in the 17th century, Flemish painters exploited the unique transparency of watercolor to render the atmospheric details of specific places. Watercolor came into its own in the 18th century, when it became the medium of choice for such artists as Constable and Turner, who sought to register the infinite changes of light nature and on objects.

▶ Charles Rennie Mackintosh, *Port Vendres*, 1926–27. Watercolor on paper. London, British Museum.

ite is not normally used when applying watercolors; the
rtist generally "reserves" the white of the paper instead.
re, however, the artist has opted to use small lead-white
ouches to focus on the highlighted surfaces of the figure.

*The ideal support for this medium is
non-greasy paper with low absorbency;
the best is made from cloth rags.*

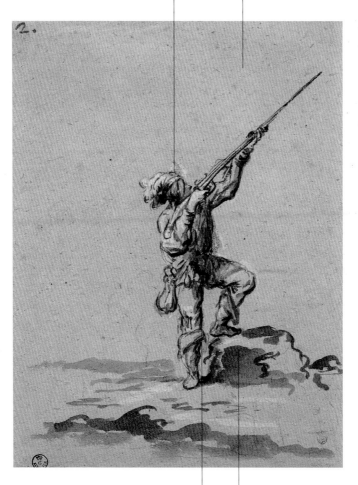

*Here a slender brush was used, dipped in brown
ink (sepia brown) with very little water, to trace
the short contour lines that define the more
shaded parts of the figure.*

*The "drop" of color, deposited on the
paper and spread quickly with a brush,
can be modulated at will by the artist
to create graceful passages of light and
dark tonalities.*

Alessandro Magnasco, *Hunter*, ca. 1710.
own watercolor and white highlights.
orence, Galleria degli Uffizi, Gabinetto
segni e Stampe.

Van Ostade uses all possible tonalities of the brown ink, more or less diluted with glazes.

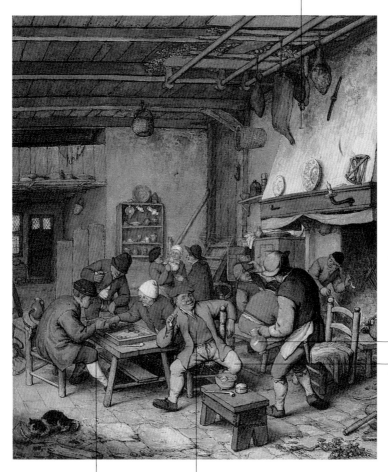

The small lig reflections objects a achieved sin ply by leavi the white the pap uncolore

Because colc must be stal in the ligh earth-bas colors, su as ochers, an stable oxid such as ir oxide, a preferre

This work was very carefully and precisely drawn in its entirety with a pen.

▲ Adriaen van Ostade, *Genre Scene*, ca. 1665. Pen and polychrome water-colors on white paper. Vienna, Graphische Sammlung Albertina.

Polychrome watercolors are not used simply to complete an image; they can also be a true expressive element in the work by effectively conveying the atmosphere of a scene. Water-color drawing can thus closely resemble painting proper.

Turner first quickly sketched the central architectural lines with a pencil.

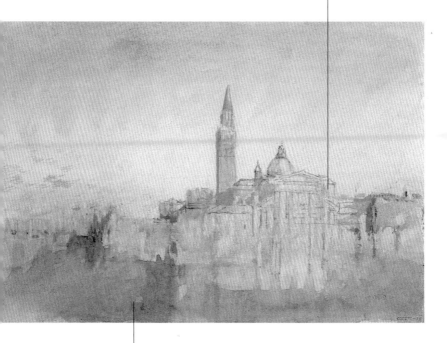

The artist used coarse-grained paper for this drawing, which he moistened lightly with a sponge. The colors, applied separately and "accompanied" by the brush across the moist background, blend together and become indistinct. With this method, Turner did not merely paint a landscape: he succeeded in communicating the sensations he felt when immersed in the unique atmosphere of Venice.

Joseph Mallord William Turner,
*nice, San Giorgio Maggiore Seen
ɔm the Customs House (Dogana),*
40. Watercolor on paper. London,
te Gallery.

Watercolor

The watercolors used by Cézanne were produced industrially and were not very different from those on the market today. Here the artist used them as a comfortable medium in which to complete a preparatory study for a larger work.

The basic composition of the work was quickly sketched in pencil. The watercolor serves specifically to emphasize the geometric positioning of the figure in space.

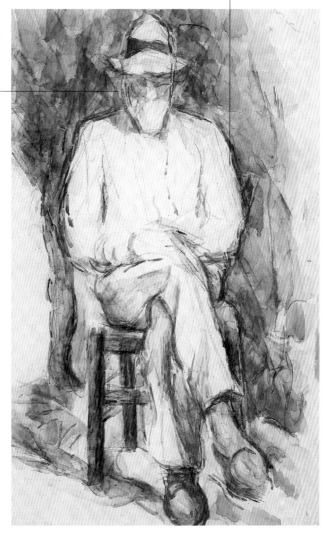

▲ Paul Cézanne, *Portrait of the Gardener Vallier*, 1906. Lead pencil and watercolor on paper. London, National Gallery, Berggruen Collection.

▶ Rosalba Carriera, *Nymph*, 1721. Pastel drawing. Paris, Musée du Louvre.

ıstels are made with colored pigments held together by waxy ıbstances. These crayons yield a soft stroke that can be easily ıtrred and rapidly applied.

Pastel

ıstel, a technique intermediate between drawing and painting, is a medium that is entirely man-made. It was probably vented in France in the 16th century. In Italy, one of the ırliest references to pastels occurs in a treatise by Giovanni ɔmazzo (1585), who wrote of "specially made points of ɔlored powders." To make pastels, mineral pigments are ıed—such as Armenian bole for reds, azurite for blues, and ack hematite for dark tones—and mixed with water and ;glutinant substances, such as gum arabic, fig-tree sap, fish ue, and sugar syrup. To obtain different hues of the same ɔlor, a bit of white clay is added. Later, the colors were mixed ith Marseilles soap and wax in different proportions to vary ıe hardness. The paste is then shaped into sticks and dried. ɔarse paper, fine canvas, or a special type of fine sandpaper :ts as a support because their grainy surfaces prevent shiny ffects and guarantee better conservation. In the 18th century, nooth supports primed with glue and marble powder were

so used for pastels. The ɔlored marks are frail, and nce the work is finished, it ıust be fixed with water nd glue or milk. The cold ut delicate tones of pastel ıarry well with the graceɪl, elegant Rococo style nd were used especially ı portraits.

Raw Materials
Mineral pigments, gum arabic, sugar syrup, Marseilles soap, wax, fig-tree sap, barley or linseed tea

Tools and Supports
Coarse paper, fine sandpaper, fine canvas, fixative (water and glue)

Diffusion
Leonardo da Vinci, Hans Holbein the Younger, Correggio, and Federico Barocci, to mention only a few. In the 18th century, pastels reached their peak of popularity in France with such painters as Quentin de La Tour, Boucher, and Fragonard; in Italy, the splendid pastels of Rosalba Carriera are noteworthy.

Related Materials or Techniques
Silverpoint, pencil, chalk, pen, watercolor

Notes of Interest
Leonardo da Vinci, who was among the first to employ this technique in Italy, used a yellow pastel to retouch a preparatory drawing for a portrait of Isabella d'Este (Paris, Musée du Louvre), which he never painted.

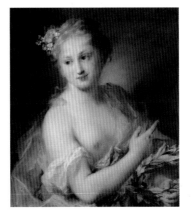

Here Liotard used parchment instead of coarse paper; the unique texture of this support, together with the artist's great skill, produced soft, dense effects. To ensure that the color would adhere to the support, the smooth surface was primed with a mixture of gum and extremely fine marble powder.

Nowhere in the drawing do the colors overlap: rather, they are applied side by side.

With pastel, the artist captures the play of light on the different fabrics.

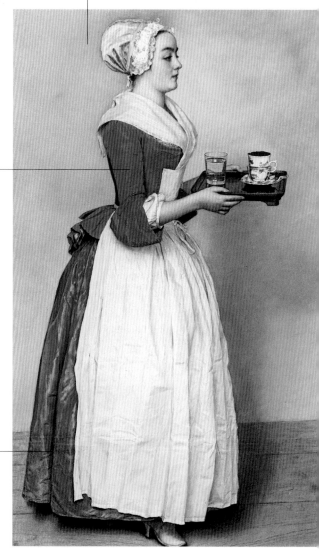

► Jean-Étienne Liotard, *The Beautiful Chocolate Server*, 1744–45. Pastel on parchment. Dresden, Gemäldegalerie.

Degas used pastel in a very personal and innovative manner: he applied the color in successive layers and fixed them one at a time with a substance whose formula remains unknown, thus creating special light effects and conserving the brilliancy of the individual tints.

Pastels must be applied to the sheet of paper with a light pressure of the hand; shading is done with the fingers, the oiliness of the skin helping to fix the color. To avoid "pastiness" and to preserve the fragile lines, colors must not be superimposed. The artist should therefore apply sure, decisive strokes.

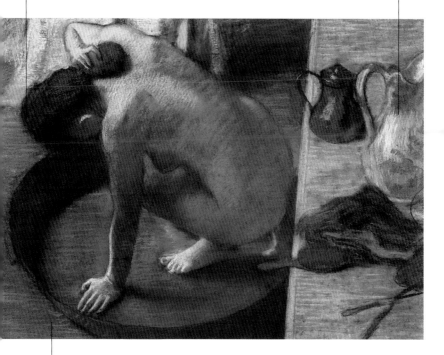

The pastels used by Degas were commercially manufactured with artificial pigments.

Edgar Degas, *The Bathtub*, 86. Pastel on cardboard. ris, Musée d'Orsay.

Graphite was probably the material used for the first mass-produced drawing tool, one very similar to the modern pencil.

Graphite

Raw Materials
Graphite, iron-bearing clay, and lampblack

Tools and Supports
Paper and eraser

Diffusion
All artists from the end of the 18th century onward

Related Materials or Techniques
Watercolor, pen, crayon, charcoal, red chalk

Graphite (also known as plumbago or black lead), so called because its intense gray color recalls that of the lead point, is a mineral composed of pure carbon. In the 1560s, the Borrowdale mines in Cumberland, England, began producing high quality graphite. English graphite became popular in the second half of the 17th century, its fine, marked lines slowly replacing those of unwieldy metalpoint. To reduce its friability, graphite powder was mixed with resins and gums, and shaped into thin graphite rods protected by two cedar stays. By the end of the 18th century, authentic English graphite was difficult to obtain in continental Europe. The Frenchman Nicolas-Jacques Conté solved the shortage problem when, in 1795, he devised a compound whose basic formula is still used today for the production of drawing pencils: a mixture of graphite, ferruginous clay, and lampblack pressed and fired in a special furnace. Depending on the degree of heat and the

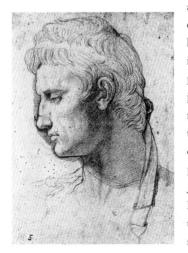

admixture of the ingredients, different degrees of hardness can be produced in the graphite. The Conté pencil, often used in conjunction with other techniques, was the preferred tool of 19th- and 20th-century artists for their preparatory drawings. Jean-Auguste-Dominique Ingres was among the first to use the Conté pencil systematically.

▶ Jean-Auguste-Dominique Ingres, *Head of Augustus*, ca. 1797. Graphite pencil on paper. Montauban, Musée Ingres.

*ch phase of a drawing has its ideal technique: implements that
oduce light marks for sketches and soft, liquid, or dusty
okes for chiaroscuro effects.*

Mixed Media

s rare for artists to use only one technique in a given work; rather,
ey often use different media in the same drawing to provide com-
etely different effects, both technically and stylistically. Although
e possibilities are almost endless, some media, such as graphite
d charcoal, are—thanks to the ease of erasure—the most suitable
r drawing the early sketches of a work. The drawing can then be
ished with pen, brush, or other media. To give the composition
imated lighting, the combination of red chalk with black pencil is
quent; and for practical reasons, too, like distinguishing different
dies, sometimes superimposed, drawn on the same sheet of paper.
arting in the Middle Ages, it became common practice to use a
ush with inks, lead white, or watercolors on pen drawings, in
me cases decorating them with applications of gold leaf, a practice
at recalls the style of illuminated manuscripts. From the second
cade of the 20th century onward, the jettisoning of academic rules
d the adoption of technical
novations radically modified
awing styles. The most impor-
nt of these new ways of work-
g, which Picasso and Braque
troduced into their paintings
well as into their Cubist
awings, and which was used
stematically by Dada and Sur-
alist artists, is surely the col-
ge: cutouts of colored paper,
ore often newsprint or wallpa-
r, glued into compositions
awn with pencil and brush.

Raw Materials
All the materials
used for drawing

Tools and Supports
Paper, parchment,
wood board, eraser,
pencil holder

Diffusion
In all epochs, starting
in the Middle Ages

**Related Materials
or Techniques**
Tempera, gouache;
recently, collage

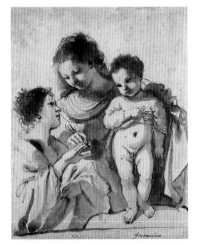

◀ Guercino, *Mystical
Marriage of Saint
Catherine*, 1623.
Black chalk, brush, and
brown ink. Oxford,
Ashmolean Museum.

The parchment was primed with a blue compound made with azurite, a copper-bearing mineral extracted from silver mines. Azurite is unstable and tends to change color when exposed to dampness; this explains why the painted ground, originally azure, now has a greenish cast.

This entire drawing was first outlined in pen.

The chiaroscuro was achieved with a brush dipped in brown ink diluted in water, while the touches of lead white applied to the drapery and the faces create intense luminosity.

Although pa, became primary supp for draw, from the end the 14th cent, forward, the of parchm, never altogeti ceas

▲ Lorenzo di Bicci, *Christ Delivers the Keys to Saint Peter*, 1410. Pen and brown washes, lead white on parchment primed with azurite. Florence, Galleria degli Uffizi, Gabinetto Disegni e Stampe.

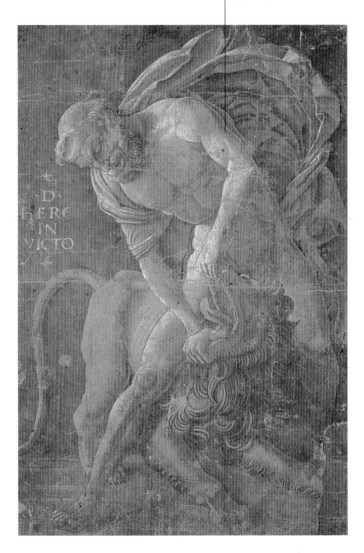

Attributed to Andrea Mantegna, *Hercules and Nemean Lion*, 1490–1510. Pen, brush, and brown watercolor on paper primed yellowish brown. Oxford, Christ Church.

Highly diluted sepia brown was applied in several glazes to render chiaroscuro effects and shadows.

This drawing was first sketched with charcoal, then completely outlined in pen. The ink is sepia brown, obtained from cuttlefish secretions that were filtered, dried, and diluted with water and gum arabic. The figures are drawn in Tiepolo's characteristic "nervous" line.

▲ Giandomenico Tiepolo, *Concertino*, 1791. Charcoal, pen and sepia ink, sepia washes on paper. Venice, Museo Correr.

► Filippino Lippi, *Study of a Youth's Head*, 1481–82. Metalpoint, lead-w highlights on paper primed green. Rome, Gabinetto Disegni e Stampe.

drawing, "the father of our three arts, Architecture, Sculpture, Painting, proceeding from the intellect, creates from many things a universal judgment" (Giorgio Vasari, 1550).

Preparatory Drawing and Cartoon

Drawing has accompanied humankind since the dawn of history; even before writing, it was one of the first, most instinctive ways to express thoughts and ideas. Drawing is the foundation of and the medium for that long, patient labor of planning that took place in the artist's workshop for works of painting, sculpture, and architecture, and also for the decorative arts, from goldwork to furnishings. Several levels may be identified in the creative and design stages of a work of art: first comes the "sketch," which usually consists of quick strokes drawn with charcoal, pen, or other medium, and the "profile," an exact rendering of the contours, especially useful in architectural design. The final step is the finished preparatory drawing, where all the details of the composition are defined, including chiaroscuro and color, sometimes suggested in watercolor. The preparatory drawing also serves as a submission to the sponsor: it can be a model for a larger-scale work to be painted on canvas or wood panel; or a cartoon, the drawing having the same dimensions as the future work. The cartoon is used not only for wall or panel paintings but also for mosaics, tapestries, and stained-glass windows.

Raw Materials
All the various drawing implements

Tools and Supports
Paper, eraser, glue

Diffusion
Preparatory drawings have been used in every period; the use of the cartoon emerged in the 15th century.

Notes of Interest
Although paper mills existed in the 13th century, drawing paper came into common use only toward the end of the 14th; prior to that, notebooks made of thin sheets of boxwood were used, along with parchment.

Preparatory Drawing and Cartoon

Paper is made from a pulp of vegetable cellulose or cloth rags (the more prized), spread to dry in very thin layers on a metal grid. It is then squeezed between two overlapping felt sheets with a press and immersed in a solution of animal glue. In this example, the marks left by the grid are visible: the widely spaced vertical marks (chain lines) and the closely spaced horizontal ones (laid lines) characterize the sheet of paper and also provide a date for its manufacture.

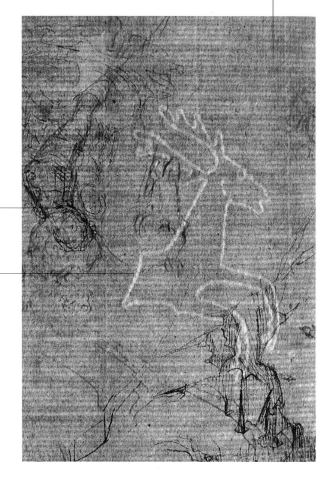

The quick pen strokes practiced by the artist are visible on the left. There is no set order to these images, some of which overlap.

The watermark is a small drawing that serves as a "trademark": it is produced by a metal thread inserted in the grid. Various symbols, such as moons or coats of arms or, in this case, a stag, are visible on the backlit page and identify the origin of the paper.

▲ French artist, Practice Sheet, 1400–1420. Pen on paper. Florence, Galleria degli Uffizi, Gabinetto Disegni e Stampe.

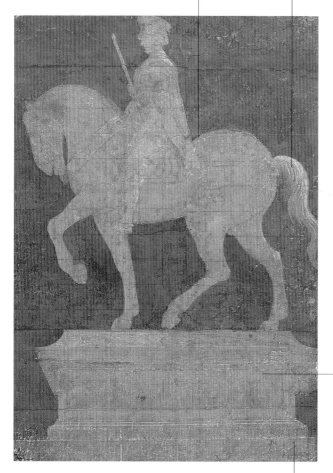

The outline of the monument is drawn with silverpoint: the thin, almost transparent marks become visible on the primed paper.

The lead-white highlights create a strong sculptural effect.

The paper was primed green, obtained by mixing terra verde (green mineral pigment), ocher powder, ground bone, and lead white with a glue prepared with boiled and filtered parchment scraps. The reddish priming was obtained by mixing the same glue with calcined clay powder rich in iron oxides.

The square grid, barely visible, enabled the artist to transfer the drawing from the paper to the wall, increasing the scale in the process.

olo Uccello, Preparatory Cartoon for the
estrian Monument to Giovanni Acuto,
5. Silverpoint and lead white on paper
ed in red and green. Florence, Galleria
Uffizi, Gabinetto Disegni e Stampe.

Preparatory Drawing and Cartoon

Often these sheets were glued at one end only so that they could be lifted to see two different versions of the same drawing.

Sometimes the changes made to a work are visible on the preparatory drawings: the artist may make simple revisions on the same sheet of paper or, as in this case, on a separate sheet, which he then glued over the part that he wanted to modify.

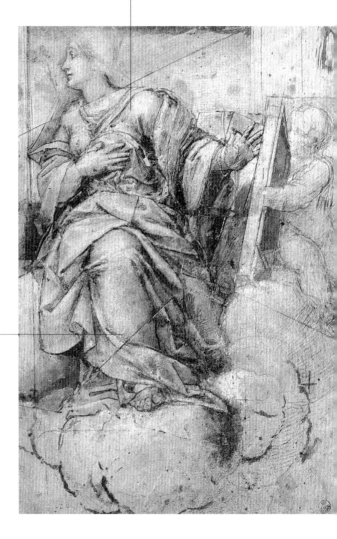

▲ Bernardino Gatti, known as Il Soiaro, *Woman Seated on a Cloud*, 1560–70. Black pencil, pen, brown washes, and lead white on white paper. Florence, Galleria degli Uffizi, Gabinetto Disegni e Stampe.

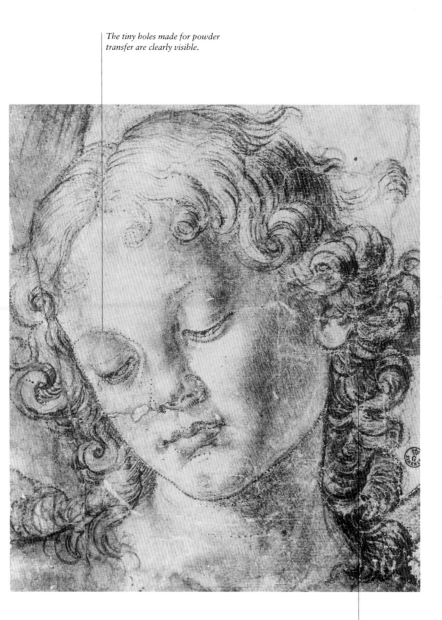

ndrea Verrocchio, *Head of an Angel*,
o–76. Black pencil, pen, and bistre on
te paper. Florence, Galleria degli
zi, Gabinetto Disegni e Stampe.

This drawing clearly shows how each detail of the image, except for the color, was laid out. This small cartoon was probably prepared for the head of an angel that appears in The Baptism of Christ *in the Galleria degli Uffizi.*

The cartoon for The School of Athens, *a fresco in the Stanza della Segnatura in the Vatican, is the largest cartoon that has survived intact; workshops usually reused cartoons repeatedly until there was nothing left.*

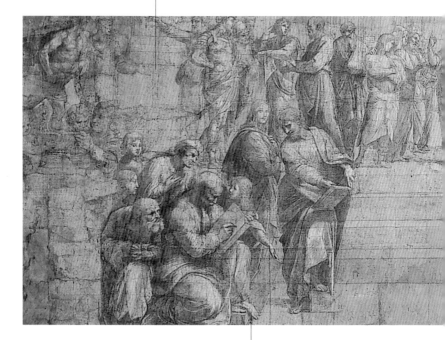

The tiny holes visible along the contours of the figures indicate that the artist used the powder-transfer method to place the figures on the wall.

▲ Raphael, *The School of Athens*, 1509. Cartoon. Milan, Pinacoteca Ambrosiana.

The composition is drawn in full on the cartoon, including the exact placement of each figure according to the rules of perspective and all the major details, such as shading and facial expressions. After the composition was transferred to the wall, the cartoon continued to be an important reference point for completing the fresco.

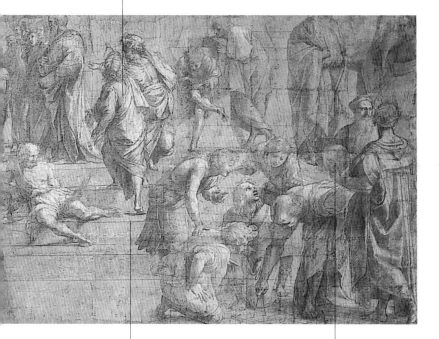

Some details were added to the fresco during the course of the work: for example, the self-portrait of Raphael that appears in the fresco is missing from the cartoon.

To make a cartoon of this size, several sheets were glued together.

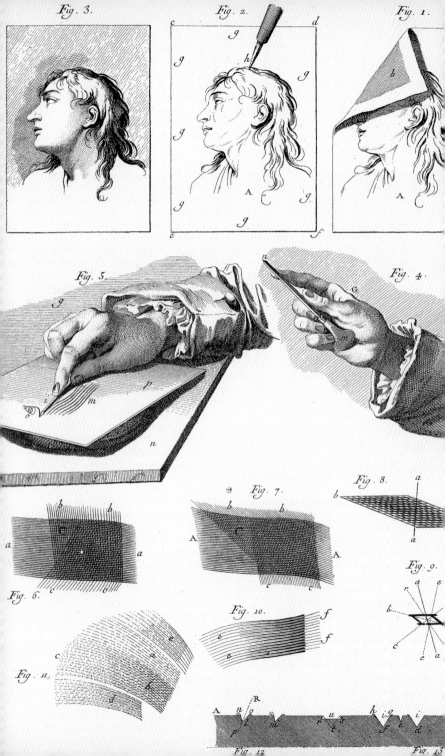

Fig. 3.

Fig. 2.

Fig. 1.

Fig. 5.

Fig. 4.

Fig. 6.

Fig. 7.

Fig. 8.

Fig. 9.

Fig. 10.

Fig. 11.

Fig. 12.

Fig. 13.

PRINTMAKING

Woodcut
Engraving
Drypoint
Mezzotint
Etching
Aquatint
Lithography
Cliché-Verre
Mixed Media
Silkscreen

Engraving, plate from the
cyclopédie by Diderot and
lembert, Paris, 1767.

Woodcut is the earliest printmaking method; a block made of hardwood, such as pear, cherry, or boxwood, is used as a matr on which designs are carved in relief.

Woodcut

▶ Unknown artist, *Saint Martin Sharing His Cloak with a Beggar*, first half of the 15th century. Woodcut. Ravenna, Biblioteca Classense.

The use of wood blocks to imprint images has had many applications: while the earliest known is that of the Egyptians, who ornamented sarcophagi with stamped patterns, the most frequent use is for decorating textiles. Fabrics printed with woodcut dies are still produced all over the world, particularly in China, India, Japan, ar South America. Wood-block printing, according to Pliny the Young was also used in classical antiquity. Woodcuts became popular in Europe toward the close of the 14th century, when a type of soft paper, called *bambagina* or Amalfi paper, began to be produced in West; this type of paper was ideal for printing images from an inke matrix. The procedure is fairly simple: the artist must use a smooth well-seasoned wood block that has been cut along the fiber grain; then draws on it and cuts the outlines of the drawing with a short, sharp knife. Gouges are used to scoop out the wood from the areas that will print white, while the parts to be inked remain in relief. Th block is then inked with a roller or a cloth pad and printed on mois ened paper either by hand or with a mechanical press. Woodcuts

were hand-colored; starting in the early part of the 16th century, they were also printed in color by superir posing different blocks, each color prepared separately. This technique, derived from chiaroscuro, was invented by Ugo da Carpi in 1516, with the use of three or four differer types of wood, each for a different color. A related technique is *camaie* so called because the two-color scheme recalls that of cameos.

The Four Horsemen of the Apocalypse *is one of a series of 25 woodcuts made by Albrecht Dürer between 1495 and 1500. In addition to conceiving and drawing these large engravings (39.4 x 28.1 cm each), the artist himself cut them as well.*

The white areas indicate the parts of the block where the wood was removed in depth with gouges.

...woodcuts, ...aroscuro can ...be modu- ...d; there are ...y blacks and ...ites. Dürer ...s able to over- ...ne this limita- ...n, inherent in ...material, by ...ucing the ...cks to thin ...eads, in some ...as set very ...sely together, ...roduce an ...sion of ...dow and ...th.

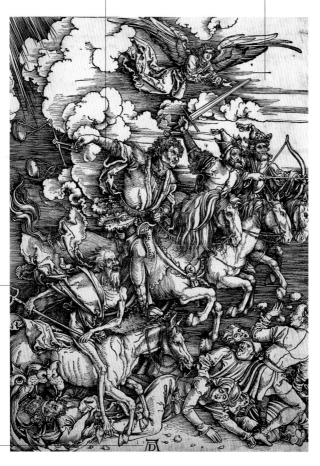

...recht Dürer ...ned his works ...h the mono- ...m "AD."

Albrecht Dürer, *The Four Horsemen the Apocalypse*, 1496–97. Woodcut. ...rence, private collection.

Woodcut

Ugo da Carpi used one block to draw the black strokes and shadows; these he carved in relief. After inking the block, he made a first impression on the other blocks.

The first wood block is "printed" on the second. Starting from this first impression, the composition is completed with lighter gray tones carved in relief and inked. The same procedure is repeated on a third and, in this case, on a fourth block as well.

The superimposed images of all the blocks are used to create the finished image.

▲ Ugo da Carpi, *Diogenes* (after Parmigianino), 1526–27. Chiaroscuro woodcut printed with four wood blocks. Rome, Istituto Nazionale per la Grafica.

The method, derived from chiaroscuro, allows the artist to print with several colors, resulting in images of greater plasticity.

Using a burin to incise images on wood can produce pictorial effects that resemble those of copperplate engravings. The illustrative character of such woodcuts makes them eminently suitable for the printing of images in books and newspapers.

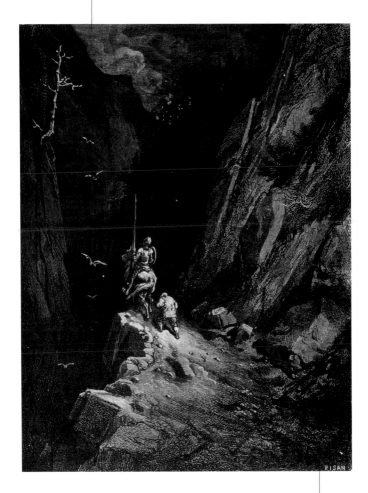

Gustave Doré, *Illustration for "Don Quixote,"* 1863. Woodcut on ʼd-grain wood. Paris, Bibliothèque ʼationale.

The illustrator Gustave Doré helped to revive the art of the woodcut, which had been mostly discarded in favor of copperplate engraving. Doré used very smooth boxwood cut across the grain (so-called end-grain wood). This wood, more dense than that cut along the grain, can be carved with the burin, a tool used mostly for metal engraving.

Woodcut

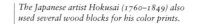

The Japanese artist Hokusai (1760–1849) also used several wood blocks for his color prints.

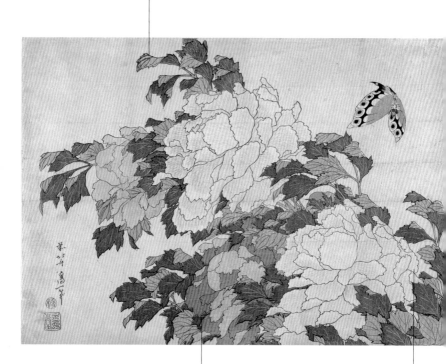

The drawing, finished in all its details, is made on several sheets of onionskin paper. These are then glued to the wood blocks and the outlines are cut on each.

The blocks are printed in succession, one for each color, until the image is complete.

▲ Hokusai, *Peony and Butterfly in the Wind*, 1833–34. Polychrome woodcut. Cologne, Pulverer Collection.

The avant-garde "rediscovered" the art of woodcut in the 20th century. This print by Kirchner makes use of the verticality of the wood fibers to give a hard, angular look to the images.

rnest Ludwig Kirchner, *Women
Potsdamer Platz*, 1914. Woodcut.
lin, Kupferstichkabinett.

The strong, mottled contrast of whites and blacks is interrupted only sporadically by a few straight lines that heighten the dramatic, almost primitive quality of the composition.

Fig. 5.

The burin, a sharp, pointed tool, is also known as a graver; originally used in goldwork, it makes sharp, clean cuts on the matrix.

Engraving

Tools
Copperplate, leather pad

Diffusion
Starting in Germany, the use of the burin spread to all of Europe from the 1440s on. Some of the most important engravers are Martin Schongauer, Albrecht Dürer, Lucas van Leyden, Master E.S., Andrea Mantegna, Pollaiuolo, Cornelis Cort, Hendrick Goltzius, and Agostino Carracci.

Related Materials or Techniques
Woodcut, drypoint, etching

Notes of Interest
The burin was originally a goldsmith's tool; according to Vasari, it was Maso Finiguerra, a Florentine goldsmith, who first made prints on paper using nielli, silver plates with engravings of images and decorations that he filled with a black mixture containing lead filings.

The burin is one of the principal tools used in copperplate engraving. Its squat, round, wooden handle is attached to a small steel shaft, usually square in section, with a slanted, sharp, lozenge-shaped point, or "beak," which makes incision into a metal plate. The preferred metal for this type of intaglic is copper, although other metals, such as brass, zinc, and steel began to be used starting in the 19th century; today, Plexiglas and plastic-vitreous materials are also used. The engraving plate must have a thickness of one to two millimeters and be perfectly smooth and even, with rounded borders to prevent their becoming soiled with ink in the printing phase. The artis starts engraving the plate as if he were drawing: the furrows will be filled with ink and will become the lines and black areas of the printed drawing. Holding the burin firmly almost parallel to the plate, which rests on a leather pad, the artist moves the tool along the plate; the beak cuts into the copper, producing a triangular furrow and a metal shaving, or burr, in front of it. The burin cuts straight, stif lines; curves are made by turning the plate. It is diffi cult to change the directic of the furrows, but their thickness and depth can be varied by altering the pressure on the beak.

▶ Hendrick Goltzius, *Tantalus*, 1588. Engraving. Rome, Istituto Nazionale per la Grafica, Fondo Corsini.

The burin is a very sharp tool that creates slender, precise cuts on copper. The chiaroscuro effect is achieved by the artist's skill in hatching: cutting short parallel strokes of varying density.

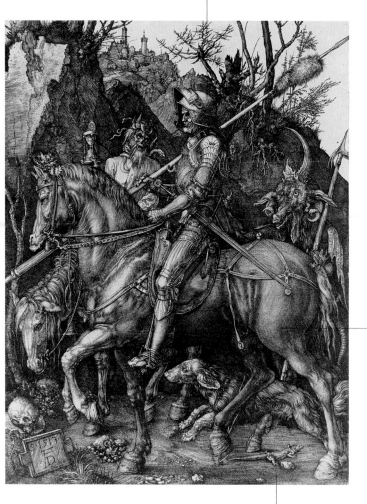

The direction in which the burin cuts cannot be changed, since the point is "captive" to the metal. The only way of making curves is by rotating the plate, which must be supported by a leather pad.

lbrecht Dürer, *Horseman, Death, the Devil*, 1513. Engraving. Rome, ate collection.

The paper used for printing should be soft and supple because it must enter into the thin inked furrows. For this reason, the sheets were slightly moistened before printing.

Engraving

Cort's new technique consisted mostly of using larger burins that made longer, deeper cuts of varying width and depth, very different from the slender, uniform marks of earlier engravers. This made it possible to broaden significantly the range of chiaroscuro effects by juxtaposing strokes of varying width and depth.

The chiaroscuro here is softer, with delicate passages, without the abrupt changes caused by thick lines or sudden cross-hatching.

The limitations of the traditional burin were partially overcome by the innovations of Cornelis Cort, a Dutch engraver who worked in Venice from 1565 on; under the sponsorship of Titian, he was given the privilege of making printed replicas of the Italian master's paintings. The Danaë *illustrated here is a faithful replica of Titian's painting in the Kunsthistorisches Museum in Vienna.*

▲ Cornelis Cort, *Danaë*, 1565–71. Engraving. Rome, Istituto Nazionale per la Grafica.

...rypoint is a thick, pointed needle that creates soft, irregular ...es; it is frequently used with other tools.

Drypoint

...e drypoint is a large, sharply pointed tool, circular in sec-
...n; it is held in the hand like a pencil and gives the artist
...most the same expressive flexibility. Like the burin, it is used
...engrave a drawing or design directly onto the copper-plate.
...the artist draws, the drypoint needle produces a barely visi-
...e irregular edge, called a burr, on each side of an incised line.
...hen the print is pulled, it is the burr that produces the char-
...teristic drypoint look: muted, painterly, intensely black
...es. Since the small burrs are quickly flattened by the pres-
...re of the printing press, the fuzziness disappears after the
...st printings. Drypoint has often been used in conjunction
...th etching and engraving, and, starting in the 18th century,
...th aquatint. In the 16th century it was rarely used alone,
...en the irregularity of the marks. Nevertheless, at the end of
...e 15th century, the Master of the Amsterdam Workshop was
...ng it alone for a set of engravings, and later, Dürer also
...perimented with it.
...mbrandt was able to
...ly exploit the expressive
...wer of drypoint and has
...t many splendid engrav-
...s executed exclusively
...th this tool.

Tools
Copperplate, leather pad

Diffusion
From the latter half of
the 15th century. It was
rediscovered in the 19th
century and the early
decades of the 20th. The
soft lines and relative ease
of use were greatly valued
by the Nabis and the
German Expressionists

**Related Materials
or Techniques**
Engraving, etching,
aquatint

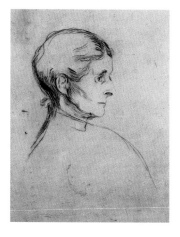

◀ Edvard Munch, *Portrait
of Ragnild Heiberg*, 1896.
Drypoint. Milan, Bertarelli
Collection.

Drypoint

Rembrandt was one of
the few great masters
who used drypoint
exclusively in some of
his engravings. It was
more common to use
drypoint to complete
prints realized with
other techniques.

▶ Rembrandt, *Ecce Homo*,
1655. Drypoint. Berlin,
Kupferstichkabinett.

The outlines of the figures clearly show how the drypoint, compared to the burin, produces a wider stroke that is also more irregular.

The irregularities are produced because the metal-point does not cut through the metal; rather, the point "pushes" the metal, creating the copper residue, or burr, along the edges of the furrows; this is what makes the lines look slightly fuzzy or irregular.

Drypoint

With drypoint (unlike the burin), the
artist can change the direction of the
line being engraved, with an effect
similar to that of a pen drawing.

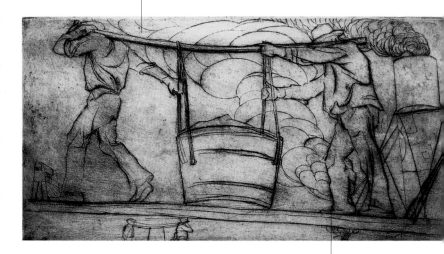

The slight fuzziness produced
by the burr is visible.

▲ Umberto Boccioni, *The Porters*,
1908–10. Drypoint. Milan, Bertarelli
Collection.

ith mezzotint (also known as mezzoprint), it is possible to resent even chiaroscuro in an almost infinite, painterly nge of gray tones.

Mezzotint

[M]ezzotint was developed in Germany in 1642 from an inven-
[ti]on of Ludwig von Siegen of Utrecht; it was used widely in the
[1]8th century and through the mid-19th, especially as a tech-
[ni]que for the reproduction of paintings. Along with drypoint
[an]d engraving, mezzotint (also known as maniera nera, or
[bl]ack style) is a technique for engraving directly on the metal
[pl]ate, but unlike the former, which are linear intaglio-printing
[pr]ocesses, mezzotint is a planar relief-printing process. With it,
[th]e artist can render chiaroscuro values pictorially. The copper-
[pl]ate is prepared by roughening the surface with a special cres-
[ce]nt-shaped tool: the "rocker," with its semicircular, densely
[se]rrated blade, passes over the entire plate several times in both
[di]rections, raising tiny burrs or irregularities that hold the ink
[an]d print in a soft, deep tone. The image is created by variously
[sc]raping out, flattening, or burnishing the burrs wherever gray
[to]nes or white highlights are required. The printed result is a

[ve]ry soft image, with
[hi]ghly nuanced
[ch]iaroscuro. Like dry-
[po]int, mezzotint does
[no]t support large print
[ru]ns because the pres-
[su]re of the printing
[pr]ess rapidly flattens
[th]e delicate surface
[gr]ain.

Tools
Copperplate, rocker,
scraper, burnisher

Diffusion
Developed in 1642
in Germany, it spread
first to Holland, then to
England, where it was
used by engravers of the
Thomas Gainsborough
and Joshua Reynolds
circle. In Italy, the mezzo-
tints of Luigi Calamatta
are noteworthy.

◄ Luigi Calamatta, *The
Martyrdom of Saint Peter*,
1865. Mezzotint and
engraving. Rome, Istituto
Nazionale per la Grafica.

Mezzotint

The initial graininess of the plate with its infinite tiny burrs can bind with a lot of ink, yielding a very intense black. Here the rough texture was left to make these zones extremely dark.

The roughness has been completely scraped away to create the white areas.

Here the name of Jan van Huysum, the artist who made the original drawing in 1722, was added. The name is flanked by the word "pinxit" (painted).

The partial flattening of the burrs creates delicate chiaroscuro in the print.

In this corner, the name of the engraver, Richard Earlom, was added next to the word "sculpsit" (sculpted).

▲ Richard Earlom, *Composition with Flowers*, 1778. Mezzotint. Private collection.

*...ching is an indirect method of engraving the metal plate,
...ing corrosive substances that bite into the metal surface,
...reating furrows or grooves on the plate.*

Etching

...etching, the artist first covers the copperplate with a thin
...yer of acid-resistant varnish composed of wax, bitumen,
...d mastic. The lines of the drawing are etched with a sharp
...int into this ground, exposing the metal; the plate is then
...bmerged in an acid bath—usually a mixture of one part
...tric acid and four parts water. The acid, which may also be
...plied with a brush or a pad, bites into the exposed grooves,
...rroding them and creating the outlines of the drawing. In
...ddition, depending on the effect that the engraver is seeking,
...fferent degrees of concentration and types of acid (hydro-
...loric or nitric acid or iron perchloride) will produce lines of
...rying width that will result in light gray or deep black marks.
...fter the acid bath, the waxy ground is removed and the etch-
...g may be inked and printed. Etching possesses a vast range
...f formal and expressive possibilities. For instance, instead of
...ching the metal directly, the artist may draw on the ground,
...ereby making an infinitely
...ore flexible and free line than
...ould be afforded by engraving
...r drypoint; the artist, in this
...se, is not constrained by the
...ard metallic surface and can
...roduce penlike strokes in all
...rections. Further, the acid
...ath eats softly into the grooves
...f the copperplate, leaving
...regularities that, once inked,
...reate delicate, painterly effects.

Tools
Copperplate, varnish,
metalpoints of various sizes,
acid baths, brushes, pads

Diffusion
Etching became widely
diffused in all of Europe
starting in the second half
of the 15th century. Numer-
ous artists used it, including
Albrecht Dürer, Lucas van
Leyden, Parmigianino,
Rembrandt, Van Dyck,
Agostino and Annibale
Carracci, Salvator Rosa,
Marco Ricci, Canaletto,
Bernardo Bellotto, and
Giovanni Battista Piranesi.

**Related Materials
or Techniques**
Drypoint, engraving,
aquatint

Notes of Interest
The etching technique was
used in the Middle Ages to
decorate suits of armor.

◄ Giovanni Battista Piranesi,
Ancient Mausoleum (detail),
1756. Etching. Rome, Istituto
Nazionale per la Grafica.

Etching

The entire work is finely covered with thin lines produced by the immersion of the plate in the acid bath. Note how the lines etched by the acid all produce the same degree of blackness: the biting cuts into the entire plate surface without varying the depth of the lines.

For this etching, artist transferred the plate a drawing which in turn reproduced Tintoretto painting. Two transfer methods are possible: spolver or dusting, achieved by perforating outline of drawing a "pouncing" it with a small muslin b full of charcoal powder, or transposing it with chalk, that spreading red chalk powder on the back of the sheet a going over drawing with stylus. In both cases, the powder will leave a slight outline of the drawing on the copperplate that is covered with the ground

▲ Lucas Vorsterman, *Portrait of an Old Man and a Youth* (after Tintoretto), 1660. Etching. Venice, Biblioteca Nazionale Marciana.

This etching by Vorsterman is a reproduction of a painting by Tintoretto, Portrait of an Old Man and a Youth, *now in the Kunsthistorisches Museum, Vienna.*

Callot's fantastic landscapes are amazing for the
analytical, "Flemish" precision with which the artist
represents the smallest and most distant details.

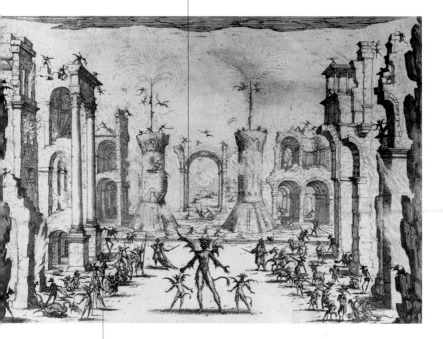

The artist Jacques Callot perfected a variant of the etching process: he
covered the copperplate with a layer of the hard, glassy varnish used by
lutemakers, and used a sort of burin, round in section with a slanted
blade, to make his etchings. In addition to being more precise than the
point normally used by etchers, this tool can be maneuvered into various
angles with respect to the plate, allowing the artist to remove more or
less varnish and to produce infinite variations in the line.

Jacques Callot, *Second Phase Where
ll Took Up Arms to Avenge Circe
inst Tyhrrenus*, 1617. Etching.
me, Istituto Nazionale per la
afica, Fondo Corsini.

The very fine line of the etching point "writes" on the varnish ground with infinite freedom, allowing the artist to create soft chiaroscuro effects, even in the smallest details.

In the 18th century, etching became an ideal medium for representing views of the great European cities. This etching was drawn and made entirely by Bernardo Bellotto.

▲ Bernardo Bellotto, *New Market Square in Dresden*, 1750. Etching. Milan, Bertarelli Collection.

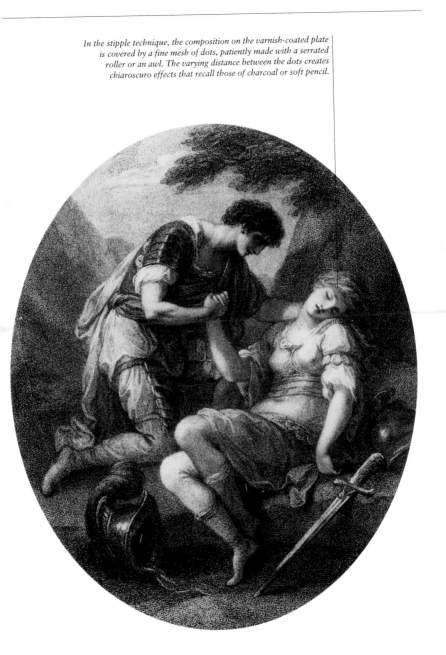

In the stipple technique, the composition on the varnish-coated plate is covered by a fine mesh of dots, patiently made with a serrated roller or an awl. The varying distance between the dots creates chiaroscuro effects that recall those of charcoal or soft pencil.

▲ Francesco Bartolozzi, *The Death of Clorinda* (after Angelica Kauffmann), 1783–84. Stippled etching. Rome, Istituto Nazionale per la Grafica.

A variant form of etching uses soft varnish that yields chiaroscuro effects similar to those of charcoal. A layer of fluid, viscous ground is applied, containing wax, resin, and tallow, which is easily removed on contact. The artist places a sheet of rough paper on the prepared plate and makes his drawing on the paper, thereby causing the pencil's pressure on the paper to detach the underlying ground, baring the metal. At this point, the plate is submerged in the biting solution, and then printed.

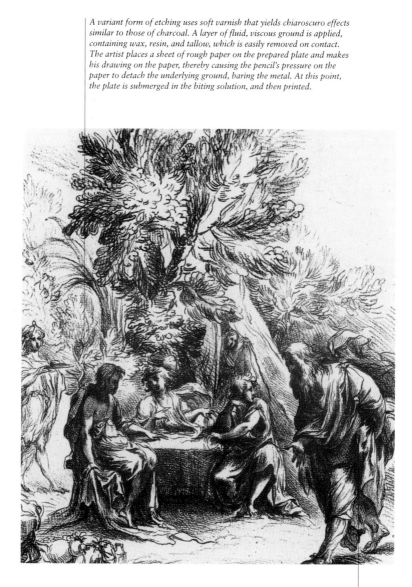

▲ Francesco Rosaspina, *The Angels Appear to Abraham* (after Ludovico Carracci), 1792–1800. Soft-ground etching. Rome, Istituto Nazionale per la Grafica.

Clearly visible here and transposed onto the copperplate with this etching technique is the impression of the pencil on the rough paper.

*quatint is a method of engraving that was born in the 18th
itury; derived from etching, it produces effects similar to
ise of watercolor.*

Aquatint

aquatint prints, the image consists of a filled ground that is
ore or less sharply defined in tones of gray. To achieve this
ect, the artist must first create graininess or granulation.
like mezzotint, granulation is not done manually but is the
direct result of the acid: the plate is sprinkled with resin or
umen granules that are fused to the plate either by heat or
wetting the plate with alcohol to lightly dissolve the granules
d set them. This done, the plate goes through the acid bath,
uch will reach only the interstices between the granules,
king the surface of the plate rough and grainy. During this
ocess, the image is also created: first, the parts to be left white
covered with an acid-resistant varnish. Then the various
nalities from the palest gray to black are obtained by succes-
e partial bitings interrupted each time by brush applications
varnish. Finally, the ground and the acid-resistant coatings
removed and the plate is ready for printing. The result of
s mixed etching-mezzotint technique is an image with sharply
ntoured areas that vary in
minosity and lack continu-
s chiaroscuro passages.

Tools
Copperplate, protective
varnish, bitumen, resin,
biting acids, brushes, pads

Diffusion
Starting in the 18th
century; aquatint was
used especially by
Francisco Goya, Giovanni
Battista Piranesi,
Giambattista and
Giandomenico Tiepolo,
Édouard Manet, and
Pablo Picasso.

**Related Materials
or Techniques**
Etching, drypoint

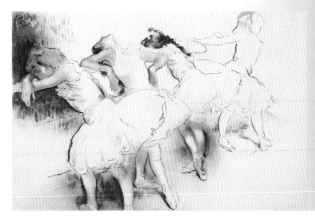

ouis Legrand, *Four Dancers*,
1905. Etching and aquatint.
scow, Pushkin Museum.

77

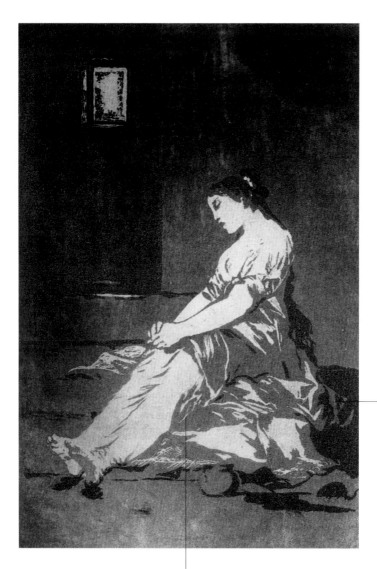

The darker to[nes]
are achieved [by]
longer immersi[on]
of the plate in [the]
acid ba[th.]

▲ Francisco Goya, *Because She Was Sensitive* (Por que fue sensible), 1797–99. Aquatint. Madrid, Museo Nacional.

Notice the clear, well-defined ground of a typical aquatint image; the light grays are the result of shorter acid baths. Once a specific area has reached the desired tone, it is covered with a protective layer of varnish.

Here the artist used a variant of aquatint technique, "sugar-lift" aquatint. Using a pen or a brush dipped in a watery solution of China ink and sugar, the artist draws the composition directly on the plate. Once dry, the drawing is covered with a thin, bitumen-based ground, and the plate is immersed in water. The sugar swells, causing the covering ground to become detached from the plate, thus baring the metal, which is then subjected to the acid bath.

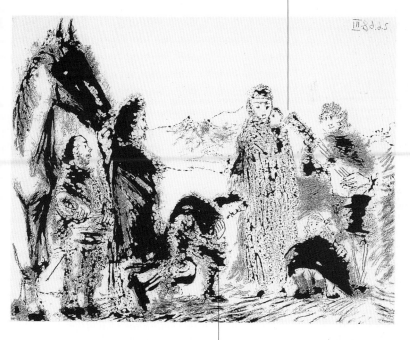

The effect of the sugar-lift aquatint is more delicate and fluid, and recalls that of watercolor.

ablo Picasso, *Variations on the
me of Don Quixote and Dulcinea,*
e 2, 1968. Sugar-lift aquatint.
ate collection.

With lithography the artist is no longer restricted by the hardness of the metal plate to be engraved because he can draw on a flat stone as if it were a sheet of paper.

Lithography

Tools
Stone plate, graining chisel, pencils, crayons, brushes, lithographic inks, light acid bath made with gum arabic, water, paper, lithographic press

Diffusion
This technique immediately became popular, especially in England, France, and Germany. Among the artists who used it are Henry Fuseli, Francisco Goya, Théodore Géricault, Eugène Delacroix, Edgar Degas, and Henri de Toulouse-Lautrec. Lithography is also used in reproductions of works of art, book illustrations, and cartoons.

Notes of Interest
One of the first applications of lithography was the printed reproduction of musical scores, which up to then had been transcribed by hand.

Lithography, a new planographic printing process that became popular in Europe in the early 19th century, was invented in Munich in 1798 by Aloys Senefelder (1771–1834). This technique calls for using a calcareous, flat stone plate as a matrix: the artist traces the composition with greasy crayons or pens, or directly with a brush dipped in tusche (a greasy black ink). The greasy substance adheres to the porous surface of the stone, making it resistant to the water that is used to moisten the stone during the printing phase; water prevents the inking roller from sticking to the blank areas. The stone is treated with a solution of gum arabic and nitric acid diluted in water; this biting solution fixes the drawing to the stone, making the stone more porous. The coating is then allowed to dry and washed with water. Once this is done, the drawn outlines must be reinforced with bitumen and turpentine. The matrix is now ready for printing: the porous stone is carefully wet with water and lithographic ink, which, being oily, is water-resistant and will adhere only to the drawn areas. Finally, the plate is placed in a lithographic press for printing. The use of superimposed lithographic matrixes—one for each of the three primary colors and a fourth for black, known as chromolithography—which enables the artist to create color prints, was first tested by Senefelder, and was perfected by Franz Weishaupt and Godefroy Engelmann between 1825 and 1836.

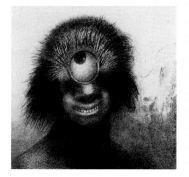

▶ Odilon Redon, *The Misshapen Polyp Floated on the Shores, a Sort of Smiling and Hideous Cyclops*, 1883. Lithograph. Milan, Bertarelli Collection.

The effect of the lithographic crayon on the plate allows the artist to create prints with the same characteristics as a pencil drawing. The marks on the stone may be corrected by erasing them with pumice stone or sandpaper.

Highlights are produced by scraping the stone.

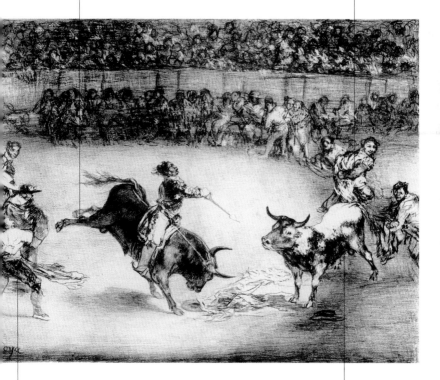

This drawing was made with lithographic crayons composed of wax, soap, and lampblack, rendered with varying amounts of pressure.

Lithographic ink (tusche) contains greasy substances or soap mixed with black pigment; available in sticks, it must be dissolved and diluted in distilled water or pure turpentine just before use.

ancisco Goya, *The Famous American iano Ceballos*, 1824–25. Lithograph. drid, Biblioteca Nacional.

The strokes of the lithographic pencil emphasize the characteristic graininess of the stone.

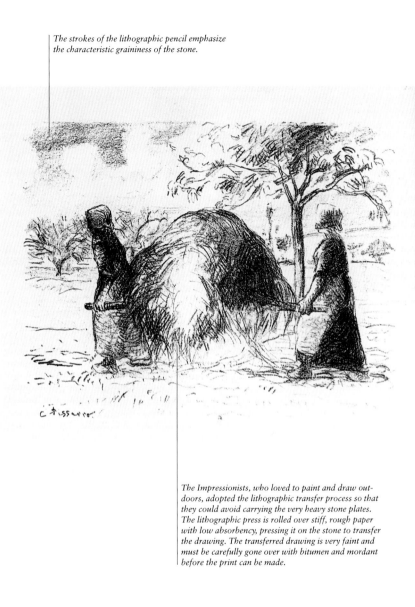

The Impressionists, who loved to paint and draw out-doors, adopted the lithographic transfer process so that they could avoid carrying the very heavy stone plates. The lithographic press is rolled over stiff, rough paper with low absorbency, pressing it on the stone to transfer the drawing. The transferred drawing is very faint and must be carefully gone over with bitumen and mordant before the print can be made.

▲ Camille Pissarro, *Women Carrying Hay*, 1874. Lithograph. Paris, Bibliothèque Nationale.

The delicate spray effect in many works by Toulouse-Lautrec is achieved by rubbing a brush soaked in ink over a grid.

The thicker lines that enhance the stylization of the image and the short wavy lines decorating the background were traced on the stone with a brush dipped in tusche.

finer lines
e drawn with
hographic
on.

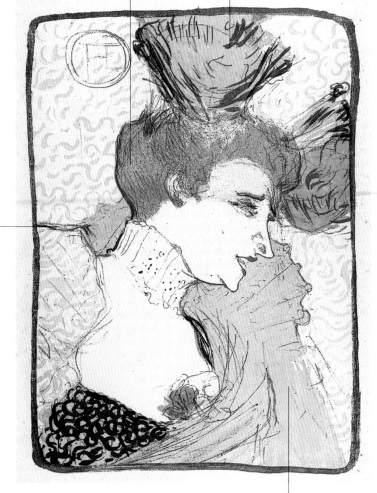

Henri de Toulouse-Lautrec, *Bust of Mademoiselle Marcelle Lender*, 1895. Lithograph with chalk, brush, and spray. Copenhagen, Statens Museum for Kunst.

The marvelous lithographs of Toulouse-Lautrec are often works of great complexity: this particular print was executed in four phases and resulted in an eight-color impression. This version, an example of the second phase, has only six colors.

Cliché-verre uses a glass plate and photographic material: it is the only printing process that yields images without employing ink.

Cliché-Verre

Tools
Glass plate, black paint, metalpoint, photosensitive sheets of paper

Diffusion
Cliché-verre was used only briefly, from the middle to the end of the 19th century. The artists of the Barbizon school, primarily Camille Corot and Jean-François Millet, along with Charles-François Daubigny, used it to make drawings printed on photographic paper. In Italy, Antonio Fontanesi employed this technique.

Cliché-verre, also known as glass printing, is an unusual type of planographic printing that is between printmaking and photography. It was used for a brief but meaningful period in the mid-19th century, especially by two Barbizon school artists, Camille Corot and Jean-François Millet. In this process, a glass plate is used as the receiver of the drawing: after coating the glass with black paint, the artist traces the drawing by scratching the surface of the plate with a metalpoint. The print is made by placing photosensitized paper underneath and in contact with the plate, and exposing plate and paper to the light. As light filters through the scratch marks, it prints on the paper the image that was drawn on the glass. Cliché-verre prints resemble drawings made with a very fine pen. This characteristic, together with the rich gray tones produced by the silver chloride solution in which the photosensitive paper is immersed, was well suited to representing the delicate atmospheric nuances typical of French landscape artists of the period.

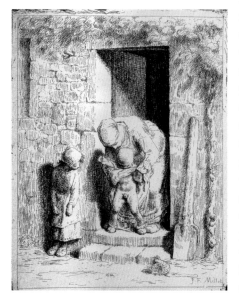

▶ Jean-François Millet, *Motherly Foresight*, 1862. Cliché-verre. Milan, Bertarelli Collection.

...ith engraving, the artist can use several techniques ... multaneously to fully exploit the various expressive ...alities of each.

Mixed Media

...engraving, the artist cuts, carves, removes, or flattens the ...etal on the plate to create an image. After inking it, this ...aglio work produces a print that can be reproduced many ...nes. The artist can work with a variety of media and ...ocesses, each with its own expressive power and technique. ...hether using one technique or several together, the artist may ...a certain stage need to print some proofs in order to make ...anges. These proofs and later variations are called "states." ...embrandt's famous prints were usually done in several ...tates," often after making major changes to the plate. The ...tate proof" should not be confused with "artist's proof" and ...un." Each state proof represents a special creative moment ...pressed on the ...ate; the "run" ...entifies a group of ...oofs printed at the ...me time; for each ...ate, there may be ...ly a few proofs or ...n specimens. The ...tist's proof is a ...ecimen printed ...ring the engraving ...ocess, before the ...al run.

Tools
All the tools used in copperplate engraving

Diffusion
In the 15th century, most engravings were done with the burin, its sharp, precise cut reflecting the clear, geometric taste of the Renaissance. By the last quarter of the century, however, Andrea Mantegna in his Bacchanals was softening his "gold-smith's" line with vibrant drypoint touches. But it was especially in the 16th century, with the growing popularity of the etching, and in the succeeding centuries, that all the various printing tech-niques were used together on the same plate to produce highly refined, original results.

◀ James Abbott McNeill Whistler, *Girl Reading in Lamplight*, 1858. Etching and drypoint on ivory paper. New York Public Library.

Mixed Media

This series was made in two versions subdivided into five states. It is a unique example in the history of engraving because the differences between the two versions are such as to transform states four and five into a different work of art than the earlier three states.

The first version, corresponding to the first three states, depicts Calvary crowded with figures: the center of the composition is the Crucifixion within a luminous ray of light that rents the dark, gloomy background.

Several characters are well defined, while others remain in shadow or are unfinished. The general effect, resulting from alternating use of engraving and drypoint, is of great movement and drama.

The darker shadows were achieved with deep burin incisions that absorbed large amounts of ink, producing a very intense black.

▲ Rembrandt, *The Three Crosses*, 1653. Drypoint and engraving, first version (third state). Berlin, Kupferstichkabinett.

The figures in the crowded composition were outlined in drypoint, recognizable from the nervous, irregular stroke that also allows quick curves.

Here the composition has been transformed. Experts do not agree on the dates of the revision, which could have been about 1653, immediately after the third state, or in 1661, because the earlier version no longer produced acceptable prints.

Although the Crucifixion is substantially unchanged from the first version, it is more clearly defined by the addition of slight chiaroscuro to the body of Christ and darkening of the background behind the cross.

The thief on the right is no longer visible, hidden by a large swath of shadow.

The figure of the mounted soldier has been radically altered: in this case, it was scraped and redone.

The kneeling centurion was removed, possibly with a scraper.

The dense grid of lines made with the burin (the longer, sharper lines visible on the lower left) and with the drypoint (the spongier, more irregular lines covering the group on the right) plunge the composition into darkness.

Rembrandt, *The Three Crosses*, 1653 or 1661. Drypoint and engraving, second version (fourth state). Berlin, Kupferstichkabinett.

The burin strokes are harsher and more uniform.

The gray ar were achie with a burnis a concave t that flattens etching and d point burrs a irregularit

In the 2 century, art often used mix media for th engravings. the last years his life, Pica frequently co bined aquat with dryp and burin on same plate. T effect of th combinatic sometimes evo a collage of d ferent materi used side by si

The burrs produced by the drypoint etching are visible here.

The dark, "flowing" patches were made with sugar-lift aquatint.

▲ Pablo Picasso, *Young Boy Dreaming: Women!*, 1968. Sugar-lift aquatint, burnisher, drypoint, and etching. Private collection.

*ilkscreen is an ancient printing technique that uses thin fabric
instead of a hard matrix, allowing the image to be reproduced
indefinitely.*

Silkscreen

*S*ilkscreen, also called serigraphy, prints by filtering ink onto a
printing surface. An ancient technique known to the Chinese for
centuries, it spread to the United States in the 1940s. The
silkscreen matrix consists of a fine-mesh fabric—originally a
piece of silk, now sometimes nylon—stretched over a frame.
The artist uses waterproof materials, like glue, greasy pencils,
and pastels, to draw on this surface, or glues stencils made of
protective material to it. Once the drawing is completed, a sheet
of paper is placed below the frame and the ink is spread over
the fabric with a spatula or squeegee: the ink filters through the
fabric onto the paper, leaving the areas protected by glue or
stencils free, printing the drawing. Serigraphy produces clear,
filled grounds without nuances. By successively screening differ-
ent parts of the fabric with stencils or glue applied with a brush,
it is possible to print in sev-
eral colors. Silkscreen can
also be done using a photo-
graphic process: photosen-
sitive paint is applied to the
fabric and the image is pro-
jected onto it and devel-
oped so that the areas of
the fabric to be inked are
left blank. This particular
version of serigraphy was
widely used by Pop artists:
Andy Warhol, for example,
used it for his celebrated
serial portraits.

◄ Andy Warhol, *Cow*, 1979.
Silkscreen. New York, Leo
Castelli Gallery.

PAINTING

Secco
Encaustic
Fresco
Tempera
Gouache
Oil
Miniature

"Everything done in fresco must be drawn finely and retouched in secco with tempera" (Cennino Cennini, 1437).

Secco

The term "secco" describes the art of wall painting on a dry support (i.e., not "fresco," fresh or wet), with colors that are fixed with binding substances such as egg, glue, animal fat, oil, or wax. The earliest examples of a secco painting are prehistoric cave images drawn directly on rock walls with colored powders derived from clay or charcoal, mixed with animal blood or fat. In the Neolithic period, the support was perfected by spreading preparatory layers of a sort of plaster containing ground straw that helped hold the color particles. This preparation is found in paintings from ancient Egypt, where the plaster was coated with a layer of mortar made with calcium carbonate, gypsum, and straw. The paint was applied to this dry layer using colors mixed with glue or gelatin. One special *a secco* technique was used in Pompeian painting, where traces of binding agents such as soap mixed with lime were found on walls that had been primed with layers of plaster. In later centuries, tempera on plaster was also used for finishing touches and for those areas

that called for colors such as minium (red lead, or lead tetroxide), lead white, or vermilion, which, if used *a fresco*, could deteriorate because of their chemical reactions to lime.

Bulls and Other Animals, c. 13,000 B.C. Painted cave wall. Lascaux, France.

The wall was prepared with plaster made of mortar, gypsum, and chopped straw, and allowed to dry.

The outlines were filled with various colors, starting from the darkest: black, azure, red, green, yellow, and white.

The contours of the figures were drawn first with a dark red color.

Egyptian painting is extremely delicate and sensitive to moisture, probably because the pigments were mixed with water and a soluble binder, such as glue or gelatin.

Hunting Scene, from an Egyptian tomb, 15th century B.C. Painting on plaster. London, British Museum.

Secco

The technique used in ancient Roman painting required priming the wall with several layers of plaster, as for frescoes; this preparation was meticulously described by the Roman architect, engineer, and author Vitruvius in his De architectura (1st century B.C.). Many of the Roman murals, such as those in the House of Livia, were painted in fresco. The paintings in Pompeii and Herculaneum, by contrast, were probably executed with colors applied to the already dry wall.

Colors such as minium and vermilion, which cannot be used with the fresco technique, often appear in the murals of Pompeii and Herculaneum. To make these colors adhere to the lime, they were mixed with a special binder containing saponified lime because the saponifying process removes the caustic quality of the lime.

The binding solution also gives the paint a lustrous, compact quality.

The upper layers of the plaster contain marble or alabaster powder.

till-lifes, from House of the Deer,
rculaneum, A.D. 45–79. Painting on
ster. Naples, Museo Archeologico
zionale.

Secco

Twentieth-century murals are usually executed a secco on tinted dry walls. Artists use industrial products based on synthetic resins, guaranteeing stable color that covers evenly.

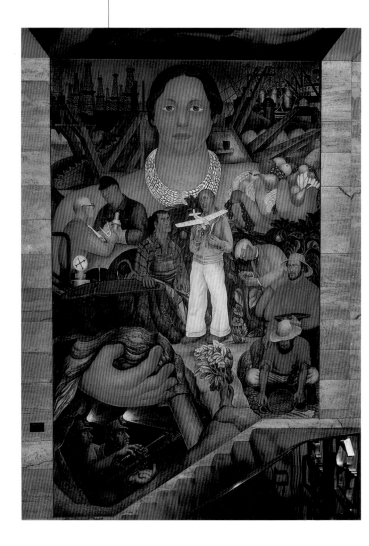

▲ Diego Rivera, *Allegory of California*, 1931. Painting on plaster. San Francisco, Pacific Exchange.

ake some glue, lye, and wax in equal parts. Put them on the
e and melt them. Add the color . . . and paint" (Dionysios of
urna, 1730–34).

Encaustic

ncaustic refers to both a painting process and the resulting
ork of art in which colors bound with wax are used. Ancient
oman artists used encaustic especially to paint on wood; the
rtraits of Fayum mummies dating from the 1st and 2nd
nturies A.D. are noteworthy. Colors are kept thin by a
rtable heating device, originally a brazier (*cauterium*), and
e applied with a brush or, more frequently, a hot spatula.
ncaustic painting is thick and creamy, and covers well. The
ainting is finished by polishing it with a linen cloth. On their
all paintings, the ancient Romans used wax as a color binder
nd also as a protective film: this "encaustication" process,
escribed in detail by Vitruvius, consists of applying a thin
ayer of hot wax to the painting, which is then polished.

Raw Materials
Wax, color pigments, lye
(an alkaline solution of
carbonate and potassium
or sodium bicarbonate,
traditionally extracted
from wood ash and
water), glue or resin.

Tools and Supports
Wood panels, plaster
walls, canvas, brazier,
brushes, spatulas,
polishing cloths

Diffusion
Known in Roman times,
encaustic was also used
in the early Middle Ages
in the Christian East to
make icons; it fell into
disuse but was revived
in the 18th and 19th
centuries, especially in
England and France.
Delacroix sometimes used
colors mixed with wax.
Among Pop artists, Jasper
Johns applies encaustic
onto canvas.

◀ Jasper Johns, *Racing
Thoughts*, 1983. Encaustic
and collage on canvas.
New York, Whitney
Museum of American Art.

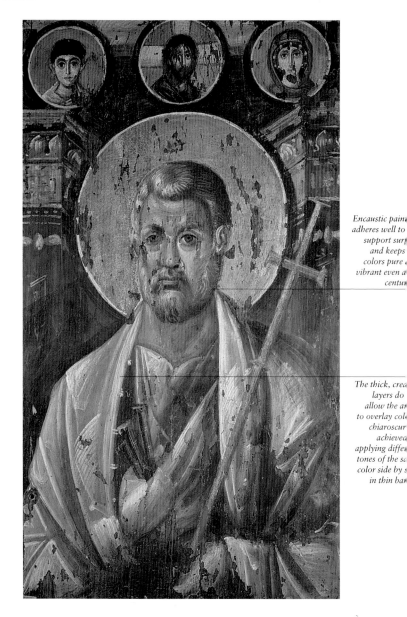

Encaustic pain
adheres well to
support surf
and keeps
colors pure
vibrant even a
centur

The thick, crea
layers do
allow the ar
to overlay col
chiaroscur
achievea
applying differ
tones of the so
color side by s
in thin ban

▲ *Saint Peter*, 8th–9th century.
Encaustic on wood. Monastery
of Saint Catherine, Sinai, Egypt.

*ow to paint walls. Put a bit of lime in the ocher to make it
ghter, and mix it with plain red or terra verde [green mineral
ment]" (Johannes Alcherius, 14th century).*

Fresco

ne fresco technique was widely used in the Middle Ages and the
enaissance, but the earliest known examples are from ancient
Iesopotamia. In the "true fresco" technique, colors are dissolved
 water and applied to the wall while the plaster is still wet. The
ne in the plaster combines with the carbon dioxide in the air to
roduce a film of calcium carbonate (carbonation); the calcium car-
onate crystals, no longer water-soluble, embed the color particles,
aking the layer of paint bright and durable. To ensure the perfect
dherence of color to wall, the wall is primed with three layers of
laster: the first, *arriccio*, is the deepest and roughest layer, made
ith sand, crushed stone, slaked lime, and water. From the 14th to
ne 16th century, a preparatory drawing, the *sinopia*, was drawn in
ed ocher on this layer. The second (*intonaco*) and third (*tonachino*)
ayers are composed of slaked lime, fine sand, and sometimes mar-
le powder, the last layer being extremely thin and applied in small
ections, allowing the artist to paint each section before the plaster
ried. The area to be painted each day was measured in a "scaf-
old," a wide horizontal strip corresponding to the width of the
caffolding. In later
centuries, this mea-
sure was replaced by
"work day," the
ength of which varied
depending on the
complexity of the
image, and the
intonaco followed the
pace of the prepara-
tory drawing.

Raw Materials
Slaked lime, sand, color
pigments, water

Tools and Supports
Plaster wall, brushes,
spatulas, trowel,
preparatory drawings
and cartoon, silver
or gold leaf

**Related Materials
or Techniques**
Secco painting, molded
stucco

Diffusion
Since ancient Rome,
fresco has been widely
employed throughout
the Western world.

◀ Piero della Francesca, *Stories
of the True Cross: The Adora-
tion of the Sacred Wood and
King Solomon's Encounter with
the Queen of Sheba* (detail),
1452–62. Fresco. Arezzo, San
Francesco, Cappella Maggiore.

On the clean, wet wall, the first plaster layer is laid: known as arriccio, it consists of sand, small amounts of crushed stone, slaked lime, and water.

The anonymous Master of Castelseprio drew only the preparatory drawing on the wet arriccio. Over it, a second layer, the intonaco, or plaster proper, was applied, consisting of fine sand and slaked lime.

Although it resembles fresco painting proper so closely as to be often confused with it, lime painting is more opaque and loses the transparency of the "true fresco," for the brushstrokes are thick and their marks visible. In lime painting, however, the artist need not stop to plaster different areas from one work day to the next.

The "lime painting" technique (also known as fresco secco) was used for these paintings: the pigments are mixed with lime and a lot of water (lime milk) and painted on the dry plaster. Although lime painting is a secco technique, it fixes the colors to the wall through the same process as the fresco, i.e., the calcium carbonate formed by the carbonation of lime fuses the color particles to the support in a dense, indelible layer.

▲ Unknown artist, *The Flight into Egypt*, 9th century. Lime painting on plaster. Castelseprio, Santa Maria Foris Portas.

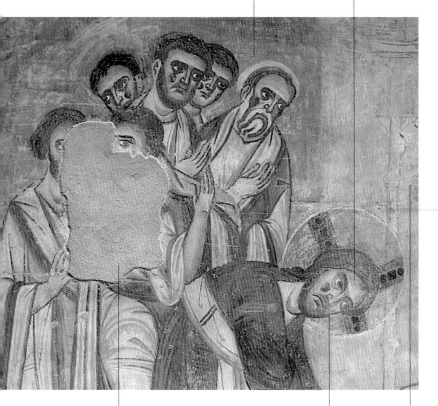

After defining the proportions and tracing the preparatory drawing, the background colors were applied.

Light and shadow were done last.

After applying the background colors, specific details, such as the outlines and details of the faces, were filled in.

Byzantine artists primed the wall with thicker layers of arriccio *and* intonaco; *since this took longer to dry, it allowed them extra time for more accurate work.*

nknown artist, *The Washing of Feet* (detail), after 1072. Fresco. erta, Sant'Angelo in Formis.

The work was done by "scaffold" width: starting from the top, the plaster was applied in a broad swath as wide as the scaffolding on which the artist was standing. The paint was applied in horizontal segments. To complete each scaffold width before the plaster dried, the masters worked with several assistants according to preset models and iconographies. This system saved time so that large sections of a wall could be quickly completed in succession.

Fresco

Sinopia, a red ocher pigment that takes its name from the city of Sinope in Pontus (Asia Minor), was imported in several shades, according to Pliny. Sinopia has become synonymous with the preparatory mural drawing for frescoes, even when it is made with different colors.

In the Italian trecento, new representational needs led to important innovations, such as the systematic use of sinopia, that is, making a preparatory drawing on the arriccio plaster, which allowed for a general draft of the fresco and exact positioning of the spaces to be filled with the intonaco and the tonachino (thin layer of fine translucent plaster) each work day.

Straight lines, useful in defining spaces, were applied by snapping a taut string dipped in charcoal powder against the wall. The string left a line that was used to section the composition. The drawing, with charcoal, was applied to this grid, then retraced with a brush dipped in water-diluted sinopia; after the sinopia dried, the charcoal marks were erased.

▲ Ambrogio Lorenzetti, *The Virgin Annunciate*, detail of *The Annunciation*, after 1340. Sinopia. Montesiepi, San Galgano, oratory.

The Virgin receiving the Annunciation is depicted according to the description in the apocryphal Gospel of Pseudo-Matthew: "Our Lady's chamber. Inside is the column that the Holy Mary fearfully embraced upon receiving the angel's message."

The sinopia drawing does not always correspond to the final version. Here, for example, the position of the Madonna was radically altered: in the final version she is not embracing the column; rather, she is depicted in a praying pose.

is Annunciation was ecuted over several rk days. The system owed the painter eater freedom, since could decide, based his composition, w much work to in for a single day. ch day the artist dertook only as ich as he knew he uld complete with e final colors.

Ambrogio Lorenzetti, *The Virgin Annunciate*, detail of *The Annunciation*, er 1340. Detached fresco. Montesiepi, n Galgano, oratory.

Fresco

Cennini suggested using a glue made of linseed oil, lead white, verdigris, and sandarac (a type of resin) boiled together. The resulting greenish glue has good adhesive qualities and also enhances color.

The flesh tone was prepared in three gradations: the lightest one was for the portions on the face that protrude; the medium tone for the ground of forehe and cheeks; and the darkest for areas i shadow, never totally overlaying the color on the green-shadowed areas.

The final task is the gilding: gold leaf is lifted with a flat brush, cut out with a dull knife, and placed on the glutinous solution that has been spread over the area to be gilded.

White is us for the fir highlights (o the nose, ou the eyebro and arou the mout Finally, usin very fine brus the artist go over the deta of eyes an eyebro

After the shadows are painted, the cheeks and lips are highlighted with white and cinnabar (red).

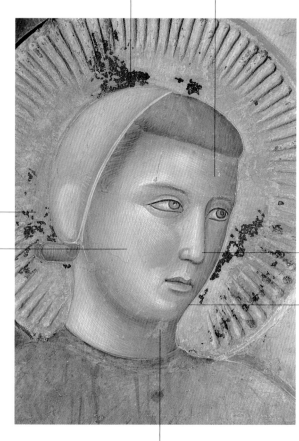

Fine verdacci colored brus strokes outli the hea

The color is never overlaid; rather, the brush-strokes are applied side by side, starting from the shadowed areas. To paint a face, Cennino Cennini suggested the use of verdaccio (a greenish color made with dark ocher, black, lime white, and cinnabar) mixed with terra verde (green mineral pigment).

▲ Giotto, *The Gift of the Mantle* (detail), 1297–99. Fresco. Assisi, San Francesco, upper church.

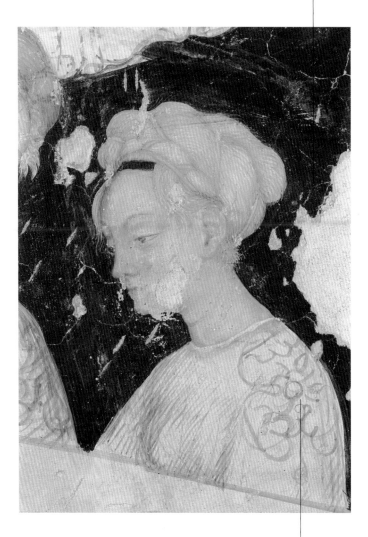

In this fragment, the first layer of arriccio *and the thin layer of* tonachino *with the film of painted colors are clearly visible.*

isanello, *A Lady* (detail),
1450–55. Fresco. Mantua,
al palace.

This fresco by Pisanello is in very poor condition; furthermore, while the face of the lady is finished, the bust was left at the sinopia stage.

Although fresco works are stable and long-lasting, they are still subject to damage from a number of structural, physical, chemical, or bacteriological causes. For the most part, though, deterioration is caused by moisture, which starts a process of calcium carbonate dissolution, the appearance of mold, and alterations of color.

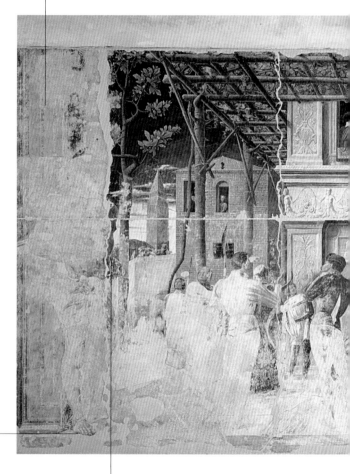

After the wall surface to which the glue and the canvas have been applied is allowed to dry, a cut is made around the perimeter of the fresco and the removal begins, rolling the canvas starting from a bottom corner and proceeding in fanlike folds.

▲ Andrea Mantegna (contr.), *The Martyrdom of Saint Christopher and the Translation of His Body*, 1449–53. Detached fresco. Padua, Church of the Eremitani, Ovetari Chapel.

Once the fresco has been fixed onto canvas, the back of the painted fresco surface must be evened out with scrapers; when the painting has been stabilized, it is set on a new canvas support mounted on a frame or other rigid support. The last phase of this operation consists of diluting the strappo glue with water in order to remove the canvas backing used to detach the painted image, thus completing the transfer.

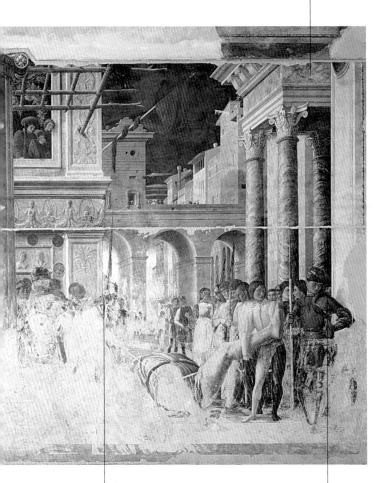

Most of the frescoes painted by Mantegna with Nicolò Pizolo between 1448 and 1456–57 in the Ovetari Chapel were destroyed by bombing in 1944.

If they cannot be restored in situ, seriously damaged frescoes are detached from the wall to ensure their conservation. If possible, they are replaced on the wall once restoration has been completed.

To detach a fresco, all dust and grease must be removed; a dense coat of water-soluble glue is applied, and over it a thin layer of cotton and another coat of glue over the cotton. A sturdy hemp canvas "backing" is then attached to the fresco using diluted glue. To avoid dripping, this process is done starting from the bottom.

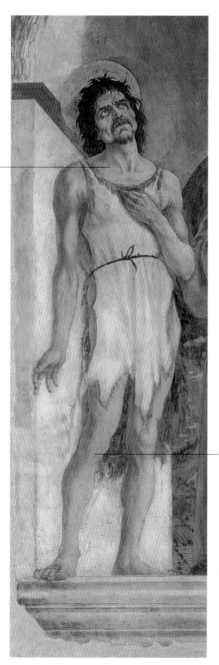

In the 15th century, the use of sinopia on the arriccio, as an on-site draft of the fresco's composition, was gradually discontinued. As perspectival composition was gaining favor, greater attention to detail was needed; thus, improvisations made by artists while they painted, so common in the past, were no longer possible. The complete composition was now drawn on a cartoon the same size as the projected fresco, and it contained all the complex elements of chiaroscuro.

The contours of the drawing are perforated with punches. The cartoon is then placed on top of the tonachino that has been applied for the day's work, and "pounced" with a small muslin bag full of charcoal or sinopia powder. In this painting, the small dots left by the dust transfer are visible next to the figure's contours.

▶ Domenico Veneziano, *Saint John the Baptist and Saint Francis* (detail), 1450–60. Detached fresco. Florence, Museo dell'Opera di Santa Croce.

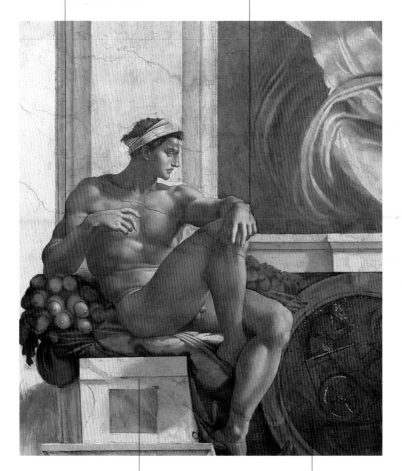

Transfer of images was done by "tracing": with the cartoon resting on the intonaco, the contours of figures were traced over with a pointed tool, thus making a light impression on the wall, which the artist retraced with a brush.

Pigments are applied in thin, transparent glazes that let the white of the intonaco show though, thus enhancing the luminosity of the colors.

The extraordinary shadows, of an almost liquid consistency, were executed on the intonaco when it was almost dry.

Many Renaissance frescoes have some secco portions, often painted with oil colors (e.g., various sections of Giulio Romano's Hall of Constantine); Michelangelo used only the fresco method, with the exception of the medallions at the feet of the nudes on the vault of the Sistine Chapel, which he painted on dry intonaco.

Michelangelo, *Nude with Medallion* (detail of the vault), 1508–12. Fresco. Vatican City, Sistine Chapel.

Fresco

To evoke the effects of painting on canvas, the plaster surface was roughed up. Its grainy quality eliminates shiny reflections and is ideal for scenic compositions best seen from a distance, such as the theatrical frescos of Villa Barbaro at Maser (near Treviso), an extraordinary example of this genre.

Veronese freely used other techniques as well, applying them to the dry plaster to finish his frescoes. These shiny, bright additions were used especially for decoration.

▲ Paolo Veronese, *Young Hunter* (presumed to be the artist's self-portrait), 1560–62. Fresco. Maser, Villa Barbaro.

As taste evolved during the 16th century, artists working in the Veneto region, in particular, tended to reduce the shiny, marble-like, compact quality of the painting in favor of softer, more vibrant colors.

The new 19th-century editions (1821 and 1859) of Cennini's treatise bolstered artists' rediscovery of traditional painting techniques. As they reread this fundamental text, they took renewed interest in the fresco technique.

Artists even used traditional pigments rather than the new mass-produced colors. Recent restoration work has found that the paint used in these frescoes contained lime white, azurite, lapis lazuli, enamel, ochers, and earth colors.

▲ Friedrich Overbeck, *Edward and Gildippe Fighting Suleiman*, scene from the epic poem *Gerusalemme Liberata* by Torquato Tasso, 1824. Fresco. Rome, Casino Massimo.

The wall paintings done by the Nazarenes in the Casino Massimo (1822–27) were executed in the fresco technique in an attempt to reintroduce as faithfully as possible the techniques and effects of the 15th and 16th centuries. The pictorial surface is very smooth, with tiny accurate details in abundance. The sections painted by Friedrich Overbeck are particularly successful in this regard.

111

"You would do well to always mix your colors with egg yolk and do it well: as many yolks as the colors you are mixing" (Cennino Cennini, 1437).

Tempera

Raw Materials
Colored pigments: lime white (*bianco Sangiovanni*), lead white, yellow and red ocher, *terra verde* (green mineral pigment), malachite, lapis lazuli, azurite, minium, ivory black, wood charcoal. Binders: egg, starch or animal glue, wax, calcium caseate (milk, or casein with lye), fig-tree sap, oil, Armenian bole, chalk

Tools and Supports
Brushes, spatulas, stone or plaster wall, gessoed wood panel, parchment

Diffusion
In every age and style

Related Materials or Techniques
Fresco, oil painting, wood sculpture, miniature painting, ivory carving

Notes of Interest
In tempera works painted on wood, sheets of tin were sometimes used to represent metal armor. Tin also appeared as a background for translucent glazes that imitated cloth of gold.

The word *tempera* comes from the Italian *temperare*, meaning to dissolve or mix in the right dosage. Tempera is any agglutinant substance to which color pigments are added to make them "bind" to the support, which may be a wood panel, a wall, a canvas, or some other material. The substances are: egg yolk or egg white—the latter used especially in miniature painting—fig-tree sap, oil, vegetable and animal glues and gums, wax and resins. With the exception of the last two, which require heat treatment, and oil painting, which began to develop autonomously starting in the 15th and 16th centuries, tempera refers to colors bound with water-soluble substances, in particular, egg tempera. This medium, painted on wood panel, reached its splendor in the Middle Ages, up to and well into the 15th century. Egg yolk is the ideal binder for colored pigments: the protein base gives body to the emulsion, the lipids have a plasticizing function on the paint once dry, and the lecithin is an excellent emulsifier and stabilizer; that is, it will "absorb" color, preventing its separation from the mixture and allowing for other substances to be added, such as small quantities of drying oil (to make *tempera grassa*). The

wood panels, cut radially from trunks of poplar, oak, fir, or fruitwood, are soaked at length to leach them of resins and tannins and then left to dry; they are primed with several coats of glue and fine gesso, allowed to dry, and scraped before the application of each successive coat. At the end of this process, the wood surface is perfectly smooth and compact, ready to receive the preparatory drawing and the color.

▶ Bonifacio Bembo, *Saint Julian*, ca. 1456. Tempera on wood. Milan, Pinacoteca di Brera.

Tiny amounts of carmine red and blackish green were added to the flesh tone to draw the eyes, nostrils, beard, lips, and wrinkles.

The cheeks were colored by adding red to the flesh tone.

...highlighting is ...final step: ... light pink ...lead white ...used.

...colors result ...successive ...lays.

...base color ...the face, ... tone pre-...d with earth ...rs and lead ...e mixed ... egg yolk, is ...ied to all the ...ed sections ...e body.

The entire surface of this wood panel was covered with strips of parchment, which in turn were coated with several layers of gesso and glue. Parchment glued to wood was a common ground in Italy in the 12th century and is documented in the treatise by Theophilus, De diversis artibus *(ca. 1125), which* illustrates painting techniques used in the Middle Ages.

...berto Sozio, *Crucifix* (detail), ...7. Tempera on wood. Spoleto, ...edral.

113

Tempera

The decorative motifs on the haloes and on some fabrics were made with small dies.

The gold leaf is prepared extremely thin sheets (thickne varies from 0.1 to 1.2 microns) beating a small nugget of gc between two layers of soft leath

The first step is gilding the wood that has been primed with several coats of gesso and glue. As an agglutinant, the artist used beaten egg white mixed with water and Armenian bole, a reddish clay earth.

Red is prepared with the extract from Reseda tinctoria, a plant also used for dyeing fabric with red ocher, lead (saline oxide), and minium.

The yellows used in the trecento palette were saffron gold, yellow ocher, arsenic yellow or giallorino (lead-tin yellow).

▲ Duccio di Buoninsegna, *Maestà Altarpiece* (detail), 1311. Tempera on wood. Siena, Museo dell,Opera del Duomo

The original color of the mantle was a da; obtained from powdered lapi.

...he whiting used most frequently in ...mpera work is lead white, and the ...ack is usually charcoal black.

Armenian bole and diluted egg white are brushed onto the gessoed ground, "reviving" the glue in the priming so that the gold leaf will adhere firmly. The red in the Armenian bole enhances the gold leaf with a warm, reddish tone. Green bole was also used.

In addition to dark blue, another shade of blue can be obtained from the mineral azurite. Greens are extracted from verdigris powder, terra verde (green mineral pigment), and malachite powder.

To render the drapery movement, the darker tones are painted first, then the intermediate colors, and finally, the lightest ones. The colors painted side by side are shaded with a brush.

After being prepared in the required tones, the colors are now applied to the gilt ground on which the composition was drawn. The colors are applied alongside each other, without overlay.

Tempera

After the application of a thin coat of varnish, colors diluted with oil and resin could be applied in transparent glazes on tempera. The varnishes, with a base of vegetable resins, were used as an intermediate layer and served to protect the underlying color, keeping it clear and bright.

In this tempera work, Giovanni Bellini used as a binder, not only egg yolk but also oil-resin components, creating tempera grassa.

Tempera grassa resembles true oil paint and yields the same transparent, luminous effect.

▲ Giovanni Bellini, *Madonna and Child*, 1460–70. Tempera. Pavia, Pinacoteca Malaspina.

The Last Supper *is not a fresco but a tempera work on* intonaco. *Leonardo chose this technique because it allowed him to work slowly and to make changes by repeatedly returning to work on the same figures.*

The most likely hypothesis is that the painting was done with several layers of tempera and oil.

ine layer of calcium ...bonate is spread ...r the intonaco, *and ...r it, lead white ...xed with drying oil. ...change the tones of ...s ground, Leonardo ...uld have added ...all quantities of ...e or gray pigment ...ere needed.*

...nardo's Last Supper *...s painted on a wall ...pared with priming ...y much like that ...d for wood.*

eonardo da Vinci, *The Last Supper* ...ail), 1495–97. Tempera and oil on ...naco. Milan, Santa Maria delle ...zie, refectory.

Despite in-depth studies and research, experts have yet to identify with certainty the agglutinants that Leonardo used; in fact, several stabilizing substances are present that might have been added in later periods.

"It is one way of mixing colors with glue obtained from parchment scraps, or gum arabic, or other similar viscous, adhesive substances" (Filippo Baldinucci, 1681).

Gouache

Raw Materials
Colored pigments: lime white (*bianco Sangiovanni*), lead white, yellow and red ocher, *terra verde* (green mineral pigment), malachite, lapis lazuli, azurite, minium, ivory black, wood charcoal. Binders: gum arabic, gelatin extracted from boiled parchment scraps or casein glue

Tools and Supports
Brushes, spatulas, stone or plaster wall, gesso-primed wood, parchment, paper, canvas

Diffusion
The use of colors mixed in a viscous binder has been documented even in ancient Egypt. It became a technique in its own right, primarily on canvas, starting in the second half of the 15th century.

Related Materials or Techniques
Fresco, tempera, wood sculpture, miniature, ivory carving. Gouache, mixed with other media, is also used on paper drawings.

Gouache is a kind of tempera technique where the color binder is neither egg nor oil but a water-soluble gummy substance of either vegetable or animal origin—such as gum arabic, gelatin extracted from boiled parchment scraps, or casein glue. Gouache is characterized by great softness of color and ease of application. Its pictorial surface can be very subtle. Colors bound with glue stand out from those of the other techniques on account of their lighter, opaque tones, which differ greatly from the dense brilliance of egg tempera or the transparency of oil colors. Gouache paintings dry very quickly and tend to brighten over time. This technique is rarely used on wood panels or walls; it is found primarily in miniatures and canvas paintings. The term "gouache" also refers to a painting technique similar to watercolor and used for drawings and sketches as well. The main difference between gouache and watercolor (both use glue as a binder) is that gouache, which can be laid on thickly, uses white to lighten the hue.

► Giovan Battista Crosato, *The Sacrifice of Iphigenia* (detail), 1733. Gouache on paper. Turin, Museo Civico d'Arte Antica.

The colors are mostly earth tones; mixed with glue, they yield opaque, chalky hues because the binder is partially absorbed by the support.

The Dead Christ *by Mantegna is one of the earliest Italian tempera paintings on canvas. Gouache uses glue as a color binder.*

The canvas used by Mantegna was scantily primed, probably only with a base of animal glue, to waterproof it.

▲ Andrea Mantegna, *The Dead Christ*, ca. 1500. Gouache on canvas. Milan, Pinacoteca di Brera.

▲ Parmigianino, *The Holy Family with the Infant Saint John the Baptist* (detail), 1527–31. Gouache on canvas. Naples, Museo e Gallerie Nazionali di Capodimonte.

Because gouache uses a water-soluble glue as binder, it can be applied in very thin layers.

This detail shows how the threads of the canvas support remain visible in some gouache paintings.

efore you go further, I want to teach you how to work with on walls or on wood, as the Germans often do, and also on n and stone" (Cennino Cennini, 1437).

Oil

oil painting, the coloring materials consist of pigments and ·ying oils such as walnut, linseed, or poppyseed, to which are ·lded essential oils such as turpentine, extracted from the istilled resins of coniferous plants, but also lavender, spike vender, or rosemary oil. Oil painting, practiced in antiquity, ·as mentioned by Theophilus in his 12th-century treatise, nd also by Cennini, who specified that the "Germans," ·eaning the artists north of the Italian Alps, employed this ·chnique. Flemish artists were the first to paint works in oil, istinguishing themselves in the systematic application of ·olored impastos made with a base of hot oil and resins. In taly, the use of oil as the sole binder became accepted about he second half of the quattrocento in conjunction with a new, ighter, more versatile type of support: the canvas. Oil painting llows for an infinite variety of results regarding both the

choice of colors and the thick-
ness of the paint; the artist can
even determine the drying time
of the colors. When the oil
colors are highly diluted and
transparent, glazes can be
applied to build depth in an
image, describing even the
minutest details; thick impastos
are also possible, applied with a
spatula or with strong, full
brushstrokes.

Raw Materials
Colored pigments, drying oils, such as walnut, linseed, or poppy-seed oil

Tools and Supports
Brushes, spatulas, wall, wood panel, canvas

Diffusion
Oil was used in antiquity to add dry touches to frescoes; starting in the fifteenth century, it was used on wood and later on canvas, spreading from Flanders to all of Europe.

Related Materials or Techniques
Fresco, *tempera grassa*

Notes of Interest
A special kind of pigment used in oil painting was "mummy brown," extracted from decomposed mummies imported illegally from Egypt into Europe since the 12th century.

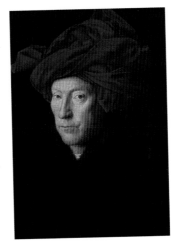

◄ Jan van Eyck, *Man in a Red Turban*, 1433. Oil on canvas. London, National Gallery.

121

Oil-diluted color is used for transparent glazes
with passages of delicate tonal qualities. This
very slow but accurate technique allows for
building images in depth.

Cloth of gold was
simulated by using
fine brushstrokes
of very pale yellow
on yellow, alter-
nating with small,
dark ocher lines.

▲ Hans Memling, *The Saint John
Altarpiece*, 1474–79. Oil on wood.
Bruges, Memlingmuseum.

The wood panels used in Flemish
oil paintings were primed with a
coat of white clay and animal
glue, which produces a very
dense, smooth surface.

The pigments diluted in oil conserve all their brilliance without altering the original tones.

The unique consistency of oil mixed with hard resins permits the artist to execute even the tiniest faraway details and give them the same importance as images in the foreground.

Lime white diluted in oil yields a luminous, almost pearl-like, effect that is also evident in the flesh tones.

The pigments were heated and finely ground with oil and resins such as amber.

Antonello da Messina used to prime
the wood first with a coating of hard
gesso, followed by one of boiled oil,
onto which he applied the colors.

The use of
resins is espe-
cially visible
in transparent
details such as
the teardrops
on the face of
Jesus, which
upon close
examination
almost stand
out in relief.

▲ Antonello da Messina, *Ecce Homo*
(detail), 1473. Oil on wood. Piacenza,
Collegio Alberoni.

The colors, layered in glazes,
were further fused by a thin
brushing of drying oil.

Under the face, the
canvas has a ground of
umber (terra d'ombra).

The priming of the Mona Lisa
is not uniformly white: the
upper part of the sky is azure.

...nardo worked
...ransparent
...aces, using
...t varnishes
...ended in a
...der of boiled
...nut oil.

...nardo
...ed with the
...ium light
... s and
...ked toward
...darker and
...er ones.
...shstrokes
...not visible.

Leonardo da Vinci, *Mona Lisa
(Gioconda)*, 1510–15. Oil on
...d. Paris, Musée du Louvre.

The priming of the
lower portion has a
reddish ground.

Oil

This wood panel was prepared with an impannatura, that is, layers of linen canvas strips soaked in oil applied to the panel joints. The surface of the canvas was then primed with gesso and glue.

The intense red is crimson lake, also known as Kermes red because it is extracted from scale insects of the Kermes genus.

Lotto's distinctive blue was made with lapis lazuli powder, which the artist purified with a heat treatment that consisted of mixing the powder with hot resin, wax, and turpentine solutions, and steeping it in a water-based solution of sodium carbonate and potash, resulting in a clear and brilliant blue.

The black used here is lampblack, which results from burning linseed oil.

The figures were transferred onto the panel by means of the spolvero (dusting) technique.

▲ Lorenzo Lotto, *Madonna with the Child and Saints*, altarpiece (detail), 1516. Oil on wood. Bergamo, San Bartolomeo.

The architectural details were achieved by cutting through the preparatory cartoon with a point.

Oil color can be used with excellent results on plastered walls, provided that they have been primed until they are perfectly smooth and waterproof.

Vasari carefully described the preparation technique for a wall that is to be painted with oils: the plaster surface must be soaked with several coats of boiled oil until the wall no longer absorbs it. Once the surface is dry, a coat of lead white, oil, lead-tin yellow, and refractory clay is applied.

Francesco Salviati, *Creation of the Sun and the Moon*, detail from *The History of Creation*, 1550–55. Oil on plaster wall. Rome, Santa Maria del Popolo, Chigi Chapel.

The third layer consists of extremely fine marble powder mixed with lime, plus a coating of linseed oil. Finally, a layer of rosin (Greek pitch), mastic, and greasy varnish (oil and resin) is applied and smoothed dry with a hot trowel.

When pigments are mixed with oil and resin, they can also be applied to copperplates; the shiny, reflecting metal surface is perfect for applying thick strokes of color.

▲ Jan Brueghel the Elder, *Flower Vase with Jewelry and Coins*, 1606. Oil on copper. Milan, Pinacoteca Ambrosiana.

The light priming applied to the canvas leaves the fibers supple. First, a coat of starch or sugar glue is applied. When it is dry, two coats of gesso and glue are added, the second applied at right angles to the first. Finally, the canvas is scraped and smoothed. Here, red ocher was added to the priming, adding a warm hue to the entire composition.

In the sky the priming is pink.

The artist applied thick, soft strokes, made possible by adding soft resins to the impasto.

Venetian artists were the first, at the end of the quattrocento, to use canvas mounted on a frame, thus creating an extremely flexible, supple support, since canvas may be rolled up and taken anywhere. The canvas used for this painting is made of hemp.

Giambattista Tiepolo, *The Triumph of Aurelian*, 1717. Oil on canvas. Turin, Galleria Sabauda.

Oil

During the 19th century, commercial production brought new colors to market. Manufactured pigments were more practical and less expensive than some of the natural materials that had been used until then. Giuseppe Pellizza da Volpedo used colors made by the Lefranc Company of Paris.

One major innovation in modern manufacturing of colors was the replacement of lead white, an effective but highly poisonous pigment, with the harmless zinc white.

In the yellow range, the painter used new cadmium yellows next to the old yellow ocher.

Other colors used for the tiny, Divisionist brushstrokes of this large canvas are cobalt blue and chromium green, both artificial, together with traditional shades, such as the old Robbia lacquers, terra verde, *and brown earth colors.*

▲ Giuseppe Pellizza da Volpedo, *The Fourth Estate* (detail), 1901. Oil on canvas. Milan, Galleria d'Arte Moderna.

The roseate component of the facial shadows was painted with rose doré, a warm, orange-hued color extracted from the urine of Indian cows fed on mango leaves. This unusual color compound was eventually abandoned.

With mass-produced colors available in small tubes, new expressive possibilities opened up for the artist: first of all, the painter's equipment became lighter and could be carried anywhere.

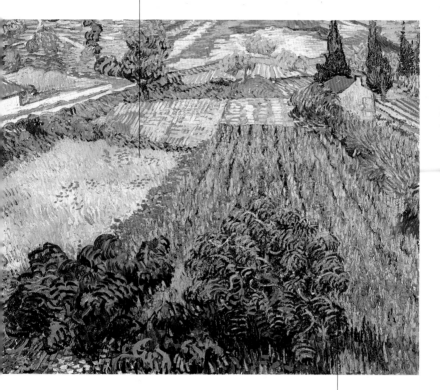

Now the artist could also use color without brushes, squeezing it directly on the canvas and leaving it as is, or spreading it with the fingers.

ncent van Gogh, *Field with ppies*, 1889. Oil on canvas. nen, Künsthalle.

Miniature is the art of decorating manuscripts in gold and vibrant colors: small works of art that the pages conserve in all their original freshness.

Miniature

Raw Materials
Colored pigments, glue, sugar, egg white, gum arabic, gold leaf

Tools and Supports
Pens, brushes, metal-points, parchment, paper

Diffusion
From the end of the Roman Empire to about the end of the 16th century

Notes of Interest
In the 14th-century treatise *De arte illuminandi*, the author, when illustrating miniature painting techniques, suggested adding ear wax (sic!) to the egg white, to prevent it from foaming when beaten.

▶ Unknown artist, *Saint Jerome*, miniature from the Bible of Federico da Monte-feltro, ca. 1480. Parchment. Vatican City, Biblioteca Apostolica Vaticana.

Miniature occupies an important chapter in the history of painting. The word comes from the custom of emphasizing and coloring the initial letters of a manuscript text with the red derived from minium (lead tetroxide). More poetic is the French word *enluminure*, derived from the Latin *illuminare*, "to give light to," and in fact the manuscripts were illuminated with gold or silver leaf together with pure, luminous colors. In the scriptoria, scribes copied the text, leaving space for illuminations. The volume then went to the decorator, who traced a very light sketch of the image on the parchment page, outlining it with more precision with a thin, dark red line. At this stage of the work, a very light touch of color was sometimes applied to the sections to be painted. The first color to be applied in final form was gold. The treatise *De arte illuminandi*, written about the middle of the 14th century, painstakingly describes illumination procedures, giving special attention to gilding. After the cleaned parchment had been primed with several coats of glue and sugar syrup, the gold leaf was applied using as adhesive a thin coating of

well-beaten egg white. This done, the gilding was polished with the tooth of a calf or wolf. Miniature images, often very small but highly detailed, required finely ground colors mixed in egg white or gum arabic. Earth colors were used for the warm tones, lapis lazuli for the blues, turmeric for yellow, lampblack for black, and minium for red.

The shadows and lines
that define the face are
applied over light colors.

Brushstrokes are
quick and concise.

To make colors
adhere better, the
naturally greasy
parchment was
rubbed with
pumice stone to
make it rougher,
or degreased by
rubbing its surface
with ox gall mixed
with egg white.

In the earliest illuminations, the
artist first outlined the composition,
then laid down the various colors
one on top of each other, starting
with the lightest colors.

ιknown artist, *Saint Augustine
ιting to a Cleric*, 8th century.
hment. Berlin, Staatsbibliothek.

The codex is transcribed by the scribe, who leaves space for the illustrations.

Once the composition is sketched, the contours of the figures are drawn in dark red.

The decorator uses very fine, transparent lines that allow for minor changes in the later stages of the process.

▲ Unknown artist, Illustration for *The Troj War* by Guido delle Colonne, second half o the 14th century. Parchment. Milan, Bibliot Ambrosiana.

Once all the parts of the composition were ready, the gold leaf was applied: the parchment was brushed with a thin coat of beaten egg white, water, and a small amount of Armenian bole (a reddish clay); the latter gave a warm hue to the gilding. After the leaf was applied, it was burnished with the tooth of a wolf or calf.

The colors had to be finely ground and mixed with either egg white or gum arabic and sugar syrup or honey water.

After the flesh tones were applied, white was used for the final highlights, and the eyes and eyebrows were defined.

Niccolò di Giacomo, Illustration for the *Commentarius in decretales* by Giovanni d'Andrea, 1354. Parchment. Milan, Biblioteca Ambrosiana.

To paint flesh tones, lead white was applied to the entire facial area. Subsequently, the shadows made with terra verde (green mineral pigment) and white were applied; finally, a mixture of red and white simulated the color of flesh.

SCULPTURE

Terracotta
Glazed Terracotta
Wood Sculpture
Ivory Sculpture
Stone Sculpture
Worked Metal Sculpture
Lost-Wax Casting
Hollow Casting
Stucco
Mixed-Media Sculpture

Since the earliest ages, humans have used fired clay to fashion sculptures, objects, and architectural decorations; terracotta is als used to make project models for marble and bronze sculptures.

Terracotta

Clay was one of the first materials that human societies employ to make objects, and its use is still prevalent today; it abounds i nature, is ubiquitous, and is easily extractable. Clay is made up principally of minerals such as kaolinite, montmorillonite, illite. and chlorite that give it the quality of plasticity, along with sand (quartz), feldspar, and a small percentage of organic substances. Preparing the mass to be sculpted is a very important step becau the quality of the clay has a significant impact on the end result. After its extraction, the clay earth must be pressed, washed, and allowed to clear in vats made for this purpose, adjusted, if neces sary, by the addition of minerals until it reaches the desired con sistency. The unformed mound is shaped by hand on a surface supported by a solid bench or stand that can carry the weight of the clay. The tools used are wooden sticks, small spatulas, and shaping sticks. Clay can also be shaped in molds, usually made of gypsum, spread inside with a viscous substanc such as soap, that allows for the easy remov of the artifact once it has been shaped. The clay, pressed by hand into the mold, is removed before it is totally dry in order to finish it and make any needed changes. Once the modeling is done, the sculpture is left to dry and then is fired at a temperature of 750–950° C. After the firing and a cooling-off period, the artifact may be paint with tempera colors or fired again for the application of glaz

▶ *Bust of Artemis of Ephesus,* Roman period. Terracotta. Milan, Civiche Raccolte Archeologiche e Numismatiche.

Large-scale terracotta sculptures were common
in Etruscan art. They were made in separate
pieces that were joined together with pins.

*Sarcophagus of a Husband and
Wife* (detail), Etruscan, 530–520 B.C.
Terracotta. Rome, Museo Nazionale
Etrusco di Villa Giulia.

Terracotta

To make a bust, the artist shapes a block of clay by hand, with the aid of spatulas and shaping sticks.

After firing, the sculpture is painted with glue-based tempera colors.

To limit cracks and breakage that might occur in the drying process, the clay must be of uniform thickness.

▲ Giovanni Bandini, *Bust of a Female Saint*, 1568–73. Polychrome terracotta. Florence, Museo dell'Opera del Duomo.

The sculpture is left to dry partially, until it reaches a "leather-like hardness." At this point, the thickness must be reduced by removing the inner mass, starting from the bottom.

Clay is an ideal material for making sketch models for marble sculptures. Antonio Canova always used clay for his models.

marks left by shaping tool clearly visible.

Antonio Canova, tch model (*bozzetto*) The Three Graces, 2. Terracotta. Lyon, sée des Beaux-Arts.

141

Luca della Robbia applied a tin-oxide enamel glaze to his earthenware sculptures, also called maiolica. As Vasari noted it was "a new, useful, and very beautiful art."

Glazed Terracotta

Raw Materials
Clay, water, glaze made with silica, calcined soda-ash, lead, tin, and metallic oxides

Tools and Supports
Shaping sticks, small spatulas, plaster molds, brushes, kiln

Diffusion
Starting about 1440 in Florence, the workshop of Luca, Andrea, Giovanni, and Girolamo della Robbia began using this technique. It was also employed by the workshop of Benedetto and Santi Buglioni

Notes of Interest
The great bas-reliefs of Giovanni della Robbia were prepared in sections and assembled on site: for this reason, it was possible to ship his great narrative composition, *The Nativity*, from Florence to Catania.

▶ Luca della Robbia the Younger, *Bartolini-Salimbeni Coat of Arms*, 1521–23. Glazed terracotta. Florence, Museo Nazionale del Bargello.

The use of glazed terracotta, also known as *maiolica*, spread to the Mediterranean basin in the wake of the Arab expansio originally it was used for utilitarian objects, such as tiles and decorative bricks. About the middle of the quattrocento, the Florentine artist Luca della Robbia abandoned marble sculpture to apply himself to perfecting terracotta glazing and its applications. Apparently, the artist's friendship with the humanist Niccolò Niccoli, a scholar of ancient artifacts and a collector of precious Oriental maiolica, was also a factor in this decision. Della Robbia's terracotta technique resembles, i part, that of plain terracotta: once the mass is ready and has been shaped, either by hand or in a mold, it is allowed to dry partially; then it is finished and allowed to complete its final drying stage. The artifact or relief is fired in a kiln at a temper ature of 750–950° C. At this point, stannite (tin-bearing) glaze is prepared containing silica, calcined soda-ash, lead, tin, and metallic oxides. The last two elements confer to the vitreous mix the qualities unique to Della Robbia glazes: the tin white it, turning it opaque, and the metallic oxides set the colors. The glaze is shaped into cakes, finely ground, mixed with water and egg white and applied with a brush to the artifact, which is fired a second time. The heat of the kiln melts the vitreous powder, fusing it to the terracotta surface, which afte the firing process is covered by a shiny, dense enamel coating.

The glaze is a vitreous paste, rendered opaque and milk-white by tin oxide.

The glaze must be fired at a high temperature to make it adhere to the terracotta support, also known as bisque. Three colors resist firing: blue, green, and yellow.

The color blue is made with cobalt.

Yellow is made with antimony oxide.

Luca della Robbia, *Madonna of the Rosebush*, 1450–60. Glazed terracotta. Florence, Museo Nazionale del Bargello.

Green is made with copper oxide.

Wood is one of the earliest materials to be used by humankin it is ubiquitous and relatively easy to shape.

Wood Sculpture

Raw Materials
Wood

Tools and Supports
Axes, saws, wood-working chisels, hammers, serrated chisels, gouges, clamps, glues, varnishes, colors

Diffusion
In all epochs and places

Related Materials or Techniques
Tempera or oil paint, mixed-media sculpture

Wood, like stone, is rigid and cannot be molded, only hollow out or carved. Additional limitations sometimes relegated wood sculpture to the ill-defined group of the "minor arts." First, it is limited by the size of the tree trunk, forcing the arti to work with separate pieces to create large-sca works that need to be assembled. Furthermore, the fiber structure of wood is not homogeneous, since one piece may here be hollow and there have different knots and grains. These irregularities, which are often exploited in contemporary art as expressive sculptural elements, were hidden in the past with treatments that used wax, lacquers, color, metal foils, fabrics, and incrustations of precious stones, coral, or ivory. Finally, wood is an organic material subject to wood-eating insects and fungi, in addition to being extremely sensitive to changes in temperature or humidity that can cause it to crack or swell. Ideal woods for sculpture are those of medium hardness, resistant to woodworms, and less sensitiv to changes in the physical environment: the most common are walnut and cypress in southern Europe and oak, linden, and pea in northern Europe.

▶ Donatello, *The Magdalene*, 1453. Carved wood, painted. Florence, Museo dell'Opera del Duomo.

This statue is made from a single piece of wood.

Locally grown wood, such as sycamore, locust, boxthorn, and tamarisk, was used in ancient Egyptian sculpture. More valuable imported woods, such as cedar, pine, and cypress, were also used.

Head Chorister of Amon, Guardian of the Necropolis of Penbui, Egyptian, 18th dynasty. Carved wood. Turin, Museo Egizio.

Wood Sculpture

Several coats of thin gesso and glue prepare the figures for decoration.

The gilding is done with the same technique used for panel painting: the gesso priming is covered with beaten egg white mixed with water and Armenian bole, a reddish clayey earth that helps the gold leaf adhere to the support and adds a transparent reddish hue.

The Antwerp artists who created this work used egg-tempera colors. Recent studies have underscored the fine quality of the pigments, which were "varnished" by the plasticizing qualities of the protein binder.

▲ Antwerp workshop, *Ecce Homo*, detail from the *Passion* altar, ca. 1560. Gilded and painted carved wood. Milan, Museo Diocesano.

The various parts of this large wooden altar were carved separately and then assembled.

The tempera decoration on this wood sculpture is by the painter Martino di Bartolomeo.

Iacopo della Quercia, *The Virgin
Annunciate*, detail of *The Annunciation*,
1421. Carved wood, painted. San
Gimignano, Church of the Collegiata.

147

Wood Sculpture

The joints of the various
pieces were covered by a
thin layer of stucco.

The figure of Narcissus was carved
separately, then joined to the rest of
the structure with pins.

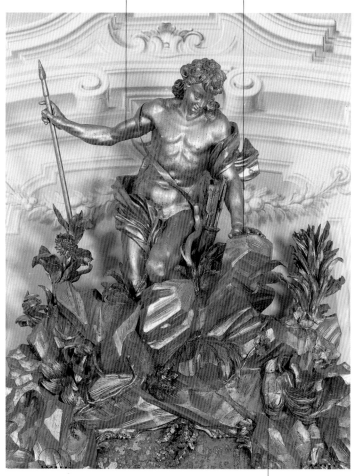

The decoration around
the mirror was gilded
entirely with gold leaf.

▲ Filippo Parodi, *Narcissus*,
detail from a table with mirror,
ca. 1680. Carved wood, gilt.
Albisola, Villa Durazzo.

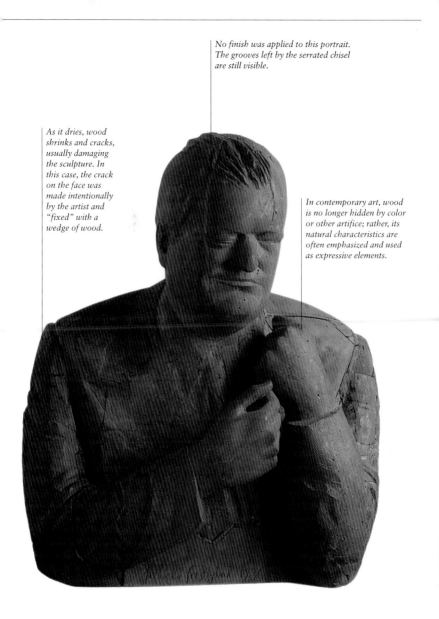

No finish was applied to this portrait. The grooves left by the serrated chisel are still visible.

As it dries, wood shrinks and cracks, usually damaging the sculpture. In this case, the crack on the face was made intentionally by the artist and "fixed" with a wedge of wood.

In contemporary art, wood is no longer hidden by color or other artifice; rather, its natural characteristics are often emphasized and used as expressive elements.

Pericle Fazzini, Portrait of Giuseppe Ungaretti, 1936. Carved wood. Rome, Galleria Nazionale d'Arte Moderna.

Ivory, the precious white material of which the tusks of exotic animals are made, has been in all ages one of the most fascinating materials for sculpture and jewelry.

Ivory Sculpture

Raw Materials
Tusks of animals such as elephant, walrus, hippopotamus, mammoth (fossilized ivory), African boar

Tools
Drill, lathe, small chisels, gouges

Diffusion
In all ages. In Europe, ivory tusks were used in Byzantine art, and in the Gothic period, especially in France. Also notable are the works of the Embriachi workshop, active in Italy in the 14th and 15th centuries.

Related Materials or Techniques
Mixed-media sculpture, gold and jewelry

Notes of Interest
In Islamic countries ivory powder was once believed to possess healing qualities.

Ivory is a kind of bone tissue that contains calcium phosphate, magnesium phosphate, and calcium carbonate, which make up dentine. Harvested from the tusks of animals, elephants in particular, it is one of the most widely used organic substances for carving objects. Ivory has been used in all ages and in all corners of the world, including India, Africa, China, and Japan. Also noteworthy is Eskimo ivory artwork. In the civilizations of the Mediterranean basin and continental Europe, ivory, an extremely valuable product that was imported from the producing countries through trading centers of the Near East, was used primarily to fashion luxury items. In ancient civilizations, ivory was used in sculpture and jewelry in Egypt, Phoenicia, Crete, Etruria, and Rome. Ivory carvings are usually small, although ancient sources tell of large-scale gold-and-ivory statues by the Greek sculptors Phidias and Scopas. Carving ivory is relatively easy, its main limitations being the narrow width of the tusks and their curvature, factors that

often determine the size and shape of the object. In addition to being partially hollow inside, ivory has a concentric-ring structure, visible especially in the tusk of African elephants, which are usually also less white and opaque than those of Indian elephants.

▶ Sicilian workshop, Hunting Horn, late 11th–early 12th century. Carved ivory. Kuwait City, National Museum, The al-Sabah Collection.

To achieve a flat surface, the tusks are cut lengthwise and immersed in a solution of vinegar and almond oil. Since ivory is an organic substance, it absorbs this solution and becomes more pliable.

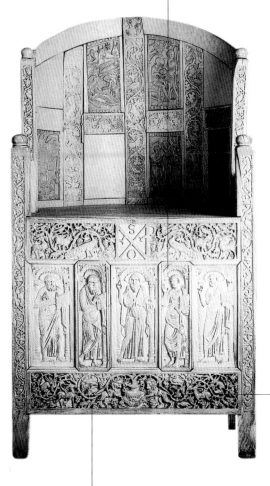

Carving is done with small chisels and a drill.

yzantine workshop, Throne of
hop Maximian, 546–56. Carved
ry. Ravenna, Museo Arcivescovile.

In Byzantine art, ivory was used to create religious objects (ciboria in particular) and bas-reliefs. The Throne of Maximian has an underlying wood frame to which the carved panels were attached.

In the 17th century, German workshops manufactured these whimsical objects: the complex shapes were made with virtuoso skill on lathes that allowed the artist to create soft curves.

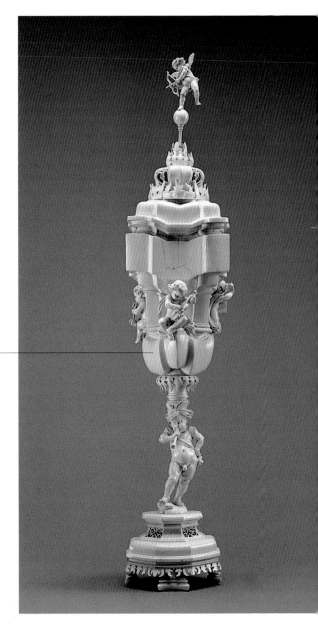

▶ Marcus Heiden, Covered Standing Cup, 1631. Ivory. Los Angeles, J. Paul Getty Museum.

*nd likewise he completed a five-ell marble of Moses, whose
auty no modern work can ever equal" (Giorgio Vasari, 1550).

Stone Sculpture

*ne is one of the materials most commonly used in art: prehis-
*ric Venuses are stone, as are Roman copies of Greek statuary,
*asterpieces of Michelangelo and Bernini, and so many of the
*onuments that fill the squares of the world. The leading type
* stone used in sculpture is metamorphosed calcite, known as
*nite marble, which has a medium hardness and a crystalline
*ain; this has been used especially in Western sculpture from
*assical antiquity until today. Igneous rocks, such as porphyry,
*salt, and granite have also been important; these are harder,
*ten intensely colored, and rich in appearance. Finally, the softer
*etamorphic rocks, such as tufa, some kinds of alabaster, sand-
*one, and travertine, are also used. Working on stone is always
*ne by removing or "hollowing out" excess material with ham-
*ers and various kinds of chisels. The artist cannot correct or
*ethink" his creation, except by adding wedges or
*her pieces. Therefore, the sculptor will usually
*epare a model of the work, either a graphic
*etch—as for bas-reliefs or Egyptian and
*esopotamian sculptures—or, more fre-
*ently, a small-scale version in terracotta
* wax, whose measurements are then trans-
*sed on a larger scale to the stone block.
*he models serve to establish a figure's pose
*d proportions, without defining the details,
* they may be carefully finished. In the
*tter case, the artist will create the plaster
*old and may occasionally leave the task of
*mpleting the work of art, down to the last
*nishing details, to an assistant.

Raw Materials
Metamorphosed calcite,
i.e., white marble;
igneous rocks, such as
porphyry, basalt, granite;
metamorphic stone, such
as tufa; some types of
alabaster, sandstone,
travertine

Tools
Drill, chisel, hammer,
serrated chisel

Diffusion
In all ages and places

**Related Materials
or Techniques**
Mixed-media sculpture

◄ *Stele (Male Figure),*
Ligurian Iron Age
culture, 6th century
B.C. Carved stone.
Filetto, Italy.

Stone Sculpture

The ancient Romans made copies of Greek bronze statues using a very exact measurement-transfer technique: measurements were taken with plumb lines starting from the most projecting points of the statue. The distances between the plumb lines and the surface of the statue to be copied were transferred to the marble block, with the perpendicular alignment of holes having the same depth as the measured distances.

After the statue was rough-hewn, it was finished in all its details and polished.

After carefully transferring the measurements of the distances between the various parts of the sculpture, the excess marble was removed with hammer and chisel, using the holes as a guide.

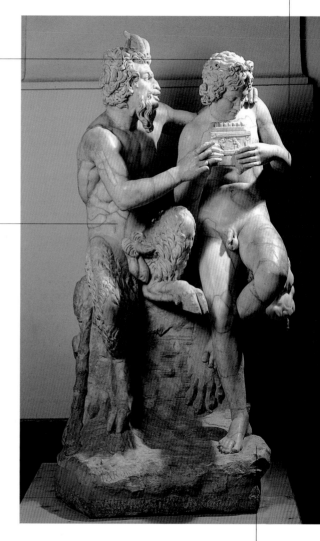

▲ *Pan and Daphnis*, Roman copy of a Hellenistic original. Marble. Naples, Museo Archeologico Nazionale, Farnese Collection.

This technique, known as pointing, allowed the artist to reproduce any model in marble. In ancient Rome the procedure was so perfected that semi-commerical workshops developed.

154

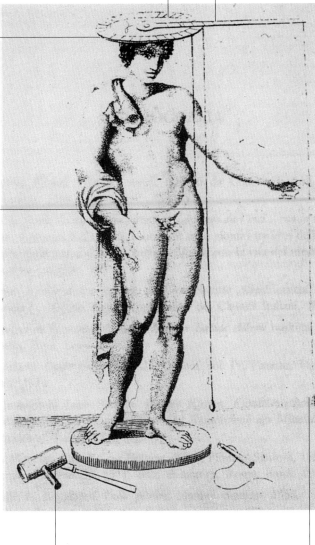

The *definitor is a tool consisting of a horizontal, graduated disk: set on top of the original statue, it is used to measure the angle marked by the revolving arm mounted on the disk.*

A graduated, revolving arm is attached to the center of the disk; a plumb line reaching the ground is attached to the arm and can be moved along the arm.

his 16th-century atise on statues, on Battista Alberti fected a system for nsferring the mea- ements of the statue be copied to a block stone and described a l, the definitor, to be d for this purpose.

e definitor *marks distance between center of the disk d the point where plumb line is iched, as well as the tance between the int to be measured d the ground.*

Definitor, engraving from Leon ttista Alberti's Della pictura et la statua, 1804 edition.

All the measurements can then be transferred to the marble block.

The artist moves the graduated arm until the plumb line touches the projecting point.

For some of his sculptures, Michelangelo employed an archaic method used in pre-classical antiquity and in the Middle Ages: the artist drew and carved on the block of stone only the central parts of the figure, subsequently shaping the marble by removing successive layers with a chisel.

By removing the marble layer by layer, the artist can stop at any time without compromising the unity of the work of art: such is Michelangelo's "unfinished work," the figure imprisoned in marble and partially freed with the hammer and chisel.

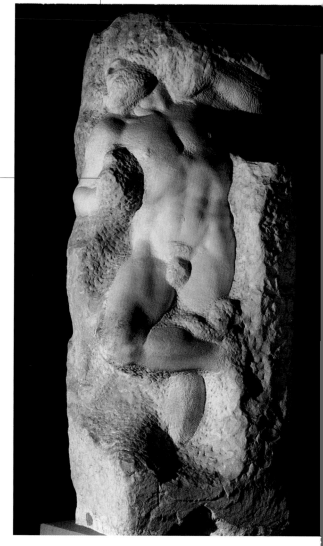

▲ Michelangelo, *Awakening Prisoner*, 1519. Marble. Florence, Gallerie dell'Accademia.

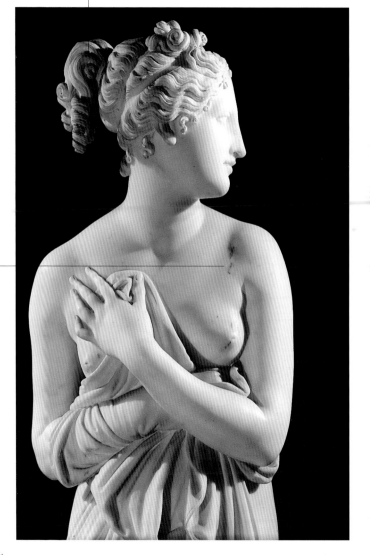

This statue takes its inspiration from the Medici Venus, a Roman copy of a lost Greek original by the sculptor Praxiteles.

...ova used to ...ly a soft, ...ate wax ...na to his ...ale nudes to ...ler the soft- ...s of the flesh ...remove the ...d feeling of ...te marble.

...ntonio Canova, *Italic ...us,* 1801–12. Marble. ...ence, Palazzo Pitti.

157

Direct work is the oldest kind of metalworking technique: the artist fashions metal sheets with hammer and chisel.

Worked Metal Sculpture

Raw Materials
Sheets of copper and bronze, gold and silver foil

Tools
Hammers, burins, punches, scrapers

Diffusion
For large-scale sculpture in antiquity, in Mesopotamia, Asia Minor, and Europe. In Greece since the 5th century, this technique was very widespread; it was called *sphyrélaton*, or "hammer-chased." From antiquity until the present, the direct-work technique has been used especially for finishing touches, for utilitarian objects, and for goldwork.

Related Materials or Techniques
Casting, and all the goldsmith's techniques

▶ Giambologna, *Giambologna Presents the Model for a Fountain in the Pratolino Villa*, ca. 1571. Gold foil bas-relief on an amethyst ground. Florence, Museo degli Argenti.

This sculpting technique consists in working sheets of copper or other metals, including gold and silver, with a hammer or other tools and setting them onto a wood frame. A hard material is used as a core, and the sheets are hammered over it. For large-scale statuary, the wood frame is covered with bitumen, a material that guarantees better adhesion of the metal sheets, which are firmly attached to the support with nails or metal wire. Hammering the metal gradually stiffens it; to continue working it, it must be heated until it almost reaches incandescence ("red heat"). This process, called refiring (*ricottura*), returns the metal to its original tensile state without modifying the shape. Parts made of softer metal, such as tin, that were fused separately or cast in a clay mold, may be soldered to the main sculpture. The work is then finished with chisel, burin, punch, and scraper. For small objects or bas-reliefs, the embossing technique is adopted: the sheet is placed on a leather pad and worked in relief from the inside (or back) using hammers and punches.

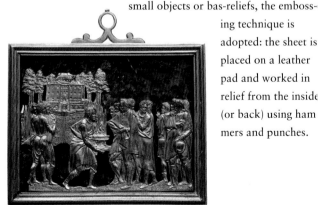

The locks of hair were fashioned with the chisel at a later stage.

A filigree diadem set with cabochon-cut precious stones and engraved gems was placed on the head.

...arate foils ...e used for ...e part, set ...e small nails.

...d foil was used for ...reliquary. A model ...hard material ...od) was used for ...head and the metal ...was hammered ...e it. The inside of ...sculpture is now ...ow and houses the ...t's relics.

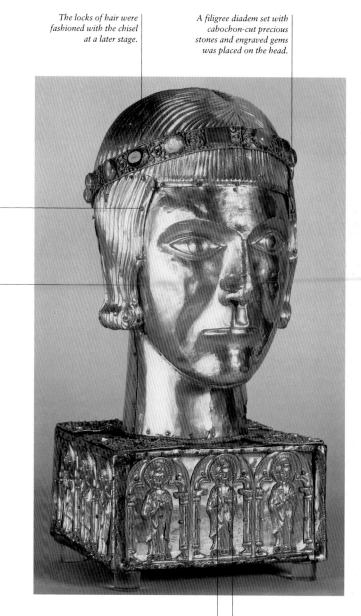

...sel artist, *Reliquary of Saint ...ace*, early 13th century. Gilt-...foil, wood, precious stones. ...on, British Museum.

The relief parts of the foil adorning the base of the statue were embossed, while the hollowed-out details were worked with a chisel.

The "dots" in the haloes were made with punches.

159

"And I saw clearly that the admirable Donatello had cast in bronze the works that he had made with earth from Florence (Benvenuto Cellini, 1566).

Lost-Wax Casting

Raw Materials
Various metals

Tools and Supports
Wax, stucco, wood, clay, sticks, shaping sticks, kiln for firing the clay model; furnace, crucible for casting; chisel, rasps, burins, oxy-hydrogen flame for finishing

Diffusion
Since the 6th century B.C.

Related Materials or Techniques
Direct metalwork, mixed-media sculpture. Lost-wax casting is also used in goldwork.

Lost-wax casting, which uses a mold of clay, plaster, or other material, is the most effective method for making metal sculptures and objects of any size. The most common casting metal is bronze, an alloy of copper and tin. "Poor" bronze alloy, which contains more copper than tin, is not very fluid in casting but is more malleable and easier to work when solid, and therefore suitable for cold-finishing. The most widely used bronze alloy contains lead in varying proportions, making it heavier, darker, and more opaque. Brass, an alloy of copper and zinc with an attractive yellow color, gives good casting results. The most important step in casting is creating the clay, plaster, or stucco mold. Different lost-wax casting methods were developed over the centuries. The oldest method, used in 6th-century Greece, called for preparing a clay model supported by an iron armature and surrounding it with a layer of wax. The form thus prepared was in turn covered with a layer of clay that formed a mold around it; the mold would have channels for discharging the wax and the casting gases. As the mold was fired in the kiln, the heat solidified the clay and melted the wax that flowed down the channels, leaving a hollow space for the molten bronze that would later fill the impression left by the wax to perfectly reproduce the model. After breaking the clay mold to free the cast, the resulting metal statue was hand-finished. Large-scale statues are usually made by separate castings of different sections that are assembled with pins and soldering.

▶ Edgar Degas, *Galloping Horse*, 1880. Cast bronze. Paris, Musée d'Orsay.

To simplify this complex process, especially during the preparation and construction of the armature for the model, this large statue was cast in ten pieces, which comprise the principal parts (head, torso, lower part, arms, and feet); these were soldered together after casting.

clay model,
orted by an
framework,
covered with
er of wax.
n it was ready,
plete with escape
anels for the
ing wax, it was
red with another
r of clay.

After preparing the model, the metal was melted in crucibles. The metal layer resulting from casting the molten metal is thin and finely shaped.

harioteer, Greek, 474 B.C.
bronze. Delphi, Archaeological
seum.

161

Lost-Wax Casting

The wax was poured inside the piece molds. Once it solidified, it was removed from the molds, cleaned of imperfections, and reapplied on the clay model, which is now ready for casting.

The procedure followed by Romans of the Imperial period was a kind of lost-wax casting that allowed the reuse of the mold and serial production of the object.

The model is made entirely of clay. Piece molds—plaster molds corresponding to the various sections—are applied to the model. These forms are detachable: once the plaster has solidified, they are detached and reassembled.

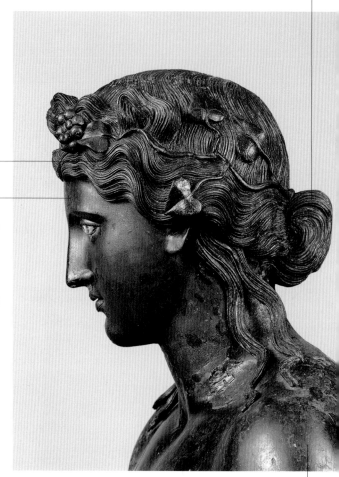

▲ *Dionysus* (detail), Roman, 2nd century A.D. Cast bronze. Rome, Museo Nazionale Romano, Palazzo Massimo alle Terme.

Thanks to plaster molds, foundry workers can repeat the casting ad infinitum, *obtaining thin, light bronze casts that are less expensive than those made with traditional wax casting.*

With Hellenism, it became common practice to gild the surface of bronze sculptures: after applying an amalgam of gold and mercury, the mercury was made to evaporate by heating, causing the gold to become fused to the metal as a patina.

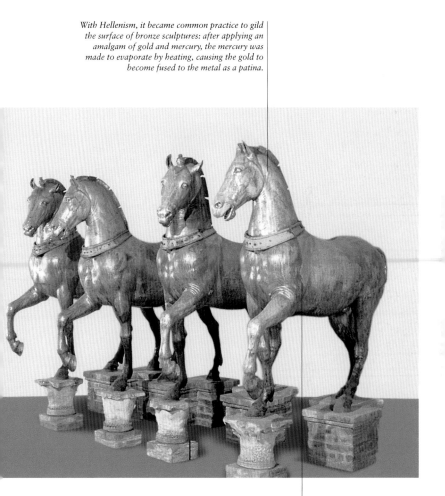

Depending on the amount of gold in the amalgam, the gilding will be more or less dense, and sometimes it will look transparent.

orses, from the Basilica di San Marco, -3rd century A.D. Cast bronze, gilt. ce, Museo di San Marco.

Lost-Wax Casting

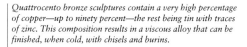

Quattrocento bronze sculptures contain a very high percentage of copper—up to ninety percent—the rest being tin with traces of zinc. This composition results in a viscous alloy that can be finished, when cold, with chisels and burins.

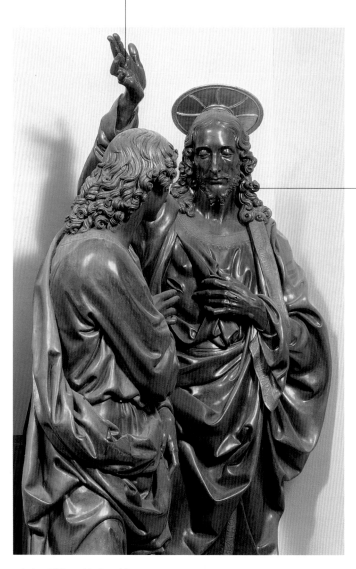

Cold finish consists mostly of chasing, through which details such as curls of hair and strands of beard are defined.

▲ Andrea del Verrocchio, *Incredulity of Saint Thomas* (detail), 1483. Cast bronze. Florence, Orsanmichele.

One of the artists who used negative
piece molds was Giambologna;
the process gave a semi-industrial
character to his production.

e-mold casting
duces very thin
rs that cannot
d extensive
sing. To avoid
mistakes, there-
, the molds were
ared with great
ision since the
ing had to be
nically perfect.
mbologna's
tiple castings
e made from
emely detailed
inal molds.

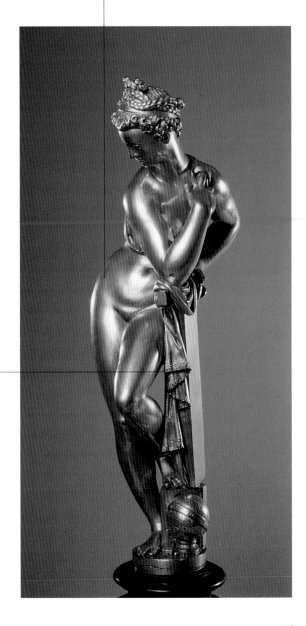

iambologna, Allegory of
onomy, 1573. Cast bronze,
Vienna, Kunsthistorisches
eum.

Hollow casting is a technique that uses sand instead of wax to create a double casting mold.

Hollow Casting

Raw Materials
Copper, bronze, gold, silver

Tools
Hammers, burins, punches, scrapers

Diffusion
In Asia Minor and Europe, for large-scale sculptures, since the 5th century B.C. In later epochs until today, it has been used mostly for finishing, for utilitarian objects, and in goldwork.

Hollow, or sand, casting, is a technique that uses hollow space for casting without wax: a negative and a positive mo are placed side by side with a thin space in between into which the molten alloy is poured. To make these double molds, the clay or plaster model is buried in a container fille with a moist mixture of clay and sand, thereby creating a ne ative impression of the mold. From that, a second, positive clay model is made; a layer corresponding to the thickness o the molten metal to be poured is removed from the entire surface, then the model is fired in an oven. The resulting product is a hollow double mold that can be used numerous times, without the need to make a new wax model each time This technique is somewhat limited in that for an object sculpted on all sides, several sections must be cast separately then mounted with pins and soldering. In addition, hollow casting produces imperfect multiple copies of modest qualit that lack the fine mode

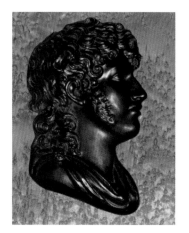

ing of the original cast Hollow casting has bee used since the early 16 century, primarily to mint medals and small bas-reliefs. It became a popular method for industrial production i the 18th century, and i the 19th, to produce small, decorative bron furnishings.

▶ Unknown artist, *Joachim Murat*, 1810–12. Cast bronze. Private collection.

*After pounding chips of the whitest marble he could find
until they turned into fine dust, he sifted it and mixed it with
white travertine lime"* (Giorgio Vasari, 1550).

Stucco

Stucco is an amalgam of lime, marble powder, washed sand, and casein glue mixed in varying proportions depending on the purpose for which it is used. It has been used since the earliest civilizations, for both decorative and architectural purposes. For the former use, it must be plastic and very fine so that it can be shaped with spatulas or sticks, or even by hand, like clay; for the latter, it should be even softer so it can be shaped with dies and molds before it hardens. A compound quite similar to stucco called *pastiglia*, made of gypsum, marble powder, and glue, is used to decorate wood furniture and frames, and to shape details on altarpieces. *Pastiglia* decorations are used frequently on Gothic and Renaissance woodwork, until the late 16th century. The art of stucco (called "Punic wax" by Pliny and Vitruvius) as wall decoration flowered in ancient Rome. The dry stucco technique—carving on dry paste—is typical of architectural ornament in areas influenced by Islamic and Byzantine art. The art of molding and painting stucco spans works from

the early Middle Ages (Tempietto in Cividale del Friuli) to the Renaissance (Vatican loggias), up to and including the elaborate stage decorations of the Baroque and Rococo periods.

Raw Materials
Marble powder, sand, casein glue

Tools
Plaster molds, spatulas, shaping sticks, brushes

Diffusion
Stucco has been used in practically all ages, in both the East and the West.

Related Materials or Techniques
Painting, mixed-media sculpture, hollow casting (for the mold), cabinetmaking

Notes of Interest
Sixteenth-century formulas for outdoor stucco called for an infusion of elm bark, mallow leaves, and fenugreek mixed with sulfur and pumice powder; this mixture added firmness to the stucco.

◀ *Panel with Head of Dionysus,* Roman, 1st century B.C. Molded stucco. Rome, Museo Nazionale Romano, Palazzo Massimo alle Terme.

The stucco here is modeled as stiacciato, a very thin bas-relief. The material used has a very fine grain that is sensitive to the slightest pressure.

Gilding and tempera coloring were applied after the stucco dried.

The ground is wood, covered with glue and a powder made from ground pottery shards.

▲ Donatello and assistants, *Madonna of the Ropemakers* (detail), 1443. Molded stucco, painted and gilded. Florence, Museo Bardini.

The more complex parts are set with thin iron wire supports hidden inside the sculpture.

In the late Baroque period (beginning of the 18th century), stucco was used to make complete architectural ornamentation that imitated marble.

he larger
aments,
 as these
 tes, the
cco masters
d to add
und straw
he mixture
build inter-
 supports
ressed
dboard.

ireplace, ca. 1705. Marble,
ded stucco. Florence,
azzo Frescobaldi.

169

Mixed-media sculpture is a generic term that describes three-dimensional sculpture made with diverse materials. The expressive results can be very unusual and surprising.

Mixed-Media Sculpture

In antiquity, sculptors modified the raw appearance of their wood and stone materials by adding colors as well as more refined contrivances, such as metal foil, fabrics, precious stones, or additions in molded, painted stucco. The history of sculpture abounds with such examples, from large gold-and-ivory statues by Phidias and Scopas, lamentably lost, to the mixed-media Riace bronzes (now in Calabria) with their ivory eyes and copper lips. Mixed-media sculpture was not particularly popular in the Renaissance, which was dominated by pure white marble and bronze, although devotion wood sculpture added materials such as fabric or hair. The showy decorations of the Baroque and Rococo periods, with their small statues made of precious materials—artifacts that are midway between true sculpture and goldwork—exemplify mixed media in the premodern era. Since the middle of the 19th century and even more in the 20th, when sculpture discarded academic rules, artists have been free to use different materials in the same work, both to create impressive realistic effects—Degas's ballerinas come to mind—and to underscore the abstraction of the piece.

▶ Pompeo Leoni (head, ca. 1556) and Balthasar Moll (bust, ca. 1753), *King Philip II of Spain*. Cast silver and terracotta, both painted. Vienna, Kunsthistorisches Museum.

The small figure is fashioned of ivory, with precious stones for the tailcoat buttons.

...re the artist ...d the different ...cious materials ...create a work ...way between ...lpture and ...dwork.

...h of the grinding ...eels is made of a ...cious stone: ruby, ...erald, amethyst, ...net, or diamond.

Unknown artist, *The Knife-...nder,* 1750–1800. Carved ...ry, gold, and precious stones. ...rence, Museo degli Argenti.

The figure of Penelope is made of brass and fabric: the spiraling wire evokes both the act of weaving and the time of waiting.

A thin fab represe Penelop clo

The princi materia brass, wh builds structure of compositie

▲ Fausto Melotti, *Penelope*, 1980. Brass and fabric. Private collection.

Filled plastic materials supported by a wood frame are used to create an ironic representation of an everyday object.

Claes Oldenburg, *Soft Toilet*, 1966.
yl, Plexiglas, and kapok on a base
painted wood. New York, Whitney
seum of American Art.

173

MOSAIC AND INTARSIA

Tessellated Pavement
Mosaic
Intarsia
Marquetry
Scagliola Intarsia
Lacquer

"Here were . . . couches gold and silver on a mosaic pavemen[t] of porphyry, marble, mother-of-pearl, and precious stones" (Esther 1:6).

Tessellated Pavement

The term "tessellated" refers to paving revetments made of pebbl[e] tesserae, marble sections, or hard stones cut into various shapes and arranged on top of several layers of lime, sand, and other materials. Depending on the type and size of the materials used, t[he] pavements have different names, such as *opus lapilli*, *opus tassella[-] tum*, *opus vermiculatum*, and *opus sectile*. *Opus lapilli* consists o[f] small, naturally colored pebbles used to compose the design. *Op[us] tassellatum* is a mosaic formed of tesserae, small, die-shaped tiles or cubes, no more than 2 cm per side, set in geometric patterns; since these tiles are cut by hand with mosaic chisel and marteline (a double-headed serrated hammer), medium-hard stones, such a[s] marble, are the preferred materials. Pavement consisting of *crust[a,]* irregularly shaped pieces of marble, is called *opus sectile* (section work). Marble, alabaster, and porphyry, often from disparate regions of the empire, were the preferred materials for Roman, a[nd] especially Byzantine, floors. Sometimes a single floor would cont[ain] sections of variegated Proconnesian marble next to Egyptian por[-]

phyry, red marble from Verona, white and black from Aquitaine, and yell[ow] from Numidia. The colorful effects cre-ated by the fanciful designs of these flo[or] mosaics are rich an[d] suggestive, and als[o] proof of extensive travel and trade.

The most ancient technique for covering and decorating a floor is opus lapilli. *Tiny pebbles are set over three foundation layers: the bottom layer consists of large pebbles set on packed soil; the second is made of stones, gravel, crushed terracotta shards, and Santorini powder (made from lava); and the top layer is a mixture of brick powder and fine sand that firmly sets the pebbles.*

...aracteristic of ...s lapilli *are the ...ll, naturally ...red, lead and ...d-clay bars that ...pe the contours ...he design.*

...e floor area is ...g down to a ...th of two ...ers and ...ked; then the ...eral foundation ...ers are set.

...Mosaic with Doves, *from ...drian's Villa at Tivoli, Roman, ...* 117–138. Detached *opus ver- ...culatum. Rome, Musei Capitolini.*

▲ *Lion Hunt,* detail of an *opus lapilli* floor, 4th century B.C. Pella (Macedonia), Greece.

Tessellated Pavement

This floor mosaic is the work of Alexandrian artists. Dating from 82 B.C., it depicts the meanderings of the Nile River from its source to the delta, a vast expanse of land that is here compressed into a single, grandiose composition, where buildings, men, and animals are represented with great accuracy.

The stone used for the darker tiles is basalt.

Variously colored granites were used to achieve the polychrome effect.

▲ Alexandrian workshop, *"The Nile" Mosaic*, floor of the Temple of Fortuna, Praeneste, 82 B.C. *Opus tassellatum*. Palestrina, Museo Archeologico Prenestino.

Several layers make up the floor foundation: first, packed earth mixed with brick shards; then a very rough layer of crushed terracotta shards, pozzolana, pebbles, and lime; finally, tu layers of increasing fineness consisting of marble powder, lim and pozzolana. These preparatory layers ensured that th mosaic would be firmly set and resistant to moistur

The lighter sections were made with limestone tesserae; the gray colors, with sandstone.

The tesserae were set in a thin layer of lime.

Once the surface was ready, the floor was covered with a temporary layer of gypsum mortar on top of which the design was sketched; if necessary, this could be changed or adapted. Each day, the artist would choose a section of the floor on which to work: the gypsum layer was removed to make space for the ground layer, a mixture of pozzolana and lime mortar, into which the tesserae were set.

Tessellated Pavement

*This panel, detached and now set inside a frame, is from Hadrian's Villa in Tivoli, near Rome. The floors of the villa were covered with various types of mosaic (*opus tassellatum *and* opus sectile *were used in the chambers of the nobility) and decorated with figured medallions, called* emblemata, *made in* opus vermiculatum *(literally, wormlike, for the undulating rows of tesserae that characterize this work).*

The tesserae of opus vermiculatum *work are tiny, as many as sixty-eight tiles per square centimeter.*

*The contrasting sizes of the tiles used in the frame (*opus tassellatum*) and in the central decoration (*opus vermiculatum*) are clearly visible.*

▲ *Decorative Panel with Fruits and Birds,* Roman, from Hadrian's Villa, A.D. 117–138. Detached *opus vermiculatum*. Vatican City, Biblioteca Apostolica Vaticana.

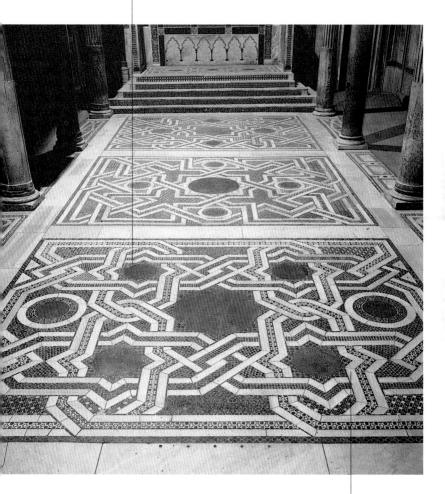

Medieval floors were often covered with opus sectile, *a type of paving closer to intarsia than to mosaic proper. Instead of tesserae, thin sections of colored marble and alabaster, cut into different geometric shapes, called* crustae, *were laid over a thin layer of lime.*

ʾaved Floor, second half of the 11th ʿtury. *Opus sectile.* Palermo, Palazzo Normanni, Cappella Palatina.

In this floor, the marble sections, cut in round and star shapes, are enclosed in a geometric interlace-meander pattern composed of lighter-colored pieces that flank a double linear pattern composed of tiny triangular tiles.

181

The opus sectile *part of this pavement is composed of a vast selection of marbles and hard stones that produce suggestive polychromy. Here, the small tiles are cut into isosceles triangles of decreasing size.*

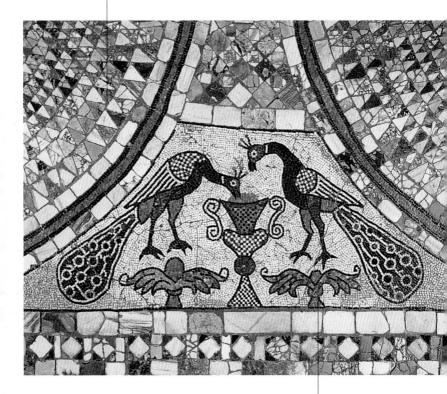

In this perfectly conserved, extraordinary pavement, dated 1141, two techniques are combined: opus tassellatum, tiny stone tesserae next to small pieces of glass mosaic tiles, was used for the figured sections, while opus sectile was used for the large geometric decorations that give a sense of rhythm to the entire composition.

▲ Floor Pavement (detail), 1141. *Opus sectile* and *opus tassellatum*. Murano, Basilica dei Santi Maria e Donato.

osaic, or opus musivum, *refers to a wall decoration that*
sembles painting; it uses small tesserae made of vitreous paste
or other materials.

Mosaic

he earliest mosaic decorations, from Mesopotamia and dating
om the 4th millennium B.C, were made of fired clay cones set
vith mortar and bitumen into walls. The manufacture of vitre-
us tiles with brilliant and varied colors required complex,
ophisticated techniques and materials and much experience in
nixing compounds. Glass is made from melting silica, a vitrify-
ng agent, with a fusing agent—in ancient times, the ash of
Driental ferns that contained sodium, potassium, and magnesium
vas used. Stabilizers such as magnesium oxide, zinc, or barium
vere added, as well as lead oxide to give luminosity to the glass.
The vitreous paste is made opaque with a compound of lead and
in, and then colored with metallic oxides. The level of oxidation
varies depending on the color to be produced: iron oxide creates

green, blue, amber, and
yellow hues; manganese
oxide yields purple and
brown; copper pro-
duces turquoise and
dark green. The vitre-
ous paste is subse-
quently shaped into
thin plates cut by hand
with a mosaic chisel,
marteline, or pincers,
and used to compose
images on walls that
were prepared with sev-
eral layers of mortar.

Raw Materials
Glass, marble, gold-leaf
glass, mother-of-pearl,
lime, sand, gravel, ground
straw, crushed terracotta
shards, pozzolana, marble
powder, cement

Tools and Supports
Tools: mosaic chisel,
marteline, pincers,
polishing wheel,
spatulas, roller, trowels.
Support: wall

Diffusion
Vitreous paste mosaic
appeared first in Egypt
and was widely used by
the Romans. After the fall
of the Roman Empire, the
mosaic technique spread
from the Byzantine world
to the surrounding
regions. Until the end of
the 16th century, Venice
was the mosaic capital.

**Related Materials
or Techniques**
Intarsia, jewelry-making
(micromosaic)

◄ *Ecclesia*, from the apse of
Old St. Peter's, Rome, 13th
century. Detached mosaic.
Rome, Museo di Roma

183

Mosaic

The background is executed with tiles of the same color but different shades. This is especially noticeable in the areas surrounding the faces; thus, the slight variation in the light added to the modeling of the faces seems to put them in relief.

Round mother-of-pearl tesserae comprise the diadem worn by Empress Theodora.

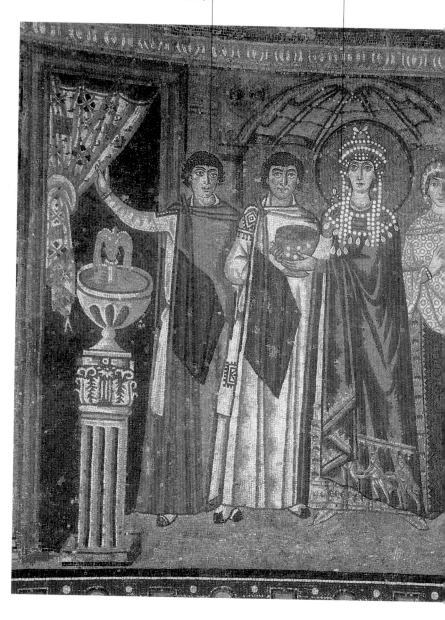

In Byzantine mosaics, the walls were primed with three layers of varying graininess that included marble powder, lime, and, in the bottom one, ground straw as well. These layers allowed for a firmer adhesion of the heavy glass mosaic tiles that are set on a thin layer of lime.

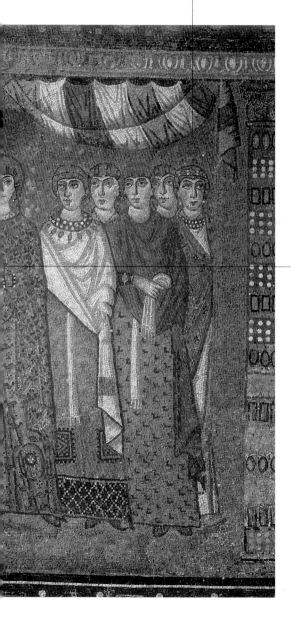

The contrasting colors of the tesserae also reproduce patterns of the rich fabrics worn by court ladies, one of whom is wearing a 6th-century Sassanian fabric imported from Persia for the court at Byzantium.

◀ *Procession of the Empress Theodora*, ca. A.D. 547. Mosaic. Ravenna, San Vitale.

Mosaic

The different angles at which the tiles are set in the mortar are clearly visible, especially in the gold background. Varying the inclination of the tesserae heightens the sparkling effect of the reflected light and enhances the brilliance of the other colors.

Gold leaf is usually applied to a reddish glass that heightens its transparency with amber reflections. In contrast, the gold tesserae manufactured industrially today are often made with a base of green glass.

In this section, the tiles were set in a herringbone pattern to imitate the metal mesh of the warrior's armor.

▲ Head of a Warrior, from San Marco, baptistery, 14th century. Mosaic. Venice, Museo Marciano.

Gold tesserae are composed of a layer of glass, the support, on which gold leaf is applied sandwich-style by "soldering" it to a layer of clear glass, called vetrina or cartellina: the latter has a different melting point than the underlying layer, allowing the tesserae to be fired again without burning the gold leaf.

This paler section was restored in recent years.

saic tile pro-
tion remained
stantially
changed over
centuries; the
rano glass-
rks gradually
ame more
cialized in this
a of production
d often utilized
zantine methods
d techniques.
portant evi-
ce for Murano
duction is the
rduin family's
lection of
cipes," which
tains several
mulas for
saic glass.

the quattrocento,
saic began to
e its autonomy
an art form,
coming more and
re a "painting
de of stones,"
th a language
ry similar to that
frescoes.

Michele Giambono, Jacopo Bellini,
drea del Castagno, and others, *The
sitation,* ca. 1451. Mosaic. Venice,
n Marco, Cappella dei Mascoli.

*The grandiose, perspectival compositions of the Renaissance
were executed from cartoons prepared by painters. This compo-
sition, which adorns the Mascoli Chapel, was signed by Michele
Giambono, assisted by other masters, including Jacopo Bellini
and Andrea del Castagno.*

Mosaic

In 19th-century Rome, small objects were produced to sell as souvenirs to travelers or as costume jewelry, decorated with tiny opaque glass tiles set in mastic.

The tesserae on this finely decorated snuffbox are laid out to create chiaroscuro effects in various shades of gray.

▲ Cesare (?) Ciuli, Snuffbox with the Orticoli Jupiter, 1803. Vitreous paste, micromosaic. Rome, Museo Napoleonico.

Venetian mosaic art began to deteriorate toward
the end of the 16th century and disappeared with
the demise of the Republic of Venice. As a result,
most of the glassworks and related industries
closed, including mosaic production.

In the latter part of the 19th century, the
Salviati Company resurrected the production
of high-quality mosaic tiles; these were used to
decorate several palaces in Venice and public
buildings elsewhere in Italy, such as the lunettes
of the Galleria Vittorio Emanuele in Milan.

ittorio Emanuele Bressanin,
gory of Venice, 1920.
saic. Venice, Società Salviati
dquarters.

189

In decorating Güell Park, Antonio Gaudí
rediscovered ceramic mosaic, an ancient
tradition that had been imported into Spain
by the Arabs in the 9th century.

Gaudí was often assisted in his work by local craftsmen.
For the irregular tesserae of this mosaic, the artist used
shards of brightly painted, luster-finished maiolica to
produce a multicolored, dynamic effect.

▲ Antonio Gaudí, *Transenna*,
1905–14. Ceramic mosaic. Barcelona,
Güell Park.

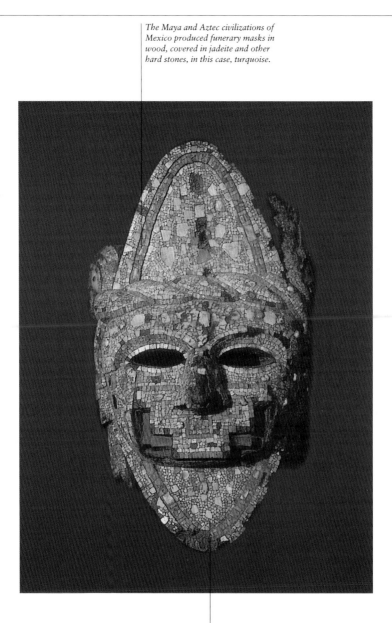

The Maya and Aztec civilizations of Mexico produced funerary masks in wood, covered in jadeite and other hard stones, in this case, turquoise.

The very small tiles used in this work were set onto the support with resin extracted from local plants.

Ritual Mask, Aztec, 16th century.
od and turquoise. Rome, Museo
orini.

191

*The ancients "discovered . . . stone floors with various combi-
nations of porphyry, serpentine, and granites, with tondi and
squares or other figures" (Giorgio Vasari, 1550).*

Intarsia

Raw Materials
Stone and marble, lime,
cement, different resins and
mastics, polishing oil and
waxes, niello

Tools and Supports
Tools: burins, drills, chisels,
lathes, roller, trowels,
pumice. Supports: floors,
walls, furniture

Diffusion
Intarsia works are still made
today in some Florentine
workshops

**Related Materials
or Techniques**
Tessellated pavement,
cabinetmaking, goldwork

Intarsia is the use of thin stone and colored marble sections or
slabs to decorate floors, walls, and furniture; the stone is cut
and inlaid to form patterns and figures on a compact surface.
Unlike mosaic, the ground does not show through in intarsia
work. The technique was known to the Sumerians, and in later
centuries it spread from Asia Minor. Intarsia was adopted in the
Rome of Julius Caesar, just after Rome penetrated Hellenistic
culture. The Romans called it *incrustatio* or *loricatio*. In his
Natural History, Pliny the Elder wrote about the use and tech-
nique of this type of inlay: slabs were cut with smooth metal
saws, helped by abrasive sand. The *crustae*, or pieces cut in
different shapes, were polished to a high gloss with pumice or
tufa powder and laid on the floor or on walls; after they were
attached with pins, mortar was poured into the interstices. This
technique evolved and was adapted according to its use. In the
12th and 13th centuries, the Cosmati masters used intarsia in
conjunction with *opus interrasile* (see p. 194), creating arresting
geometric decorations. Intarsia revetments became an integral
part of Tuscan decorative tradition
both in architecture (the polished mar-
bles of San Miniato and the baptistery
in Florence, and the floor of Siena
Cathedral) and in interior furnishings.

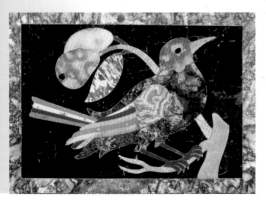

The hair decorations are
made from mother-of-pearl.

In the paving panels of the
Basilica of Junius Bassus,
the portions that formed
the intarsia background
are granite.

stones used in
ient Roman floors
e cut with stone-
ing saws, burins,
ls, chisels, and
le lathes. All
se tools were used
h moistened emery
der to precision-
the pieces so that
could fit together
reate smooth,
grounds.

Vitreous paste was
used to create the
effect of water pour-
ing from the jar.

ird, early 17th century.
d-stone intarsia. Rome,
seo Nazionale Romano,
azzo Altemps.

▲ *Nymph Pouring Water from a Jug*,
from the floor of the Basilica of Junius
Bassus, 4th century A.D. Stone intarsia.
Rome, Museo Nazionale Romano,
Palazzo Massimo alle Terme.

Opus interrasile *required the insertion and fixing of very thin strips of marble or other materials inside the hollowed spaces of slabs having contrasting colors.*

The Cosmati masters were active in Rome and in the Campania region in the 12th and 13th centuries. They recycled marble from ancient buildings and used it in their intarsia work on thrones, ciboria, and altars.

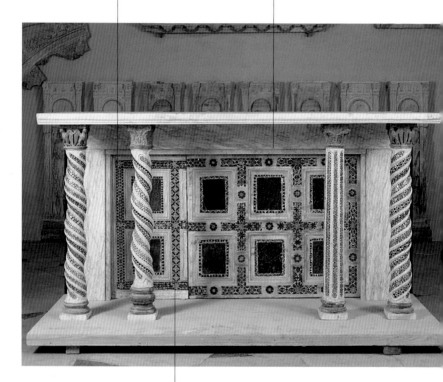

The unique technique of the Cosmati combined opus interrasile *with* opus alexandrinum, *a technique in Byzantine art that utilized glass mosaic tesserae together with tiny tiles of hard stone.* Opus alexandrinum *was probably perfected in Alexandria under Emperor Augustus and much later spread to the workshops of Byzantium through the Islamic world.*

▲ Cosmati masters, Altar, ca. 1200.
Mosaic and hard-stone intarsia. Vatican City, St. Peter's, sacred grottoes.

In this marble floor, the spaces left hollow from the carving are filled
with niello, a special substance also used in goldwork. Niello is a
black, pitch-based mixture that serves to emphasize the design, in this
case inspired by the local damasks produced at the time.

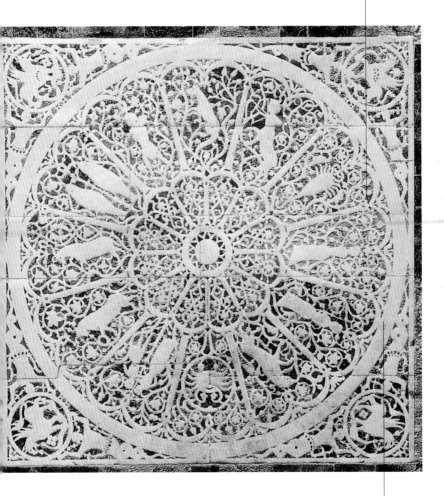

The floor of San Miniato is
made of large white marble
slabs with carved ornament.

Florentine workshop, *Zodiac*,
detail of floor, early 13th century.
Carved marble with niello. Florence,
San Miniato.

The mantle of Cosimo
II de' Medici is made
with embossed gold foil
decorated with enamel.

This splendid artifact combines
hard-stone intarsia with the
skill of the goldsmith to create
a true jewel.

The floor, a perfect
opus sectile, has a
perspectival design.

▲ Grand-ducal workshops, *Panel
with Cosimo II de' Medici in Prayer*,
1617–24. Hard-stone intarsia, gold,
enamels, diamonds. Florence, Museo
degli Argenti.

196

Mother-of-pearl was used for the daisies.

This complex design was made mostly with breccias and marbles of different colors, alternating with uniformly colored stones such as basalt and lapis lazuli.

The stone surface of this table was made in the grand-ducal workshops in Florence. The walnut-wood structure inlaid with boxwood and rosewood dates from the end of the settecento; the anonymous artist, G.B.M., may have been an apprentice of Giuseppe Maggiolini.

The sections of hard stones were cut very thin and in many different shapes. To achieve a smooth surface, each piece had to have the same thickness.

G.B.M. and grand-ducal workshops, tabletop, ca. 1800 (structure), 1615 (tabletop). Inlaid walnut wood and hard-stone intarsia. Milan, Castello Sforzesco, Civiche Raccolte d'Arte Applicata.

The marquetry technique first appeared in Europe in the Middle Ages, in Carthusian monasteries, where it was used to decorate small objects such as coffers and jewel cases.

Marquetry

The earliest marquetry, or wood intarsia ("Carthusian style"), used different kinds of wood, bone, and mother-of-pearl cut into tiny pieces and set onto a wood structure with mastic to create geometric designs, usually very small. The technique grew popular for furnishings, and decorations increased in size and complexity. In late medieval times, pictorial, or perspective, marquetry appeared: figured scenes or architectural landscapes were made to decorate large surfaces. Woods were dyed by soaking them in colors boiled with oils or herbal infusions. In the Renaissance, the "dry" technique became popular: wood pieces were fitted together on a framed surface without mastic, a technique made possible by the precise cutting of the component pieces to an identical thickness. In Italy, starting in the late 1500s, furniture was encrusted with precious materials in addition to marquetry inlay. In northern Europe, marquetry artisans developed extraordinary compositions of flowers, birds, and fantastic landscapes with ruins. In 17th-century France, André Charles Boulle added

materials such as gilt brass, copper, and mother-of-pearl, inspiring the richly decorated furniture of the Turin cabinetmaker Pietro Piffetti. In the later 18th and early 19th century, the production of the Milanese Giuseppe Maggiolini is noteworthy.

The marquetry work created by Giovanni Capodiferro from cartoons by Lorenzo Lotto is very different from the 15th-century designs that followed strict geometric perspectives and conformed to the natural rigidity of the wood. In the 16th century, designs were pictorial and required great virtuosity from the cabinetmaker.

In many sections, the cabinetmaker used wood pieces dyed with herbal infusions or vegetable oils.

Here the wood was only partially dyed, to create a slight chiaroscuro effect.

The carved pieces in 16th-century marquetry were thinner than those of the preceding century. This gave the cabinetmaker more freedom and the possibility of crafting smaller, more precise details.

Mola Brothers, *View of a City*, 06. Marquetry. Mantua, ducal lace, grotto of Isabella d'Este.

▲ Lorenzo Lotto, *Noah's Ark*, 1525. Marquetry. Bergamo, Santa Maria Maggiore.

Giuseppe Maggiolini fashioned a strong Neoclassical composition on this chest. He used mostly light-colored woods, such as pear and maple, combined with roseate woods, such as cherry and boxwood, with touches of mahogany and walnut in the darker sections.

The chest is covered entirely with rosewood veneers.

The cartoons for the images on the panels were drawn by Andrea Appiani.

Dark ebony is used as a ground for the decorative frames that enclose and define the perimeter of the lower section.

▲ Giuseppe Maggiolini, Chest, 1780–85. Wood with rosewood veneers and marquetry. Milan, Castello Sforzesco, Civiche Raccolte d'Arte Applicata.

Painting with selenite, commonly called scagliola, *or* mischia, *Carpi touchstone" (Eustachio Cabassi, 18th century).*

Scagliola Intarsia

Scagliola intarsia appeared in the seicento in Carpi, a small city near Modena (Duchy of Este) with a strong tradition of craftsmanship that was applied, during the Counter-Reformation especially, to the interior decoration of new churches. Scagliola is made with selenite, a natural gypsum abundant in the Apennines in the Carpi region of Emilia. To be worked, selenite must be fired at high temperatures (300° C), finely ground, and sifted. The resulting fine powder is mixed with glue extracted from scraps of tanned hide boiled into a malleable paste that is separated into parts, each to be colored differently. Scagliola paste can imitate any marble. The Carpi craftsmen, using a complex technique that required only inexpensive local materials—water, gypsum, linseed oil, and thin frames made of reeds—perfected an inlay that imitated precious hard-stone intarsia produced in the grand-ducal workshops of Florence in the 17th and 18th centuries. The technique spread to other regions of Italy, where, in addition to providing material for altar frontals, it was used to fashion landscape designs for table-tops and consoles. These secular objects were greatly esteemed by English travelers as souvenirs of their Grand Tours.

Raw Materials
Selenite, glue extracted from boiled, tanned, animal-hide scraps, color pigments, walnut or linseed oil

Tools and Supports
Spatulas of various sizes, metalpoints, trowel, pumice stone, charcoal, reeds, preparatory cartoon

Diffusion
From about 1600, in Carpi (near Modena), the technique spread to the Lake Como region and most of northern and central Italy. Outside Italy, craftsmen in France, Germany (Bavaria), and the Czech Republic worked in scagliola intarsia.

Notes of Interest
The interior of Milan's Central Station is covered entirely in imitation marble made of scagliola.

◄ Gennaro Mannelli, Imitation Inlaid Marble Floor, early 18th century. Scagliola intarsia. Formerly London, now Sotheby's.

Scagliola Intarsia

The first step in making scagliola inlay is to prepare the base, a mixture of gypsum and water, which is placed in a mold or on a reed frame to harden.

A layer of scagliola paste, a few millimeters thick, is spread on the frame. After it has dried, it is carefully polished; then the composition is transferred to the smoothed ground via the spolvero (dusting) method.

Black scagliola is poured over the entire surface; it adheres only to the hollowed-out portions because the white areas have already been smoothed. Finally, the surface is polished with pumice stone and olive oil.

The outlines of the composition are etched with an ivory point; then the sections that will be colored black are hollowed out.

▲ Band of Blossoms and Lace, detail of altar frontal, ca. 1650. Scagliola intarsia. Carpi, Museo Civico "G. Ferrari."

To make a supporting frame for polychrome scagliola, the same procedure is used as for white and black designs.

The design, transferred by means of the spolvero (dusting) method, is carved and each hollow shape is filled with colored scagliola.

orkshop of Blausius Fistulator, *Architec-
l Scene*, ca. 1630–70. Scagliola plaque.
Angeles, J. Paul Getty Museum.

At the end of the process, the scagliola residues are removed and the surface is polished.

Scagliola Intarsia

Polychrome scagliola imitates to perfection the delicate hard-stone intarsia work made by Florentine craftsmen in the 17th century.

▲ Giovanni Gavignani, Frontal of the Addolorata Altar (formerly Altar of the Assumption), 1660–70. Carpi, Cathedral of the Assumption.

In the 17th century, white and
black scagliola was also used to
reproduce prints, with an effect
similar to that of engraving.

Scagliola can reproduce many textures
with great accuracy, even lace, as in the
ornament surrounding the panels, or straw,
as in the baskets holding the flowers.

"Is there anything more wonderful than to have our rooms covered with a varnish more brilliant and sparkling than polished marble?" (George Parker, 1688).

Lacquer

Raw Materials
Resin, colored pigments.
In imitation lacquers, the materials are more varied: resins, gypsum, gum arabic, and sawdust.

Tools and Supports
Tools: brushes, spatulas, carving tools. Supports: wood, leather, fabric, metal

Diffusion
In China and Japan. From the seventeenth century on, it is also present in Europe.

Related Materials or Techniques
Cabinetmaking, inlays, jewelry-making

Notes of Interest
One of the best Western lacquers is the French *vernis Martin*. More than forty layers are applied to the surface: once dry, each layer must be polished. Martin varnish is extremely smooth and brilliant, with delicate colors that sometimes contain specks of gold that make it sparkle.

The term "lacquer" refers to several substances: a red pigment extracted from dried insects (cochineal or Kermes); resinous varnishes used to waterproof wood, metal, leather, and fabrics; and all materials that create smooth, polished surfaces. True lacquer is a substance extracted from the sap of a Far Eastern plant, *Rhus vernicifera*, also known as "lacquer tree": its bark oozes a grayish liquid that polymerizes upon contact with the air, becoming plastic; once filtered and heated, it is ready to be used. Lacquer is applied in thin layers onto wood or fabric. The lacquer-coated surfaces are very resistant and may be engraved and inlaid with other materials such as mother-of-pearl. Lacquer is waterproof and very hardy. First imported into the West in the 17th century, it became so popular that every European country had its own imitation. The Dutch, in particular, specialized in the production of lacquer furniture: in addition to the raw material—*shell-lac* or mother-

of-pearl lacquer—they also imported the craftsmen who knew how to work it. In other places, especially Venice, cabinetmakers reproduced on furniture the lucid compactness of lacquer and its fanciful decoration, crafting bizarre chinoiseries, both carved and painted.

s Chinese lacquer has
n carved into soft
l elegant floral motifs.

eral coats of lacquer
re applied before the
ce was carved, and
h layer was allowed
dry completely before
next application. As
ries, resin polymerizes
l becomes plastic,
dy and light-weight,
erproof, and resistant
nolds.

Writing Case (*Suzuribako*),
rior, Japan, Edo period,
h century. Makie lacquer.
ice, Museo d'Arte Orientale.

▲ Vase with Floral Motifs, Ming
Dynasty, ca. 1400. Carved lacquer.
Taipei, National Museum.

The images on cut paper glued to this furniture constitute a kind of "poor man's lacquer." They depict fantastic landscapes and figures that evoke the Orient, in addition to the "chinoiseries," fanciful representations of Chinese customs and life.

In the 18th century, Venetian craftsmen devised new techniques to imitate the decorative effects of costly oriental lacquers whose formulas were still unknown.

▶ Venetian workshop, Writing Desk, ca. 1740. Carved, painted wood with decorations of glued paper and lacquer. Milan, Castello Sforzesco, Civiche Raccolte d'Arte Applicata.

This writing desk is an odd combination of Rococo style (the broken, curved tympanum, small pilaster strips, repetitive floral decoration) and chinoiserie motifs that recall the fashionable "bizarre" fabrics produced in France at the time.

*other technique
fected in Venice
mitate oriental
quers called for
application of
eral layers of gesso,
e, color pigments,
d gold leaf. The
ers were carved,
led, and finally
ished with
darac, a resin-
ed varnish.*

Venetian workshop, Writing
k, ca. 1750. Carved, painted,
quered wood. Milan, Castello
zesco, Civiche Raccolte
rte Applicata.

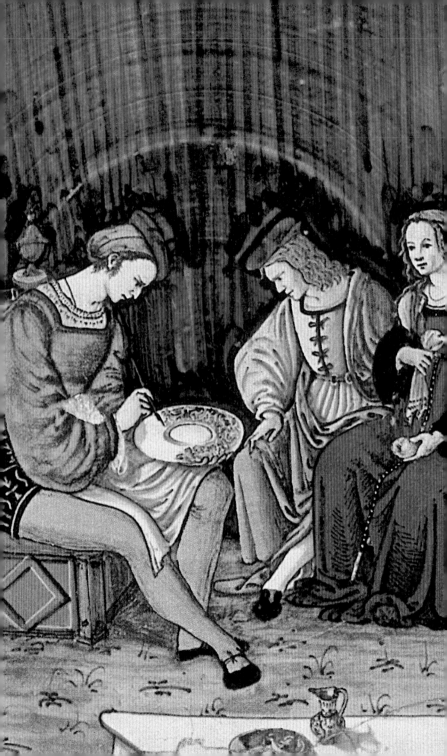

CERAMIC

Terracotta
Glazed Terracotta
*Slip Terracotta (*Ingobbio*)*
Maiolica
Grès
Bisque
Soft-Paste Porcelain
Hard-Paste Porcelain
Stoneware
Sgraffito Decoration
Relief Decoration
Painted Decoration
Luster Decoration

afaggiolo manufactory, *Maiolica*
ter at Work, detail of plate with
chrome decoration, ca. 1510.
don, Victoria & Albert Museum.

Consisting of clays mixed with water, terracotta is the basic ceramic material from which everyday objects and construction materials are made.

Terracotta

Raw Materials
Clay, water

Tools and Supports
Sticks, shaping sticks, molds, wheel, kiln

Diffusion
Since the 3rd millenium B.C.

Related Materials or Techniques
Terracotta is the the basic material for all types of ceramic: glazed, slip, enamel, sgraffito, and luster decoration.

Terracotta (literally, baked earth) is obtained by working and firing clay. It is the basic material for all brick and ceramic products, such as maiolica, grès, porcelain, and even the vast class of abrasive, insulating, and refractory industrial materials. Clay has always been the most important material for making objects because it is abundant in nature and—when mixed with water—is easily shaped by hand without tools. Clay contains a mixture of minerals, including decomposed feldspar, quartz, and limestone, in addition to mica and serpentine, and a small percentage of organic matter. To shape clay, it must first be softened with water; the resulting paste is pressed, washed, and allowed to decant in small tanks placed on a slant so that impurities flow out and down. Clay can be shaped with the hands, by coiling it in clay "ropes," or with the aid of molds; these primitive systems were replaced by the potter's wheel as early as the 3rd millennium B.C. After the body of a vessel has been shaped, spouts and handles are added, and the artifact is left to dry, which causes it to lose some water and to harden; it is then fired in a kiln. Firing is the most delicate step: clay can be fired in open hearths or in kilns that gradually reach a constant temperature of 1300–1400° C. During firing, the clay loses more water and becomes extremely hard and dense; finally, it is removed from the kiln and allowed to cool slowly.

▶ Vase Shaped like a Top, from Italy, 1st century B.C. Terracotta. Turin, Museo Civico d'Arte Antica.

In this vessel, two partially dried sections are joined with liquid clay.

...is odd
...omorphic
...ttle was made
...pressing the
...y into molds,
...e for each half
...the object.

...Strap-handled Bottle, Moche culture
...eru), 4th–5th century A.D. Terracotta.
...lan, Castello Sforzesco, Civiche
...ccolte d'Arte Applicata.

Finishing touches are applied with flat or pointed sticks before the object has dried out completely.

213

The key invention in the perfecting of ceramic products is undoubtedly the potter's wheel, which spins as the potter forms the clay into a uniform shape.

Finished objects are on display next to the craftsman.

The potter regulates the speed of the wheel, which he turns with a stick.

Several balls of clay sit ready to be used.

In this 14th-century French miniature, the potter's wheel is a simple cartwheel set horizontally.

▲ Unknown artist, *Potter at the Wheel*, miniature from *Translation et exposition de la Cité de Dieu* by Saint Augustine, ca. 1390. Paris, Bibliothèque Nationale.

erracotta is naturally porous, and several methods were eveloped to waterproof it; the simplest method, glazing, the application of a vitreous, transparent coating.

Glazed Terracotta

A glaze is a vitreous coating applied to terracotta to waterproof nd decorate it. The most common glazing compound is a lead-earing varnish, probably invented in China in the 3rd century .D. and brought to Europe by the Romans. The clay object is irst dusted with lead-oxide powder, then fired in a furnace at temperature of 750° C. Upon contact with the lead oxide, the ilica in the clay melts and covers the object with a clear, vitre-ous film of different colors depending on the amalgam: yellow or brown if the clay was amalgamated with iron oxide, green with copper, blue with cobalt, purple with manganese. Another method for preparing lead-bearing varnish (also called frit or *marzacotto*), known in the Middle Ages, was to combine silica-based clay with burnt wine dregs. This mixture was finely ground, mixed with lead oxide, and used to coat the terracotta. The lead-bearing glaze has a higher expansion coefficient than that of the underlying bisque, and this causes the coating to crack. If the lead-glaze components seep into a food-storage vessel, they can not only spoil the contents but react with the food salts to form highly poisonous lead salts. This problem was solved in the 19th century with the invention of feldspar-based glazes (which are lead-free) for use in the production of dishware.

Raw Materials
Lead oxide, sodium and potassium carbonate (at one time derived from burnt wine dregs), clay, sodium chloride (table salt)

Tools
Brushes, firing kiln

Diffusion
Invented in China in the 3rd century A.D., it spread to Europe through the Roman Empire.

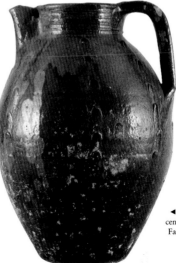

◄ Pitcher, from Italy, 6th–7th century A.D. Glazed terracotta. Faenza, Museo Internazionale delle Ceramiche.

Slip (ingobbio) is a blend of fine clay and water, used originally on utilitarian clay vases to reduce their porosity. Glazed ingobbio terracotta is known as "half-maiolica" or "bianchetto."

Slip Terracotta (Ingobbio)

Raw Materials
Clay that remains white when fired, water

Tools and Supports
Slip is applied to shaped, dried objects. Metallic oxides and brushes of different sizes are required to apply the painted decoration, and sticks or other pointed tools for the sgraffito decoration.

Diffusion
Since remote antiquity in Anatolia and Mesopotamia

Related Materials or Techniques
Painted or sgraffito decoration

The term "terracotta" generally refers to plain, utilitarian objects made by shaping and firing clay: this traditional ceramic is easy to make and uses inexpensive earth. Terracottas made with more select clays and finished with slip work, glazing, or tin-bearing enamel are part of the large group called "Faenza" or "faience" ceramic. Slip is one method for covering a clay object with a white, dense coating suitable to receive decorations or lead-based glazing. It consists of a coating made with a mixture of water and clay that remains white when fired. Slip is applied to the clay after the object has dried; then the object can receive the painted or incised decoration; the last steps are glazing and firing. This technique, which was used in ancient Anatolia and Mesopotamia as well as in classical antiquity, was adopted in Europe only in the early 14th century.

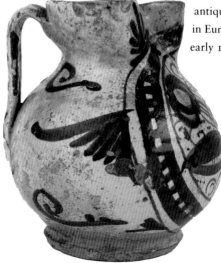

► Pitcher, Lombardy, second half of the 16th century. Slip terracotta and underglaze. Milan, Castello Sforzesco, Civiche Raccolte d'Arte Applicata.

After being shaped and allowed to dry, this
bowl was dipped in the semiliquid slip that
covered it with an opaque white coating.

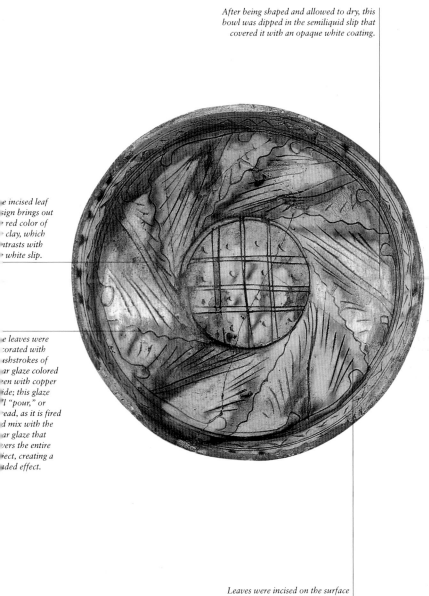

ে incised leaf
sign brings out
ে red color of
ে clay, which
ntrasts with
ে white slip.

ে leaves were
corated with
ushstrokes of
ar glaze colored
een with copper
ide; this glaze
'l "pour," or
ead, as it is fired
d mix with the
ar glaze that
vers the entire
ject, creating a
aded effect.

Leaves were incised on the surface
of the slip-coated bowl before it
was completely dry.

Bowl, Lombardy, second half of the
th century. Slip terracotta and
derglaze. Milan, Castello Sforzesco,
viche Raccolte d'Arte Applicata.

*Maiolica is terracotta bisque covered with stannite enamel
that contains silica, calcined soda-ash, lead, and tin.*

Maiolica

Raw Materials
Clays, water, stannite
enamel (silica, calcined
soda-ash, lead, tin),
metallic oxides

Tools
Sticks, shaping sticks,
molds, potter's wheel,
kiln, brushes

Diffusion
Spain: Paterna, Manises,
Málaga, Granada,
Majorca, Valencia; Italy:
Bologna, Cafaggiolo,
Faenza, Urbino,
Casteldurante, Gubbio,
Montelupo, Padua,
Pavia, Castelli, Deruta,
Venice, Savona, Siena,
Florence, Turin; Holland:
Delft; France: Saint-
Cloud, Marseilles, Nevers,
Rouen, Moustiers, Saint-
Porchaire, Lyon

▶ Jug, from Italy, end of the
14th century. Painted maiolica.
Faenza, Museo Internazionale
delle Ceramiche.

The term "maiolica" is probably a corruption of the name Majorc
in the Middle Ages that Mediterranean island was a center for the
importation of Spanish-Moorish maiolica ware. Starting in the 10t
century, the Islamic world experienced an extraordinary flowering
of this art: in Egypt and Syria, ceramic objects were produced
coated with a white opaque varnish; it was fabricated by Middle
Eastern craftsmen to imitate precious Chinese porcelain. The earli-
est maiolica ware was made with a yellowish terracotta covered
with a rough enamel made opaque not with tin, as in European
maiolica, but with a lead-bearing glaze mixed with quartz powder
that covered the object with a compact, shiny layer
Over the centuries, Islamic maiolica
reached high levels of inventiveness and
refinement; objects were decorated with
substances extracted from copper (for
green) or manganese (for brown), or with
luster. As trading intensified, this exotic
painted and glazed ware began to appear
on wealthy tables, and was often added
to church walls as highly valuable
decoration. Beginning in the 13th
century, maiolica production spread
from Islamic regions and its areas of
influence, such as Sicily and Spain, and
took root in Italy, where several centers
flourished. Maiolica production was
especially intense in the town of Faenza; the
name of that town ultimately became syn-
onymous with high-quality ceramic ware.

"Faenza white" ware exhibits the typical technical innovations of high-quality maiolica: the object is made with very fine clay that can be molded into thin shapes; the thick, white, stannite enamel enhances the pure shape and is suitable for simple center or border decorations.

After a first firing, this bowl was coated with stannite enamel with a high tin content that gives the coating unusual density and covering power, typical of "Faenza white," the expensive maiolica produced in Faenza in the second half of the 16th century.

The single decoration on this bowl is a putto drawn with few, slender brushstrokes complemented by a soft, yellow-rose shading.

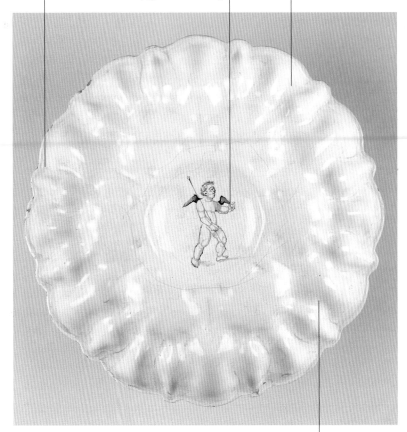

Faenza manufactory, Bowl, ca. 1570.
...nted maiolica. Milan, Castello
...rzesco, Civiche Raccolte d'Arte
...plicata.

This elegant bowl is called "crespina" (ruffled) for its wavy shape, made with a mold.

Grès is a hard-paste ceramic material that is compact and waterproof, white or colored. The name is derived from the French griot, "gravel," because it is hard as rock.

Grès

Raw Materials
Noncalcareous clay, water, sodium chloride (table salt)

Tools
Potter's wheel, kiln

Diffusion
Grès was discovered in the Rhine region of Germany about 1100. Starting at the end of the 14th century, this technique spread to all of Europe, particularly England, Scandinavia, France, and the Netherlands. Grès began to be manufactured in England in the second half of the 17th century.

Notes of Interest
Before the discovery of porcelain in the 9th century, comparably hard grès was produced in China under the Shang dynasty (1550–1025 B.C.). In fact, grès has been improperly called proto-porcelain.

► Friedrich Böttger, Teapot, ca. 1712. Painted grès. Dresden, Porzellansammlungen.

Unlike ceramic products made with terracotta, grès is dense, hard, and sonorous, composed of clays with high silica content that vitrify at very high temperatures. Whereas the limestone in the faience products melts quickly, creating pores, grès clays have low limestone content and possess a "vitrification interval": when subjected to the highest temperature, the vitreous substances melt gradually rather than immediately. The resulting ceramic piece is much stronger, with no cracks or microfissures, and is much more fire resistant. The use of grès became widespread starting at the end of the 14th century, when more advanced techniques allowed ceramicists to produce the high temperatures needed for firing this type of material. German grès spread to all of Europe, particularly to England. Fulham became an independent manufacturing center in the second half of the 17th century, thanks to John Dwight; later, the Eller and Wedgwood families became active in Staffordshire, which became the capital of the English ceramic industry.

Salt glaze, unlike the old lead-based varnishes used on terracotta, is not toxic.

This flask was made with salt glaze on grès. During the firing, salt is thrown into the kiln; as it vaporizes and reacts with the smoke, it covers the surface with a shiny, clear glaze. The temperature required for this process is very high: 1200° C.

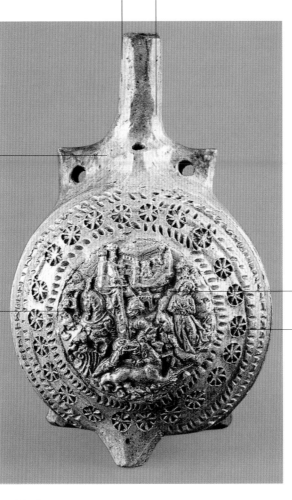

The central decoration in relief, made with a mold, depicts Saint George and the dragon (in the center), and the princess (on the right). A landscape with a castle floats in the background. Such compositions often were inspired by ivory carvings.

s pilgrim k was le with a ʼd and er coarse s paste.

e presence ron in the paste ounts for reddish es.

The corona of stars was incised with a small punch, the dashes with a pointed tool.

ologne manufactory, *Saint George the Dragon*, Pilgrim Flask, ı–ı6th century. Salt-glazed grès. ogne, Kunstgewerbemuseum.

221

Bisque is a white, opaque ceramic material that recalls marble; it came into use especially in the second half of the 18th century for statuettes, busts, and decorative objects.

Bisque

Raw Materials
Kaolin, quartz, and feldspar

Tools
Molds, kiln, decorating tools such as brushes, gold leaf, and colored pigments

Diffusion
In Europe starting about 1750, especially in France (Sèvres manufactory) and Naples (Royal Manufactory of Capodimonte)

"Bisque" is a French term that can be translated as "twice cooked" (*biscuit*); it refers to the first firing of terracotta, porcelain, or ceramic in general, which causes the object to lose water and harden, preparing it for the decorating and glazing phase. Bisque also refers to objects made with the same paste used for porcelain, that is, kaolin, quartz, and feldspar, fired only once. This single firing (*biscottatura*) is done at a low temperature of 900–1000° C in an oxidizing environment, where the air circulates freely. It promotes hardening of the paste and complete combustion of all organic substances. Bisque is thin, white, and opaque, more fragile than porcelain and not suitable for the production of dishware; it is ideal for decorative objects, such as statuettes and knick-knacks. The elegant statuettes of pastoral scenes or *fêtes galantes* modeled by Étienne-Maurice Falconet after 1750 and produced by the Sèvres manufactory are stellar examples of this genre. Some kinds of dolls were, and still are, made with bisque.

▶ Royal Manufactory of Capodimonte, *Dionysiac Scene*, end of the 18th century. Bisque. Naples, Museo e Gallerie Nazionali di Capodimonte.

*ft-paste porcelain is a dense material containing a vitreous
*mponent that allows it to be fired at a lower temperature
*an hard-paste porcelain.

Soft-Paste Porcelain

*ft-paste porcelain was invented in Europe before the hard-
*aste variety, in an attempt to imitate the valuable artifacts
*nported from China. During the Renaissance, the first
*xperiments were made to discover the formula of this
*niquely white, compact, light, and translucent ceramic.
*hanks to the interest shown by Francesco I de' Medici, an
*mateur alchemist, the Medici manufactories produced an
*rtificial paste consisting of about twenty percent extra-fine
*aolin and vitreous quartz silicates. This compound, also
*alled frit, resembles closely the material perfected by the
*ersians in the 13th century in yet another attempt to imitate
*hinese porcelain. The main difference between the European
*ersion and Eastern frit
*eramic lies in the coating:
*hat in the Medicean
*rtifacts is a tin-bearing
*namel similar to the one
*ised for maiolica. English
*oft-paste porcelain, called
*oone china, employs a
*inique process still in use
*oday: calcareous minerals
*ind ground bone ash are
*idded to the base mineral,
*oroducing an especially
*ine, light porcelain.

Raw Materials
Kaolin, alabaster
powder, marble
powder, vitreous
frit, potash oxides,
magnesium, aluminum.
The soft-paste porcelain
produced under the
Medicis also contained
stannite enamel.

Tools
Molds, potter's wheel,
kiln

Diffusion
Frit-based paste was
produced in the Middle
East in the 14th century;
in Europe, since the
Renaissance. Since the
18th century, soft-paste
porcelain has been
manufactured in France
(Sèvres, Rouen, Chantilly,
Sceaux, Saint-Cloud),
Germany (Meissen), Italy
(Capodimonte and Doccia
factories), and England
(Bow factory).

◄ Medici porcelain manufactory,
Pilgrim Flask, 1580s. Soft-paste
porcelain, painted. Los Angeles,
J. Paul Getty Museum.

Soft-Paste Porcelain

The shape of this bowl was made with a mold.

The surface of the bowl was covered with a clear glaze, which also filled the small decorative perforations, sealing them and making the entire bowl waterproof.

This unusual bowl, dating from the Seljuk period, was made with a paste that remains white when fired, and vitreous frit, a mixture of silica sand, alkaline ash, and feldspar.

The frit paste imitates the look of thin, translucent hard-paste porcelain. To enhance the transparency, the bowl was decorated with fretwork.

▲ Persian manufactory, Bowl, ca. 1200. Soft-paste porcelain. Private collection.

They use as currency white porcelains that are found in the sea and which they make into bowls" (Marco Polo, late 13th century).

Hard-Paste Porcelain

Porcelain is a ceramic material consisting of very finely grained, compact, waterproof, white, translucent paste so hard that even a steel point cannot scratch it. The earliest high-quality porcelain was manufactured in China during the Sui dynasty (A.D. 581–617) and at the end of the T'ang period (A.D. 618–906). In Europe, the earliest reports about this unusual material were brought back by Marco Polo, though the importation of porcelain artifacts through the markets of the Middle East began in earnest only about 1300.

The attractiveness of this material was such that during the Renaissance attempts were made to discover the formula and process used; it was also counterfeited with *lattimo* glass. Even maiolica, which is coated with stannite enamel, was developed to imitate the light, snow-white Oriental porcelain. In was only in Dresden in 1708–9 that Friedrich Böttger, an alchemist, succeeded in uncovering the secret of porcelain. He used two components: kaolin, extracted from the caves of Colditz, and calcined alabaster, both feldspar minerals. Böttger's compound was fired continuously for twelve hours at 1300–1400° C, a temperature never before used for ceramic. In 1710, the first factory to produce hard-paste porcelain was inaugurated at Meissen.

Raw Materials
Kaolin, quartz, feldspar. For the coating: ground quartz and feldspar; for decoration: metallic oxides; for gilding: gold amalgam

Tools
Potter's wheel, molds, kiln

Diffusion
In China, starting in the later 6th century A.D.; in Europe, after 1710.

Notes of Interest
The ancient Chinese method for purifying kaolin consisted in leaving it outdoors in slanted tanks for a period of thirty to forty years.

◀ Vase, China, Southern Song dynasty, 1127–1279. Porcelain. Taipei, National Museum.

225

Production of white-and-blue Chinese porcelain begin in the second half of the 13th century (Yuan dynasty). The blue decoration is painted on the raw porcelain before the application of the glaze.

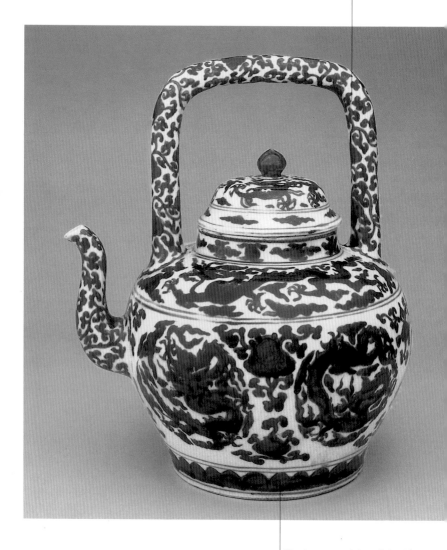

▲ Teapot, China, Ming dynasty, 16th century. Painted porcelain with underglaze blue. Taipei, National Museum.

The pigment containing cobalt oxide develops into a lovely, deep blue. This is one of the few colors that can withstand the high temperatures at which hard-paste porcelain must be fired.

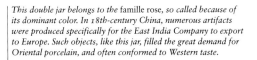

This double jar belongs to the *famille rose*, so called because of its dominant color. In 18th-century China, numerous artifacts were produced specifically for the East India Company to export to Europe. Such objects, like this jar, filled the great demand for Oriental porcelain, and often conformed to Western taste.

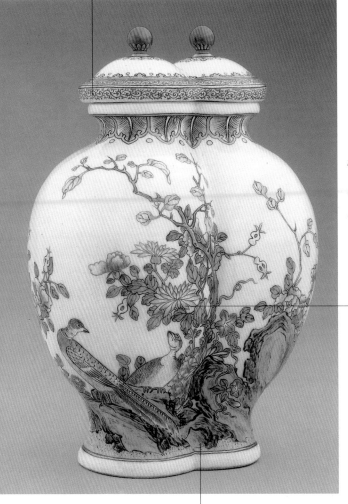

The delicate decoration was applied over the fired glaze after the object was finished. The colors used—pink and light green especially—are not compatible with the high firing temperatures required to set the underglaze blue. These pastel tints were fired in a muffle—a small, low-temperature oven—and are therefore called "small fire" and "overglaze."

Double Jar with Cover, Decorated ith Birds and Flowers, China, Qing ynasty, Qian-long period, 1736–95. *amille rose* porcelain. Taipei, ational Museum.

The glaze, also called "cover," is applied to the object with a spray or through immersion. Once coated, the object is fired at the highest temperature.

Hard-Paste Porcelain

After Böttger's discovery, factories were established in Saxony; Meissen became the site of a large-scale manufactory of prestigious hard-paste porcelain with entirely original qualities.

The small birds were prepared separately in a mold, then set with liquid porcelain onto the cover and the vase.

This type of decoration, known as "snowball," was invented by Johann Joachim Kändler about 1739. It consists of flower incrustations made with semiliquid porcelain by means of a long and demanding process, proof of the virtuosity of the Meissen artists.

Because of its extremely fine grain, porcelain is suitable for complex creations that require very thin ceramic walls.

The base and central body of this precious vase were attached to each other, and then the cover was added.

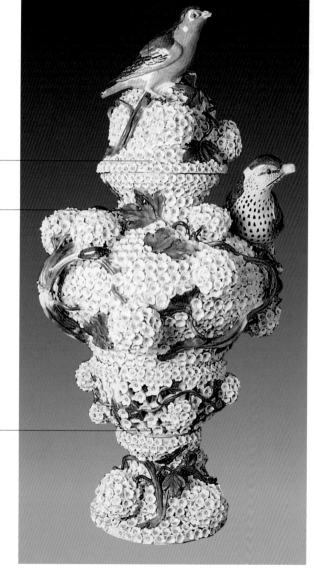

► Meissen manufactory, Large Covered Vessel Decorated with Viburnum, ca. 1755. Overglaze painted porcelain. St. Petersburg, Carskoe Selo, State Museum.

This small parlor created for Queen Marie-Amélie de Bourbon is the highest artistic achievement of the Royal Manufactory of Capodimonte. It was designed by Giovan Battista Natali, a set designer, aided by two painters, Sigmund Fischer and Luigi Restile.

The room is entirely lined with porcelain panels, which are attached with screws to a wooden frame.

The décor is enriched with large mirrors that reflect the decorations, theatrically multiplying the effects.

The decoration with festoons, scrolls, and musical instruments is executed in modeled stucco that has been painted and gilded.

The central medallions in each panel depict chinoiserie scenes and figures, inspired by the work of French artists like Watteau and Boucher.

Royal Manufactory of Capodimonte, porcelain parlor in the royal palace at Portici, 1757–59. Painted and gilt porcelain and stucco. Naples, Museo Gallerie Nazionali di Capodimonte.

Stoneware denotes a very hard, resistant material consisting of different white clays mixed with silica-rich and calcined earths

Stoneware

Raw Materials
White clay (kaolin) and silica obtained from calcined quartz; vitrifying varnish composed of silica, minium, lead white, and galena

Tools
Lathe, molds, kiln

Diffusion
Invented at the end of the 17th century in England, it was exported to all of Europe. In Italy, it was produced by the Nove factory in Bassano del Grappa; in France, at Orléans, Douai, and Chantilly. Today England holds the record for stoneware production.

Stoneware, invented in Fulham at the end of the 17th century in the workshop of John Dwight, was soon imitated by John Astbury, Enoch Booth, Thomas Whieldon, and Josiah Wedgwood, the leading English ceramist. Stoneware is a superior product compared to faience: it is porous, very fine, compact, and strong, and it frequently replaces porcelain for everyday household objects. There are two kinds of stoneware: soft (calcareous) and hard (feldspathic). The former is grayish white, and its paste includes clays containing limestone and small quantities of iron oxide. Hard stoneware, by contrast, contains large percentages of kaolin and quartz. The formula for stoneware resembles that for grès; the difference is in the firing, which is done at low temperatures ($800°$ C). Before firing, stoneware is waterproofed with a fluid varnish containing silica, minium, lead white, and galena ground in water. The object is dipped in this glaze after a first firing and is returned to the kiln for a second firing. Modeling is by mold or wheel. Decoration may be incised or applied by pouring a fluid paste. The body may also be decorated with transfer designs, with enamel (cream ware enamel), or with colors on top of the glaze (black ware).

▶ Wedgwood manufactory, Teapot, 1769–80. Painted "Black Basalt" stoneware. London, Victoria & Albert Museum.

*graffito decoration may be applied to either plain terracotta
slip, thus creating a pleasing contrast with the white of the
overing and the red of the clay.*

Sgraffito Decoration

ne of the earliest and simplest methods of decoration is
ncision on the artifact with a pointed tool or a perforating
e. The earliest sgraffito ("scratched") specimens date from
ne 4th millennium B.C. and were usually done on unfired
lay. The decoration may be incised on the dry object before
ring or after the first firing. The slip covering can also be
ncised, thus exposing the underlying bisque color.
"Scratched" terracotta appears as early as the 12th century
n Syrian artifacts, where the figures are incised on the object
lready coated with slip, then finished with brushstrokes of
ead glaze colored with metallic oxides, such as copper green
nd manganese brown. From the 13th century on, slip
eramics finished with sgraffito and glaze were popular
n Italy, especially in the regions of Lombardy, Veneto,
Emilia-Romagna, and Tuscany, and
continued to be so intermit-
ently until the latter part
of the 16th century.
Incised decorations
are also found on
other ceramic
materials, such as
stoneware and grès,
sometimes associ-
ated with relief and
stamped images.

Raw Materials
Clay, water, slip, lead
glaze with or without
metallic oxides

Tools
Brushes, pointed sticks,
and wood stakes

Diffusion
Present in prehistoric
civilizations (4th
millennium B.C.). Plain
decorations incised with
punches are present on
Roman ceramics. Starting
in the 12th century, the
sgraffito technique is
found in the Middle East,
and in north-central Italy
into the 16th century.

**Related Materials
or Techniques**
Relief and painted
decoration

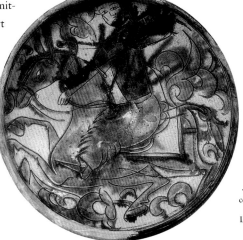

◄ Bowl, from Syria, 13th
century. Incised terracotta
decorated with glazes.
London, British Museum.

This egg-shaped flask
is covered with slip.

The vine-shoot decorations were
applied with the sgraffito technique,
using a stick of wood.

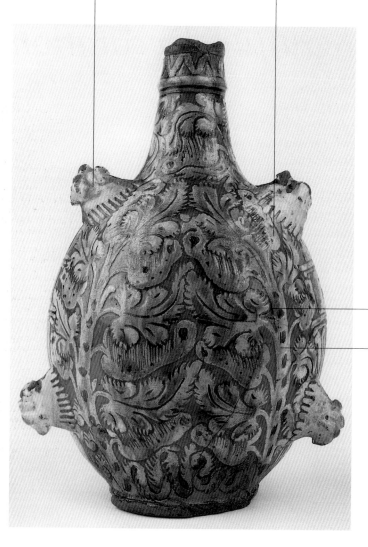

The thinner, call
graphic scratche
were applied wit
a thin poin

The flask i
finished with
clear glaze that
in addition t
making it water
proof, envelops the
colored decoration
and gives it lively
harmoniously
fused nuances

▲ Emilian manufactory, Flask, ca.
1600–1650. Glazed slip. Milan,
Castello Sforzesco, Civiche Raccolte
d'Arte Applicata.

▶ Urbino, Patanazzi workshop, Pitcher,
ca. 1585. Maiolica with decorations in
relief. Milan, Castello Sforzesco,
Civiche Raccolte d'Arte Applicata.

*elief ornament offers the widest range of expressive possibili-
es; different motifs that have been modeled separately, either
y hand or in a mold, can be added to the body of the object.*

Relief Decoration

)bjects made on the wheel can be finished with different
inds of relief (raised) decorations. The simplest technique
alls for shaping separate motifs, which are then set on the
ody of the object using wet clay. The relief can also be pre-
ared with a technique that recalls metal embossing: using a
nold of hard material, such as gypsum, on a sheet of soft
lay will create a relief. Spanish-Moorish ceramicists typi-
ally used two decorating techniques: the *cuenca* and the
uerda seca. Both are employed especially for making tiles.
The first uses a mold that creates a hollow in the still-soft
lay, which is then filled with colored enamel. The second
ıses a thin, greasy string
ıeld tautly along the
ıreas where the artist
vants polychrome sec-
ions. As the tile is fired,
he string burns away,
eaving grooves. The
tring's tension creates
vell-defined, softly raised
iections on the soft clay.
With "barbotine"—liquid
clay used with a brush or
poured in a thin stream
from a suitable con-
tainer—the artist can
make relief decorations
of all kinds.

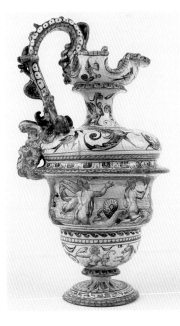

Raw Materials
Clay, water, slip, colored
and clear glazes, metallic
oxides, grease

Tools
Molds, string, spatulas

Diffusion
Relief decorations of
all kinds are very common
in the ceramic arts of
every period.

Related Materials
or Techniques
Painted and sgraffito
decorations. Relief
decoration is used on
all types of ceramic
(terracotta, grès, maiolica,
porcelain, stoneware).

Notes of Interest
Appointed by Catherine
de' Medici, Bernard Palissy
(1510–1590) created the
lost grotto in the Tuileries
between 1567 and 1572. It
was lined entirely with tiles
that imitated rare marbles
and granites and was covered
with plant and animal deco-
rations in relief finished with
polychrome glazes. Judging
from fragments that were
found in 1865, it must
have been truly unique.

Thin strings, pressing on the soft clay, traced grooves and created slightly raised linear patterns.

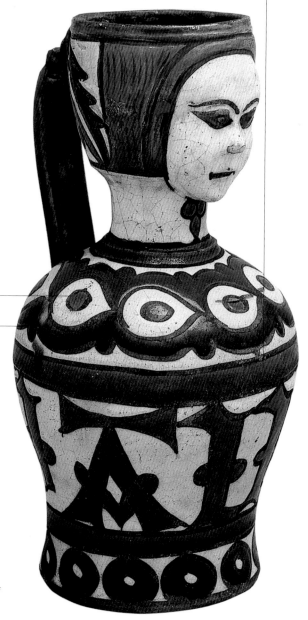

The contoured design was filled with polychrome enamels.

The black lines were delineated with a string soaked in grease and, in this example, manganese oxide, pulled taut along the surface of the vase. The high firing temperature burned the grease and the string, which in turn deposited the brown of the manganese oxide on the body.

▶ Seville manufactory, Jug with a Human Face, first half of the 15th century. Terracotta with tannite glaze and *cuerda seca* decoration. Sèvres, Musée National de la Céramique.

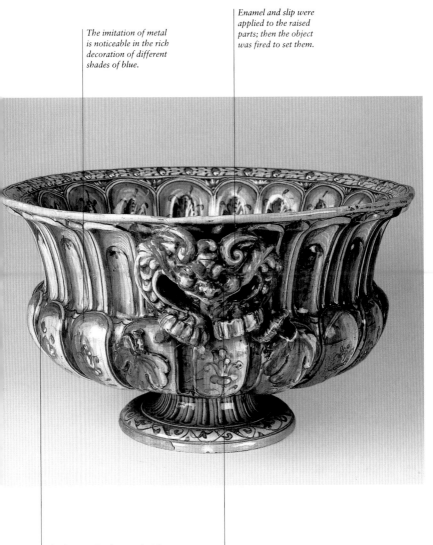

The imitation of metal is noticeable in the rich decoration of different shades of blue.

Enamel and slip were applied to the raised parts; then the object was fired to set them.

This large cooler, decorated with a concave-convex pattern, imitates contemporary silver artifacts.

The handle in the shape of a mask was prepared in a mold and applied with liquid clay (known as barbotine).

Venetian manufactory, Cooler, d of the 16th century. Painted aiolica. St. Petersburg, Hermitage.

Reviving a traditional Huguenot technique, Palissy used shiny, wet-looking colored glazes to add a highly realistic touch to the reliefs.

Palissy made frequent use of barbotine for raised decoration, achieving very delicate, highly detailed reliefs.

▲ Bernard Palissy, Oval Basin, 1580–90. Lead-glazed earthenware. Los Angeles, J. Paul Getty Museum.

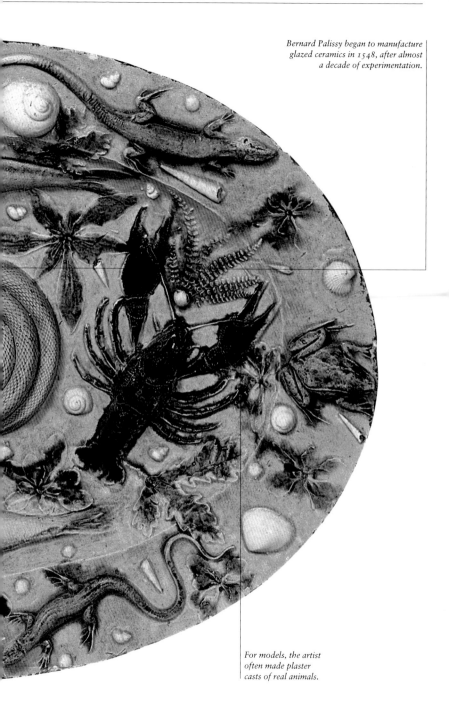

Bernard Palissy began to manufacture glazed ceramics in 1548, after almost a decade of experimentation.

For models, the artist often made plaster casts of real animals.

237

The history of maiolica and porcelain is highlighted by the stylistic innovations of the images and motifs painted on clay and on slip, under or over the glazing.

Painted Decoration

Raw Materials
Metallic oxides, stannite enamel, glazes

Tools and Supports
Tools: brushes, kiln, muffle. Supports: unfired clay artifacts; ceramic fired once for high-fire decoration; artifacts fired twice for "low fire" decoration; unfired porcelain to be decorated underglaze; fired porcelain to be decorated overglaze

Diffusion
Since the 4th millennium B.C.

Related Materials or Techniques
Relief and sgraffito decoration

Painted decoration appears on ceramics starting in the 4th millennium B.C. in the peripheral regions of Asia and Europe. Ocher powders containing iron oxides, when fired, changed the clay's color wherever they were applied. Beginning in the 2nd millennium B.C., the Mediterranean region produced naturalistic decorations with red-orange and gray-blue figures; after the 8th–7th century B.C. in Greece, the painted ornament evolved into black figures on a red ground, and later, to red figures on a black ground. Greek decorative techniques also appear on Etruscan and Roman ceramics. The colored decoration was applied to plain or slipped bisque, or covered with stannite enamel (maiolica) before or after glazing. Colors were extracted from powdered metallic oxides. Red, blue, green, yellow, and black-brown are resistant to high temperatures. The other colors and gold had to be applied to the finished artifact and fixed with a third firing at a low temperature. The principal technique used on maiolica in Europe was the unfired enamel, which was applied to the bisque; then the object was coated with a water and gum solution and decorated with oxides. Finally, the artifact was fired a second time on a high fire, which fixed the stannite enamel and the painted decoration.

▶ *Young Women at a Well,* Athenian hydria, from Italy, 530–520 B.C. Painted terracotta (black figure). Rome, Museo Nazionale Etrusco di Villa Giulia.

The dried vase is coated with a thin layer of liquid clay to which have been added alkaline compounds (limed ash) that will confer shine after the firing. The figures are delineated on top of this coating.

...er the vase was ...orated, it was ...aside to dry, ...n fired at ...0–960° C in two ...ses, to develop ...colors. In the ...st (oxidizing) ...se, air circulates ...ely, while in the ...ond (reduction) ...se, the firing ...mber fills with ...oke, which ...cks the air ...culation and ...ses the black ...or to fuse to ...e entire surface ...the vase.

After a third firing with free air circulation, the unpainted clay areas become red again: being porous, they absorb oxygen differently than the black, painted portions.

Attributed to the Karneia ...nter, *Dionysiac Scene*, Volute ...ter, 410 B.C. Painted terracotta ...d figure). Taranto, Museo ...heologico Nazionale.

Using a fine brush, the decorator paints the outlines of the figures; the figures will be "reserved," that is, they will not be painted with the black that completely covers the "ground" of the vase.

Painted Decoration

This pitcher belongs to a type of Turkish maiolica called "Iznik," named after the city where it was born and flourished, principally between the 15th and 18th centuries. Such vessels consist of very thin bisque coated with vitreous opaque glaze that contains lead oxide and quartz powder, fired at a low temperature, 700° C, without melting.

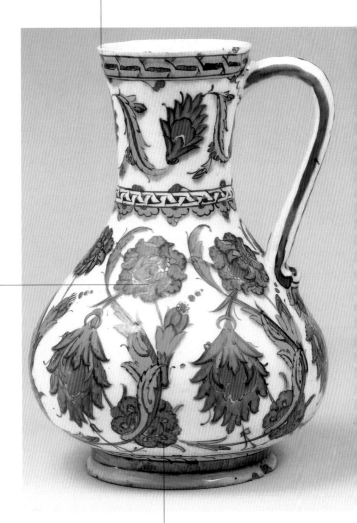

The painted decoration underneath the glaze has a typical motif that recalls the porcelain's style: a carnation alternating with the pliant, dented shaz leaf.

▲ Pitcher Decorated with Leafy Motifs, Iznik (Anatolia), second half of the 16th century. Painted maiolica. New York, Metropolitan Museum of Art.

In the 17th century, Iznik-type maiolica was widely imitated in the Italian Veneto, especially in Padua and Venice; it was called "Turkish-style maiolica."

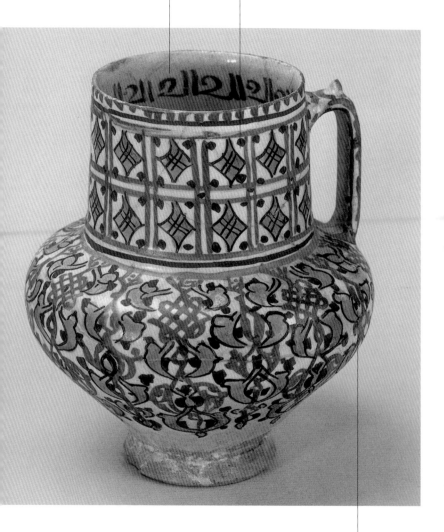

This small pitcher is decorated inside with Kufic characters.

The 13th-century terracotta vessel is covered with an opaque, alkaline glaze.

itcher, Kashan (Persia), 13th tury. Glazed terracotta, painted gilded. London, Victoria & ert Museum.

Here the decoration was applied as an overglaze after the object was fired and glazed. The object was then fired a third time in the muffle kiln. This technique, known in Persia in the 12th century, was widely adopted in Europe only in the 18th century and was used to apply polychrome motifs.

Painted Decoration

This maiolica, made in Florence about 1430, belongs to a ceramic family known as zaffera a rilievo; these were usually large-bellied jars or pharmacy jugs.

Zaffera a rilievo *was produced with a special color,* zaffera, *a very intense blue made with cobalt oxide. Applied with thick strokes, it appears almost black and looks like relief.*

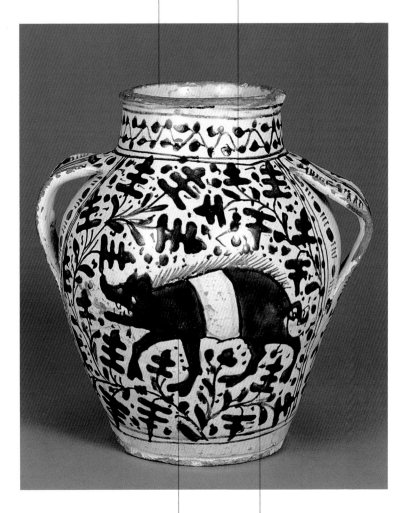

The lobed oak leaf is characteristic of this type of ceramic.

▲ Florentine manufactory, Two-handled Oak-leaf Drug Jar, ca. 1430. Tin-glazed earthenware. Los Angeles, J. Paul Getty Museum.

In addition to plant motifs, this group of painted ceramics was often decorated with animal or heraldic motifs.

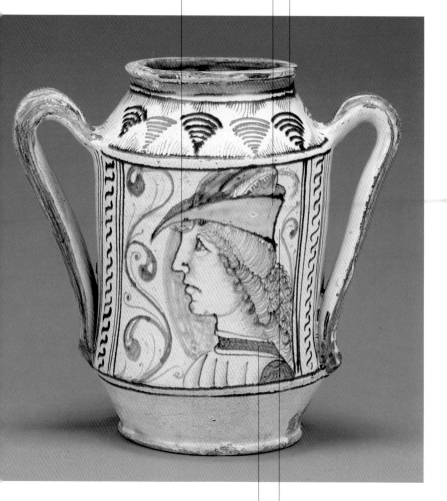

This two-handled maiolica jar is decorated with simple, stylized motifs surrounding a central frame, which contains the profile of a young man.

Green was extracted from copper oxide.

Blue was extracted from cobalt oxide.

Deruta or Montelupo manufactory, [Ja]r with the Profile of a Young Man, [15]60–80. Tin-glazed earthenware. Los [An]geles, J. Paul Getty Museum.

Yellow was extracted from antimony oxide.

After the artifact was fired once, it was immersed in a stannite-enamel coating fixed by a water and gum solution. Decorations and images were applied onto this unfired coating, which was subsequently fired at a high temperature.

Painted Decoration

This large vessel with an elaborate painted scene may well represent the archetypal Renaissance production of the first half of the 16th century. The polychrome decorations were copied from engravings of sacred or historical scenes. Here, the heroic deed of Horatius Cocles (on horseback, at the center of the bridge) is depicted.

The incised outlines were trace or copied on a sheet of paper that became the preparatory cartoon. They were transferre to the surface of the object by means of the spolvero (dusting technique.

This composition of the battle scene was inspired by Giulio Romano's fresco in the Stanza di Costantino in the Vatican. The decorators took as their model the printed reproductions of painted works, of which the etchings of Marcantonio Raimondi were especially popular.

The painted scene occupies the entire inside surface of the cooler, up to the rim.

▲ Workshop of Guido da Merlino (Urbino), *Horatio at the Bridge*, decorating a wine vessel, 1540. Maiolica. St. Petersburg, Hermitage.

The handles, in the shape of snakes, are quite fanciful; each is tied with a bow in the center.

These bucolic scenes often evoke images of China. On this plate, fanciful Oriental figures are seated at a table amid trees executed in a delicate stylized manner.

The decorator added an unusual, graceful detail: a small bird chasing a tiny dragonfly.

This plate is part of a large maiolica table service; every plate is decorated with a fête galante or scene from the Commedia dell'Arte.

Lombardy manufactory, *Fête galante*, chinoiserie decoration on a platter, ca. 1770. Painted maiolica. Milan, Castello Sforzesco, Civiche Raccolte d'Arte Applicata.

The finished plates were decorated with delicate pastel colors set with "small fire" temperature. The models are taken from the overglaze decorations of imported porcelains.

245

Luster is an iridescent film with changing reflections, the result of applying a coat of metallic oxides and ocher to the finished object. It is typical of Spanish-Moorish ceramics.

Luster Decoration

Raw Materials
Ocher, silver and copper oxide

Tools and Supports
Tools: brushes, points, muffle oven. Supports: glazed maiolica or ceramic

Diffusion
Originating in Mesopotamia about 850 B.C., it was used much later by decorators at the Fatimid court in Baghdad in the 10th century A.D., and spread to the Islamic-influenced areas in the Mediterranean basin. In Italy, luster was applied to Deruta vases in the 16th century.

Related Materials or Techniques
Painted and raised decoration

▶ Deruta manufactory, Pitcher, first half of the 16th century. Painted maiolica with luster decoration. Milan, Castello Sforzesco, Civiche Raccolte d'Arte Applicata.

An important variant in maiolica decorative techniques is metallic luster, an iridescent film with shimmering color reflections. It was originally used on glass and later on ceramic. This technique, known in Mesopotamia by about 850 B.C., spread to all the Islamic regions up to the Iberian Peninsula, starting in the 10th century. The luster effect is achieved by applying copper or silver oxide mixed with ocher to the surface of the finished enameled or glazed artifact. The pigment can be measured according to the effects one wants to achieve: a thin layer will result in delicate iridescence, while a thicker layer will produce a strong, metallic effect. After applying the metallic oxide coating, the artifact is fired in an oven at about 800° C, filling the firing chamber with smoke. This creates a reducing, oxygen-free environment, which develops the pure metal while the heat fixes it to the enamel. Luster was highly popular until the 15th century. It did not totally disappear in the Renaissance: it is present on Deruta artifacts, where rich golden lusters add the finishing touch to polychrome decorations. Luster was rediscovered in the 1700s by Josiah Wedgwood at the Staffordshire manufactory as a method for decorating stoneware. In the 19th century, also in England, a mother-of-pearl luster, achieved with bismuth nitrate, became popular.

The luster was applied to the glaze after firing; then the platter was fired again, this time in a muffle kiln in a reducing atmosphere (without oxygen) in order to develop the metal that deposits itself on the surface.

A thick layer of copper oxide was used to decorate this large platter: the resulting luster is an intense gold-colored patina.

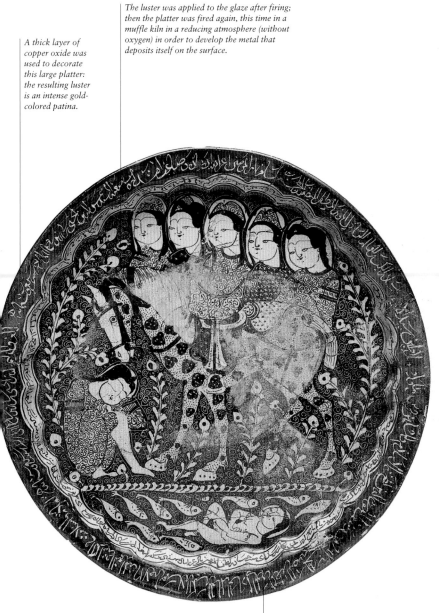

Vision of a Sleeping Youth, decorating Persian platter, 1210. Luster-painted maiolica. Washington, D.C., Smithsonian Institution, Freer Gallery of Art.

Here the luster compound was applied in a uniform layer, then scratched with a thin point; the Kufic script around the outside border was delineated using the same technique.

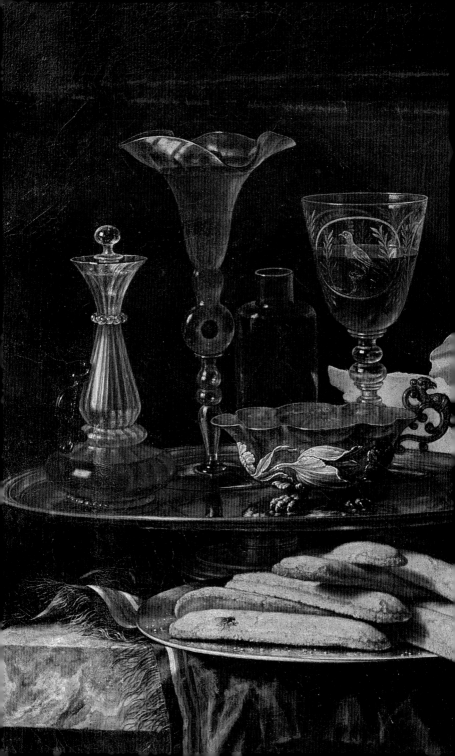

GLASS

Soda-Lime Glass
Crystal
Chalcedony Glass
Lattimo Glass
Ice Glass
Modern Venetian Glass
Blown Glass
Painted Decoration
Pincer Decoration
Sgraffito Decoration
Intaglio Decoration
Murrhine Glass
Filigree Glass
Reticello Work
Gold Glass
Stained Glass

Christian Berentz, *Crystalware*
d Plate of Cookies (The Fly)
etail), ca. 1690. Oil on canvas.
me, Galleria Nazionale d'Arte
tica, Palazzo Corsini.

Soda-lime glass has always been the most versatile type of glass; it is used to produce elaborate, refined objects as well as common everyday ones.

Soda-Lime Glass

Raw Materials
Quartz-rich pebbles or sand, soda, metallic oxides, glass shards, alum

Tools
Pot furnace, crucible, blowing iron, pontil, iron pincers, glass-cutting shears, molds

Diffusion
In all epochs and places. From the 15th to the 18th century, the Venetian island of Murano was the leading manufacturing center of luxury glass objects.

Related Materials or Techniques
Mosaic and stained glass. Artists create lovely artificial pearls (in the past, counterfeit gems as well) by working soda-lime glass with the lamp.

Glass is one of the most ancient man-made materials. According to Pliny the Elder, it may have been discovered by the Phoenicians; more likely, it is the result of experiments that were carried out as early as the middle of the 3rd millennium B.C. in Mesopotamia, where the earliest traces of working this material have been found. Glass is a solid, amorphous material composed of silica, a vitrifying element obtained from quartz-rich pebbles or sand, along with a melting or fluxing agent, a substance that lowers the melting point of the glassy mass. Soda, obtained from the calcined ash of algae and seaweed, is the flux. These substances, fired at 1200–1400° C, yield frit, a mass that is the result of the first melting. "Refining" substances, such as coloring agents and washed glass shards, are added to the frit, which is then fired a second time and molded. Unlike potash-lead glass, soda-lime glass (also known as "long glass") maintains its plasticity for extended periods of time, allowing it to be shaped by blowing and modeling, typical techniques of the ancient art of glassmaking and of Murano glass. Objects made of soda-lime glass are much lighter than those of lead glass; they are not resonant, and their yellowish, smoky tinge gives clear glass a warmer tone than that of English-Bohemian crystal glass.

▶ Murano manufactory, Basket-shaped Bowl with Fruit, 18th century. Clear and polychrome blown glass. Murano, Museo Vetrario.

This openwork, which evokes a ship's rigging, was made by lamp work using slender, clear-glass canes heated over an open flame and shaped with small pincers and scissors.

Soda-lime glass, old glass especially, tends to turn opaque in a humid environment, a phenomenon caused by an excess of sodium that affects the surface as it oxidizes, creating a whitish patina.

da-lime glass
n be subjected
heat model-
g for a long
riod time; for
is reason, it is
so known as
ong glass."

he body of the
oat was blown
d lightly
aped with
ncers.

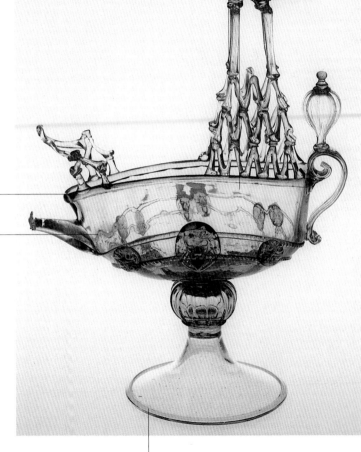

Murano manufactory, Boat-shaped
cquereccia, 1500–1520. Clear and
quamarine blown glass. Murano,
1useo Vetrario.

This strange object is an acquereccia, an ornamental water jug, in the shape of a ship. In the early part of the cinquecento, objects such as these were made for export, especially to Holland.

Soda-Lime Glass

The vitreous mass was decolorized with manganese dioxide (pyrolusite), a substance known as "glassmaker's soap."

This chalice was made with an especially pure type of clear glass, known as Venetian cristallo or cristallino glass, invented by Angelo Barovier about 1450.

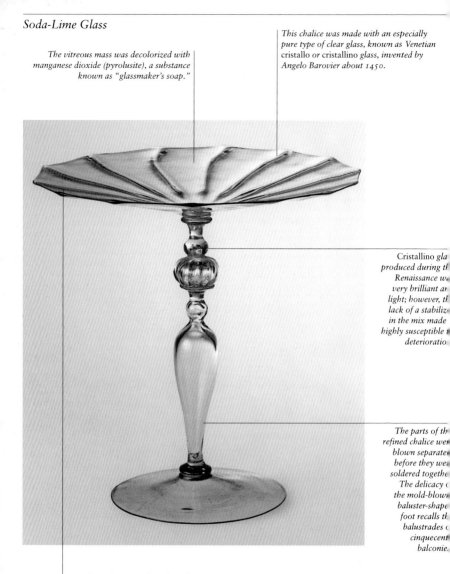

Cristallino glass produced during the Renaissance was very brilliant and light; however, the lack of a stabilizer in the mix made it highly susceptible to deterioration.

The parts of the refined chalice were blown separately before they were soldered together. The delicacy of the mold-blown baluster-shaped foot recalls the balustrades of cinquecento balconies.

Cristallino glass is made with pebbles from the Ticino River as the vitrifying material, since they are rich in quartz and have very few impurities. After the pebbles are crushed and subjected to several thermal shocks and washings, the resulting powder is mixed with a large quantity of flux, which in turn has been purified by several water washings.

▲ Murano manufactory, High-footed
Chalice, end of the 16th century.
Blown *cristallino* glass. Murano,
Museo Vetrario.

*nlike regular glass, crystal can be cut and incised easily,
anks to its hardness and its crystalline appearance.

Crystal

*rystal glass is what is commonly known today as "lead
*rystal" or simply "crystal." A glass of superior quality, it is
*sed for glassware, lamps, and decorative pieces, and often
*ut and sculpted. Crystal is the product of a long, evolving
*rocess in northern European glassmaking that in earlier
*enturies had used potash cinders from oak and beechwood
*s flux, to lower the melting point of silica. That process,
*owever, yielded a greenish, impure glass. In the 17th century,
*hanks to the intensified experiments of Bohemian glass-
*nakers (often assisted by Murano artisans who had left the
*epublic of Venice), a perfectly clear, sparkling, potash-
*ased crystal was perfected. In the same year, 1674, George
*avenscroft in England received a patent for "flint glass," a
*igh lead-content crystal glass that would later be produced
*n Bohemia as well. Today, it is commonly known as
*ohemian crystal. Johann Kunckel introduced a major inno-
*ation around 1679 at the Potsdam glassworks, when he
*ucceeded in creating a ruby-red glass
*sing gold chloride. This particular
*dditive at first produces a gray glass
*hat is used to make objects, which
*re then slowly heated to bring out the
*ed coloring. Generally speaking, lead
*crystal is very different from soda-lime
*glass because it solidifies rapidly and is
*harder, heavier, and more sparkling
*han common glass, all qualities that
*make it an ideal medium for simple,
*thicker shapes and for intaglio work.

Raw Materials
Sand or quartz-rich
pebbles, lead oxide,
potash oxide

Tools
Pot furnace, blowing
iron, molds, pincers,
pontil, diamond point,
grinding wheel, rotina

Diffusion
Crystal glass made
with lead and potash
spread to all of Europe
starting in 1674.

Notes of Interest
Today, lead crystal must
have a minimum content
of 24 percent lead oxide
to be classified as "half-
crystal"; glass with a
higher percentage (at
least 30 percent) is
classified as "superior
crystal." Recent European
Union regulations prohibit
classifying as lead crystal
a product that does not
meet these standards.

◄ Potsdam or Bohemian
manufactory, Drinking Glass,
1690–1700. Ruby-cut crystal.
Vienna, Wolf Collection.

253

Crystal

Potash-lead glass is more transparent and sparkling than soda-lime glass, as the latter always retains a faint gray or straw-yellow hue.

These slender decorations were incised with the *rotina*, a small, hand-held cutting disk.

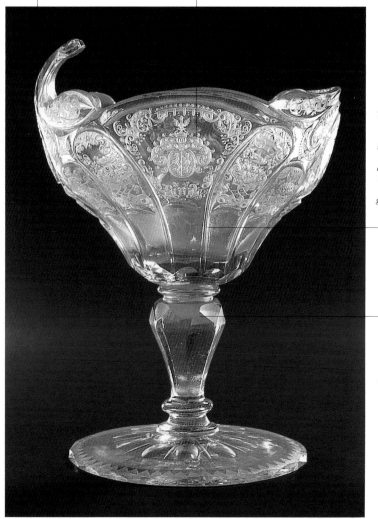

The crystalline look and greater hardness of crystal, compared to common glass, make it highly suitable for grinding-wheel intaglio or etching.

Objects made with potash-lead glass are solid and resemble large precious stones.

▲ Silesian manufactory, Footed Bowl, 1725–50. Cut crystal decorated *alla rotina*. Vienna, Wolf Collection.

halcedony glass, also known as agate glass, was developed to
nitate certain hard stones, those precious minerals once used for
ne splendid objects that filled the treasuries of European courts.

Chalcedony Glass

he art of imitating stones was known to the glassmakers of
ncient Rome, who mixed vitreous masses of different colors
o create marble-like effects. True chalcedony glass was
nvented in Murano in the 15th century, probably by Angelo
arovier, whose formula called for adding to the crucible
arious metal compounds, each at a set time and using a
nique process. The result was a transparent glassy red with
olychrome streaks that resemble agate. The popularity of
halcedony glass varied from period to period: it was widely
sed in the Renaissance to make bowls, flasks, and other
bjects, but it fell into disuse in the 17th century, only to be
evived in the following century to make blown-glass cups,
rinking glasses, and bottles coupled with other kinds of
olored glass, such as aventurine, an amber paste flecked
vith tiny copper flakes. When the Republic of Venice was
lissolved (1797), and with it, the art of glassmaking, the
ormula for chalcedony glass was lost. It was rediscovered
n 1856 by
orenzo Radi,
 leading master
of the 19th-century
Murano glass renais-
ance, who studied old
ormulas and experi-
nented for years in search of
the variegated glass that imitates
hard stones.

Raw Materials
Sand or quartz-rich
pebbles, soda, metallic
oxides, glass shards

Tools
Pot furnace, crucible,
blowing iron, pontil, iron
pincers, glass-cutting
shears, molds

Diffusion
In ancient Rome, a type
of variegated glass was
produced that imitated
hard stones; in 15th-
century Venice, a formula
for chalcedony glass was
perfected that continued
to be used for about
three hundred years; it
was rediscovered by
Lorenzo Radi in the
19th century.

**Related Materials
or Techniques**
Pincers decoration

◄ Murano manufactory, Footed
Bowl, ca. 1500. Free-blown
chalcedony glass. Los Angeles,
J. Paul Getty Museum.

Chalcedony Glass

This glass is made opaque by tin oxide and the addition of other metallic oxides to the vitreous mass, each at a different time and with a different process, producing these colored streaks. While the glass is being worked, the blowing and twirling of the mass shape the striations into a wave pattern.

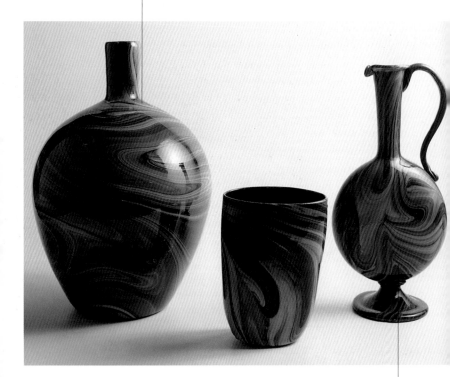

The forms of these 19th-century objects crafted by Lorenzo Radi recall the essentials of the Renaissance tradition, which was so adept at reproducing the rich chalcedony markings.

▲ Lorenzo Radi, Bottle with Beaker and Small Pitcher, 1856. Chalcedony glass. Murano, Museo Vetrario.

paque white and shiny, lattimo *glass is generally used decora-*
vely, although in the 18th century, it was often used to imitate
orcelain.

Lattimo *Glass*

paque and milky white, *lattimo* glass (sometimes called milk
ass) closely resembles porcelain. It is produced by adding man-
anese dioxide (a decolorant) and tin oxide (an opacifying agent)
o clear-glass frit. *Lattimo* glass was invented in Venice in the
uattrocento, although precedents existed in ancient Rome, where
white glass was used to decorate clear-glass objects. *Lattimo* glass
as been used for different applications in different epochs: in the
arly part of the 16th century, sacred scenes were painted with
olychrome enamels and gold on objects made entirely of white
lass. Because of its resemblance to expensive Chinese porcelain,
attimo glass was often used in the 18th century for everyday items
uch as tea and hot-chocolate cups, perfume bottles, and flacons,
rnamented with colorful hard enamels that were also used to
ecorate small *lattimo* tiles with sacred scenes or views of Venice.
Many of these objects were
made in the Miotti workshop,
which specialized in this type of
work. Most importantly, *lattimo*
glass was used to decorate crys-
alline glass: plain or twisted
white strands were embedded in
he glass using the *reticello* (lat-
ice) or *retortoli* (spiral) technique;
n the 17th century, they were
applied to the outside of small
lasks or flacons in wavy patterns,
using a special tool that "combed"
he glass, producing festooned (also
called "feathered") decorations.

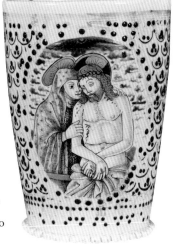

◄ Murano manufactory, *The
Virgin Mary and the Dead
Christ*, footed beaker,
1500–1525. *Lattimo* glass
painted with hard enamels.
Murano, Museo Vetrario.

Raw Materials
Sand or quartz-rich
pebbles, soda (in ancient
times obtained from
purified fern or seaweed
ash), metallic oxides,
glass shards, tin oxide
(an opacifying agent)

Tools
Pot furnace, crucible,
blowing iron, pontil, iron
pincers, glass-cutting
shears, molds

Diffusion
Invented in 15th-century
Venice, it later spread to
all of Europe.

**Related Materials
or Techniques**
Pincers decoration.
Glass opacified with tin
oxide is the base for the
vitreous paste of mosaics
and enamels. All filigree
techniques can be applied
to *lattimo* glass.

Lattimo *Glass*

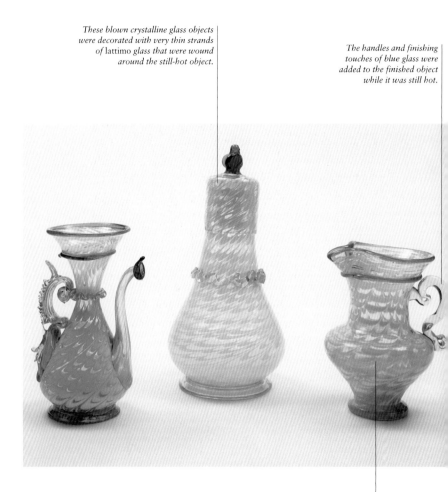

These blown crystalline glass objects were decorated with very thin strands of lattimo *glass that were wound around the still-hot object.*

The handles and finishing touches of blue glass were added to the finished object while it was still hot.

To achieve this festooned, or feathered, decoration, the lattimo-*glass strands were shaped with a special metal tool, called a "comb."*

▲ Murano manufactory, Flacon with Two Small Pitchers, 17th–18th century. Colorless glass with "feathered" decorations. Murano, Museo Vetrario.

The decorations on these objects were made with hard enamels. In the 18th century, enamels were perfected that were simpler to use than those from the 16th century, which required elevated firing temperatures. This innovation made enamel decoration possible on everyday objects as well.

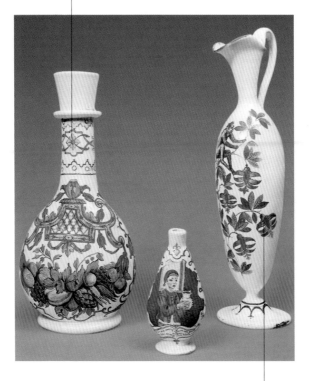

In the 18th century, lattimo *glass was used to make objects that imitated porcelain.*

Miotti Glassworks, Bottle, Small uff-bottle, and Pitcher, 1775–1800. amel-painted *lattimo* glass. Murano, useo Vetrario.

Characterized by cracks that imitate ice, this type of glass was invented in Venice, and the technique spread to other European glassworks.

Ice Glass

Raw Materials
Sand or quartz-rich pebbles, soda (formerly obtained from purified fern or seaweed ash), manganese dioxide (a decolorant), glass shards

Tools
Pot furnace, crucibles, blowing iron, pontil, iron pincers, glass-cutting shears, molds, cold water

Diffusion
Invented in Venice in the 16th century, it later spread to other parts of Europe (Holland, France, England).

Related Materials or Techniques
Pincers decoration, gold leaf

Typical of the Murano production of blown glass are objects processed entirely in the furnace, without any painted decoration, where the transparency and lightness of the material is given prominence. Ice glass takes its name from its "cracked ice" appearance, an effect achieved by plunging the semi-processed piece into cold water, then refiring it in the furnace. The piece is blown once more to give it final form and polished while still hot to make the cracks uniform. The "iced" effect is enhanced by the whitish hues that give a slight opacity to the glass. This type of glass is well suited to simple shapes such as bowls, fruit or cake stands, and buckets, sometimes embellished with simple touches of aquamarine glass. The Venetian ice-glass technique was adopted by French and Spanish artisans in the 17th century and by the Apsley Pellatt English glassworks in 1850; the latter, however, uses a different process: the

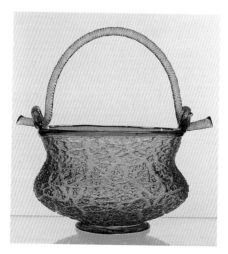

object, while still hot and malleable, is rotated over a refractory surface covered with clear and colored glass fragments that become embedded in the vitreous mass. Objects made with this technique are known as "English-Venetian glass."

► Murano manufactory, Bucket, second half of the 16th century. Ice glass. Milan, Museo Poldi Pezzoli.

The history of contemporary glass began with a radical renewal of form and materials, which marked a definitive break from traditional Venetian glassmaking.

Modern Venetian Glass

Murano glass manufactories revived during the second half of the 19th century when glassmakers began focusing on rediscovering formulas, techniques, and shapes of the vast Renaissance and Baroque glassmaking art. By the 1930s, traditional styles were being discarded in favor of experimentation, driven by frequent exchanges with other European masters who were exhibiting at World's Fairs and Venice Biennials. Among the leaders of this innovative activity were Vittorio Zecchin, with his delicate bubble-glass creations executed by Cappellin and Venini; Niccolò Barovier, who made transparent murrhine vases; and Napoleone Martinuzzi, who invented *pulegoso* glass, filled with a myriad of tiny bubbles. Other processes include "heat coloring without melting," in which substances that do not melt are embedded in the vitreous mass: examples of this are the "bejeweled autumn" and "bejeweled lagoon" glasses that contain irregular patches of colored powders with sometimes iridescent effects. Also notable are "corroded" glass and all the combinations of "submerged" glass in which glass layers of different colors are combined with gold leaf or uniform rows of bubbles. These experiments ushered in contemporary glassmaking, which is very rich and diverse.

Raw Materials
Sand or quartz-rich pebbles, soda, metallic oxides, glass shards for heat decoration without melting, other materials such as steel wool and powdered metals

Tools
Pot furnace, crucibles, blowing iron, pontil, iron pincers, glass-cutting shears, molds, cold water, gold and silver leaf, acids and corrosive agents

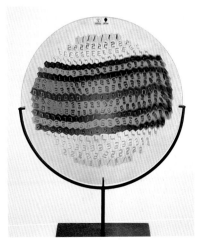

◀ Laura de Santillana, Venini Glassworks, *Numbers*, murrhine plate, ca. 1975. Colorless glass and transparent murrhine. Private collection.

This blown-glass pigeon is one of a limited series of objects made with milky-white glass traced with a dense, seemingly craquelé lattice pattern. The production of Primavera glass is very small because the vitreous mix, obtained by accident, could not be replicated.

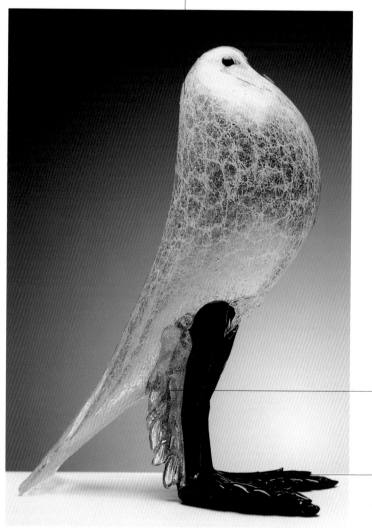

The feathers, shaped with pincers, are made of colorless glass.

Primavera glass objects are complemented by details in black opaque glass.

▲ Ercole Barovier, Barovier Glassworks, "Primavera" Pigeon, 1929–30. Primavera and black glass. Venice, Angelo Barovier Collection.

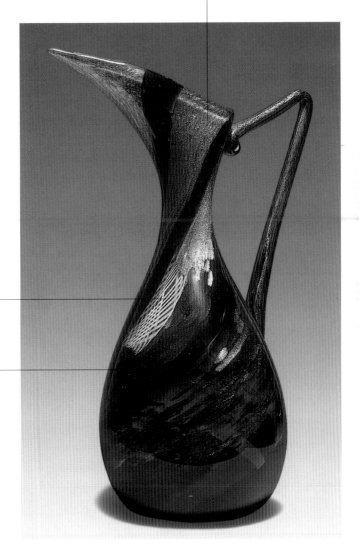

The upper part of this pitcher and the streaks on the body are in aventurine, an amber-colored glass densely filled with gold-copper flecks, first invented in the 16th century. The name is not derived from the mineral of the same name, but rather from the word "adventure," alluding to the difficulty in creating and molding this particular glass.

...small, reticello ...igree pattern ...is inserted here.

...e spare, modern ...ape evokes the ...nearity of some ...own-glass objects ...m antiquity; the ...eek form is coupled ...ith an experimental ...e of different ...reous mixes.

Dino Martens, Aureliano Toso Decorative ...lassworks, "Eldorado" Pitcher, 1954. ...olychrome glass, aventurine glass, and filigree. ...rivate collection.

Blowing is the principal technique for giving form to glass because it allows the craftsman to fashion all sorts of shapes using very thin glass.

Blown Glass

Tools
Pot furnace, crucibles, blowing iron, pontil, iron pincers, glass-cutting shears, molds, marver

Diffusion
Glassblowing was first practiced in the 1st century B.C. in the Syria-Palestine region. The technique spread throughout the Roman Empire into all of Europe. It is still the leading technique for molding glass, whether artisanal or industrial.

Related Materials or Techniques
Pincers decoration, sgraffito, intaglio, enamel. The panes for stained-glass windows are made of blown glass.

Once the vitreous mass is melted, it is removed from the crucible and rolled onto a metal surface, called a marver, to give it a cylindrical, uniform shape. The bole is then attached to a long metal tube, the blowing iron, through which the glassmaker blows air to inflate the bole. Sometimes, after a partial shaping, the bole is reheated and molded with special tools over several sessions, until the desired form is achieved. Blown glass may be free-form or made in a mold. In the latter case, the mass is placed in a concave mold made of iron, bronze, or wood and inflated until it fills the contours of the interior walls. A special technique perfected by the Murano glassmakers is the half-mold, which allows the artisan to create ribbed surfaces: a second layer of glass is applied to the bottom of a partially molded mass that is still attached to the blowing iron, and the object is blown again into a ribbed, open mold. This process creates objects with thin upper walls and a more or less deeply ribbed lower part, with an unusually elegant appearance. After blowing, a drop of fused glass is applied to the bottom of the object and a meter-long solid metal rod, the pontil, is attached to it to support the object while it is heat-finished and decorated. This done, the object is detached from the pontil and placed in a special oven where it gradually cools.

► Paolo Vittorio Zecchin, Venini Glassworks, "Veronese" Vase, 1921–25. Clear blown glass. Private collection.

This small Roman vase was made by free-form blowing.

The small handle was added after the glassmaker finished the body and neck of the bottle and riveted the outside rim.

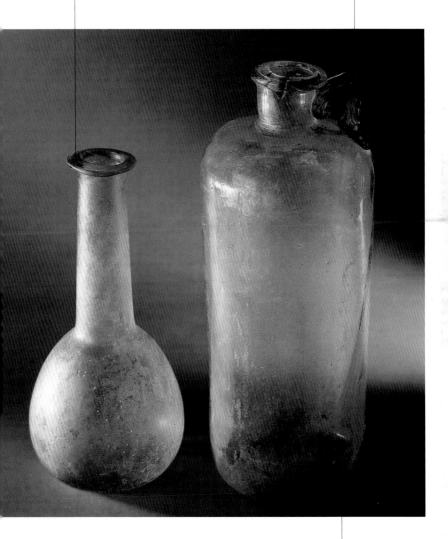

Pear-shaped Bottle and Cylindrical ottle, Roman, 1st century B.C. Glass. mpeii, House of Menander.

The glass used in antiquity was not very refined: often the objects have bubbles and thick walls. The green coloring is due to impurities, usually iron oxides that are in the vitreous mass.

Blown Glass

The discovery of crystalline glass in the 15th century ushered in the production of simple, elegant objects such as this drinking glass, made with the half-mold technique, which allowed for the application of streaks and thicker relief motifs.

Often, the most expensive drinking glasses were decorated with simple, dotted enamel patterns that add a colorful note and emphasize the transparency of the glass.

A diamond-shaped mold was used for the decorative motif.

As a final step, the base was decorated with the application of a pincer-worked cane of glass.

▲ Murano manufactory, Drinking Glass, end of the 15th century. Clear, half-molded blown glass, with enamel decoration. Milan, Museo Poldi Pezzoli.

This footed bowl of blue glass was produced with
the half-mold technique, which created deep ribbing
on the base and the lower part of the bowl.

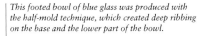

The white decoration was made with strands
of lattimo glass applied to the ribs of the
partially molded piece. The lattimo strands
break up when the glass is heated and then
inflated in the mold, which results in this
fine decoration of contrasting dashes.

Murano manufactory, Footed Bowl,
th century. Blue, half-molded blown
ass with *lattimo* glass strands.
urano, Museo Vetrario.

In the past, glassworks also made fusible enamel cakes: small, opaque glass blocks that were rendered into powder and used as colors to paint finished objects.

Painted Decoration

Raw Materials
Enamel cakes (colored opaque glass), grease, gold leaf

Tools
Brushes, furnace for refiring enamel

Diffusion
Practiced since the 1st century B.C. in ancient Syria and Palestine, it spread to the Roman Empire; it reached Venice in the 13th century and from there the rest of Europe, notably the Germanic regions and Spain.

Related Materials or Techniques
All the glassworking techniques, including grisaille and enamel painting; sometimes used on stained-glass windows

Notes of Interest
To protect their income, the glassmakers' guild in 1469 forbade painters from decorating glass and selling it independently: painters could work only inside the glassworks. This restriction was necessary because enamel-decorated objects sold at twice the market value of plain ones.

Once the glass object has been molded and has cooled, it may be painted with fusible enamels that require firing or with enamels that can be applied without heat. Enamel decoration originated in Syria and from there spread to many regions of the Roman Empire. In the 13th century, thanks to trading with the Islamic world, this technique reached Venice, where the artisans transformed it into a thoroughly original technique. Enamel is an intensely colored, opaque vitreous paste prepared in small round blocks, which are later broken up and finely ground with mortar and pestle. The resulting powder is mixed with a greasy substance that acts as a binder for the decoration. Once the colors of the decoration have dried, the object is returned to the glassmaker, who heats it in a slow-heating oven until the temperature reaches 500° C. Only then does the artisan attach the object to the pontil and insert it into the oven to fire the enamels. This is a delicate, challenging operation that tests the glassmaker's skill, for he risks damaging the finished piece. These enamels, characterized by a melting temperature equal to that of the glass object, were used on blown glass especially in the 15th century and early decades of the 16th. Later, this type of enamel decoration fell into disuse, but it became fashionable again in the 18th century, when low-temperature fusible enamels were invented.

Enamel decoration
covers the entire flat
surface of the chalice.

Once the blown glass has cooled, the painter's
first task is to spread a thin layer of a greasy
substance over the areas to be decorated with
gold leaf. After applying the gold leaf, the
excess gold is removed with a small brush.

lors result from
ely pulverized
amels, always
xed with a greasy
bstance. In this
se, the decoration
s done in delicate
stel tones that,
ongside the gold
f, are illuminated
ainst the dark blue
ckground.

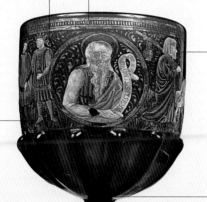

Since 15th-century
enamels had a
high melting
point, this object
had to be refired
after its firing in a
slow-heating oven.

This chalice with deep
ribbing was made with
the half-mold method.
The shape recalls the
metalware in use in
Italy around the middle
of the quattrocento.
This is a unique case of
a liturgical chalice
made of glass.

firing is a delicate
p that risks dam-
ing the object. In
is case, the high
at curved the
m of the chalice
er so slightly.

Murano manufactory, Plate,
60–70. Amethyst glass decorated
th enamel. Trento, Museo Provin-
le d'Arte, Castello di Buonconsiglio.

▲ Murano manufactory, Chalice,
1470–80. Blue, half-molded blown
glass decorated with enamel and gold.
Bologna, Museo Civico Medievale.

Another decorative painting technique is cold painting, applied with oil colors on the reverse of cups and plates; cold-painted images are often more elaborate and have a greater range of colors than those of the fusible enamels.

The cold enamel technique does not require firing the colors and is a simpler process than that of the fusible enamels.

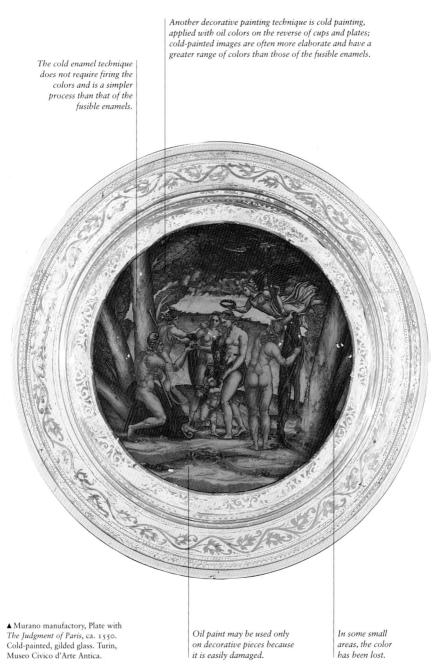

▲ Murano manufactory, Plate with *The Judgment of Paris*, ca. 1550. Cold-painted, gilded glass. Turin, Museo Civico d'Arte Antica.

Oil paint may be used only on decorative pieces because it is easily damaged.

In some small areas, the color has been lost.

Decoration with fusible enamels was also popular with Catalan glassmakers.
Spanish enamel is easy to recognize because of the thick, dense brushstrokes that
almost create reliefs over the entire surface, hiding the glass underneath dense
plant and animal motifs. Across the middle of the flask, the symbolic monogram
of Christ (Greek letters iota, eta, sigma)—IHS—is written twice in white.

talan glass is not
ecially refined;
en the walls are
ck and have
ny bubbles.

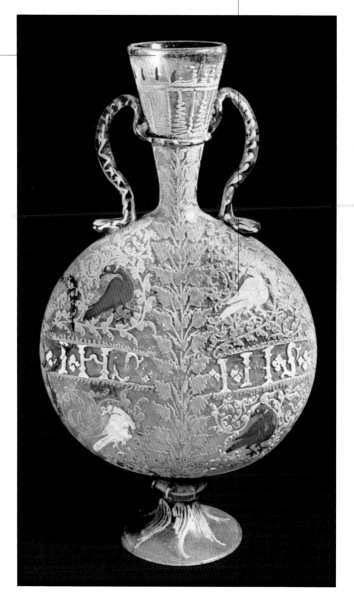

Catalan manufactory,
grim Flask, second
f of the 16th century.
wn glass decorated
h enamel. Murano,
useo Vetrario.

271

Eighteenth-century enamels had a lower melting temperature than glass; therefore, refiring was done in a muffle kiln, a small oven that heats at relatively low temperatures, thus facilitating the decorative work and also enabling its application to everyday objects.

Toward the end of the 18th century, Osvaldo Brussa revived glass decoration with fusible enamels, an expensive process that had fallen into disuse for almost two centuries owing to the difficulty of the workmanship.

▲ Osvaldo Brussa, Decorated Drinking Glasses, end of the 18th century. Blown glass with enamel decoration. Murano, Museo Vetrario.

Osvaldo Brussa painted his glass creations with courtly scenes and plant motifs, small birds and simple religious images in the popular style. Venetian glass production of this type stands out from analogous objects made elsewhere (e.g., Austria) because of the high transparency of the enamels used.

Soda-lime glass can be shaped with elaborate heat-molding processes and decorated with glass filaments pinched with special pincers.

Pincer Decoration

Once an object made of soda-lime glass has been blown into its final shape but is still at the working temperature of about 500° C, it can be detached from the blowing iron and attached at the bottom to a pontil (a metal rod that holds it in place) for the finishing operations. These may include making the rim smooth or ridged, applying handles, or decorating the outside walls of the object with vitreous strands to make linear patterns. Throughout the 15th and especially from the end of the 16th century, the more prestigious blown-glass objects were finished with a twisted and modeled, often very elaborate, glass cord. The glassmaker used special iron pincers to squeeze and pinch the decoration when it was still at the plastic stage or to create undulating patterns around the rims of vases and drinking glasses. One popular type of decoration with pincers found on many Venetian drinking glasses (and also on the large Dutch "snake glasses" that date from the end of the 16th century and continue throughout the 17th) were the wide "wings" called *morise* in Venetian dialect; *morise* were made with a glass cord, sometimes in a contrasting color, applied to the object, and shaped with the pincers into elaborate wave motifs. Some pincers had knurls or small patterns on their tips for impressing designs onto the glass.

Raw Materials
Glass

Tools
Smooth or ridged pincers

Diffusion
Since the 1st century B.C., when glassblowing was discovered. From the 16th century on, great virtuosity in Pincer decoration was achieved by artisans in the Murano glassworks.

Related Materials or Techniques
All the techniques of working with blown glass

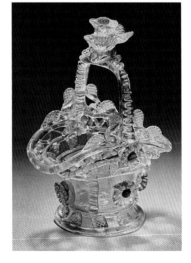

◀ Murano manufactory, Basket with Handle, middle of the 18th century. Clear glass. Murano, Museo Vetrario.

273

Pincer Decoration

This series of chalices was made by the Salviati Glassworks for the great Universal Exposition held in Paris in 1867. The objects exhibit the eclectic fantasy made possible by the heat-decorating techniques revived by Murano glassmakers.

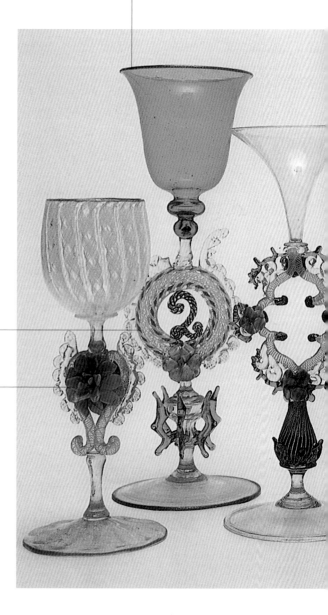

A pinched glass cord decorates the elaborate movement of the thin filigree cane that makes up the stem of this chalice.

Here, the still malleable vitreous paste was cut with glass-cutting shears and shaped with pincers, one petal at a time.

▶ Salviati Glassworks, Decorative Chalices, ca. 1867. Blown glass decorated with filigree and pincers. Venice, Salviati-Camerino-Tedeschi Collection.

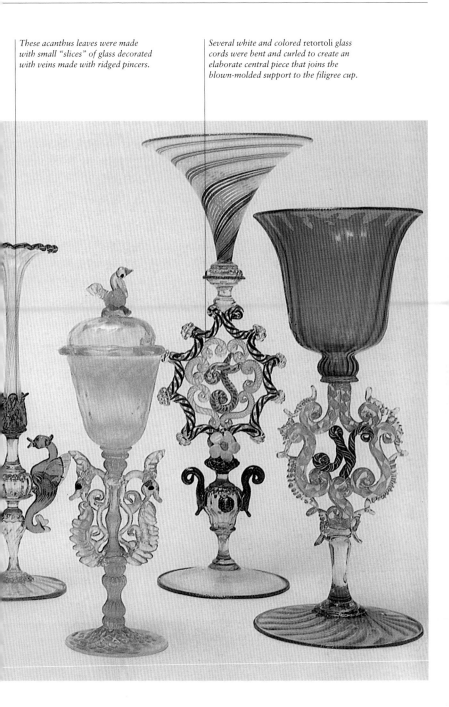

These acanthus leaves were made with small "slices" of glass decorated with veins made with ridged pincers.

Several white and colored retortoli glass cords were bent and curled to create an elaborate central piece that joins the blown-molded support to the filigree cup.

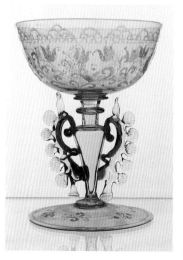

Sgraffito is a type of decoration applied to the glass when it is cold, by etching the surface with a diamond point or a small cutting disk (rotina).

Sgraffito Decoration

Raw Materials
Soda-lime glass and potash-lead glass

Tools
Diamond point, *rotina*, diamond-tipped stippling hammer. More recently, sand-casting and hydro-fluoric acid are also used.

Diffusion
Diamond-point etching began in Venice ca. 1400 and spread to Holland, Germany, Bohemia, and Silesia. *Rotina* decoration began in Prague in the 17th century and from there spread to Germany and the rest of Europe. *Rotina* decoration and intaglio were especially popular in the Biedermeier period (1820s–40s).

Related Materials or Techniques
Intaglio, gold-leaf decoration

▶ Murano manufactory, Chalice, 1630–50. Etched and blown glass, pincer decorated. Murano, Museo Vetrario.

Sgraffito decoration, like other incised ornament, is applied to the finished object without heat. The first sgraffito work appeared on Early Christian glass objects covered in gold leaf, known as gilt glass or gold-background glass, and is quite distinct from the sgraffito designs made with a diamond point on Venetian artifacts at the end of the cinquecento and imitated in the following century by French and Dutch glassmakers. Sgraffito made with a diamond point is very subtle: the figures, usually plant motifs, are sketched in delicate outlines filled with thin, parallel vertical or diagonal hatches. In 16th-century Venice, sgraffito was preferred over enamel decoration because the subtle interplay of etched white lines in the former heightened the transparency of the glass instead of hiding it. In keeping with Renaissance taste, blown glass had to appear to be an impalpable screen, its decorations a delicate lacework that enhanced its airiness. For this reason, Murano glass decorated with sgraffito is light and stylized, very different from the 17th-century work that embellishes Dutch and French plates and stemware. Murano products are denser and have more detailed decorations with vegetal motifs, often represented naturalistically, alternating with small landscapes, heraldic symbols, and inscriptions.

Potash-lead glass is
highly suitable for
etched decorations: in
this case, the glass was
given a simple shape
and milled. Note the
thickness of the glass.

Etched glass may be
polished or, as in this case,
left opaque to create a sort
of chiaroscuro effect.

o avoid breakage, the
ass surface was covered
ith an abrasive paste of
ery fine sand and
umice powder mixed
ith grease and emery.
he artist held the object
nder and against the
oving cutting disk.

he rotina is a small
opper disk that can
ch lines at various
epths; here, the
ecoration merely
ratches the surface
ithout cutting it.

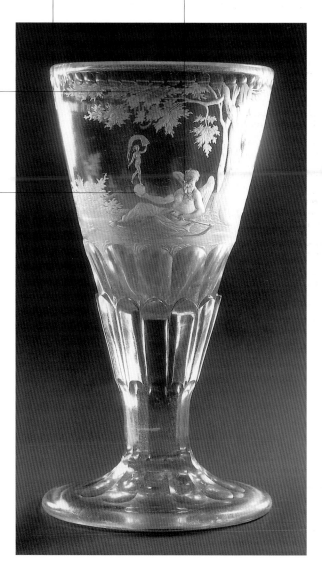

Elias Rosbach, Chalice,
a. 1735. Etched crystal.
ienna, Wolf Collection.

Sgraffito Decoration

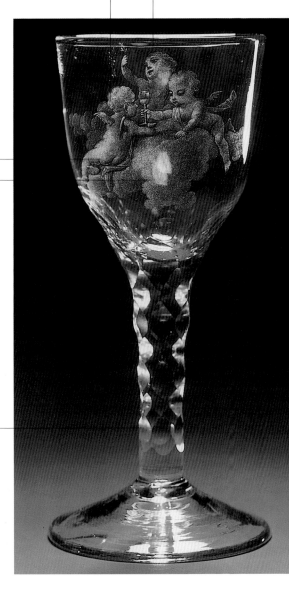

This decoration was made with a technique called stippling, first used in Holland in 1621 by Anna Roemers Visscher. The technique spread to the Low Countries and England, and especially to Newcastle, about a century later.

Stippling marks are made with a small hammer equipped with a diamond point that etches many tiny dots on the surface.

With stippling, it is even possible to make short, straight lines.

Shadows are achieved by making closely dotted areas that contrast with the shiny, clear glass ground. The effect recalls that of mezzotint etching.

The full glass stem is worked in intaglio.

▶ English or Dutch manufacture, Chalice with *Putti Celebrating*, 1775–80 (chalice), 1785–95 (etched decoration). Etched crystal. Vienna, Wolf Collection.

ntaglio was known to the ancient Romans, who manufactured iatreta glass and cameo-glass vases. In the 18th century, Bohemian intaglioed glass was highly prized.

Intaglio Decoration

ntaglio is a decorative technique that uses special tools to reate ornamental motifs by removing part of the material of the object to be decorated. This technique is present on ncient Roman cameo-glass objects made in Alexandrian workshops starting in the 1st century B.C. To make cameo glass, dark blue or dark green glass is used; after blowing it nto shape, it is covered with a layer of *lattimo* glass. The vase s incised with points to create the outline of the figures, and carved with small milling cutters. This technique lends itself o decorating sturdy artifacts made of thick glass; for this eason, it was not used on the fragile, soda-lime glass made n Venice, where light, diamond-point etching was favored. Potash-lead glass made in England and Bohemia s ideal for intaglio work: solid, clear, and sparkling, its beauty is heightened by an accurate intaglio design that gives it the brilliance of a large precious stone. For a greater effect, the design may be left opaque or partially polished with a grinding wheel.

Raw Materials
Crystal glass

Tools and Supports
Diamond point, rotina, grinding wheel

Diffusion
Practiced in areas of the Roman Empire since the 1st century B.C., the technique was used on some rare medieval glass, and since the 16th century, on many German, Silesian, and Bohemian objects.

Related Materials or Techniques
Gold glass, incision, sgraffito, enamel

Notes of Interest
The technical "opposite" of intaglio is the German *Hochschnitt*, which consists in carving away the glass ground so as to leave the design raised and intact.

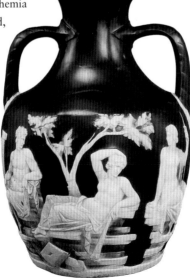

◄ Roman manufacture, Portland Vase, 1st century A.D. Cameo glass with intaglio work. London, British Museum.

This cup is an example of the high technical level reached by Roman glassmakers. The vessel was shaped in a mold and has rather thick walls.

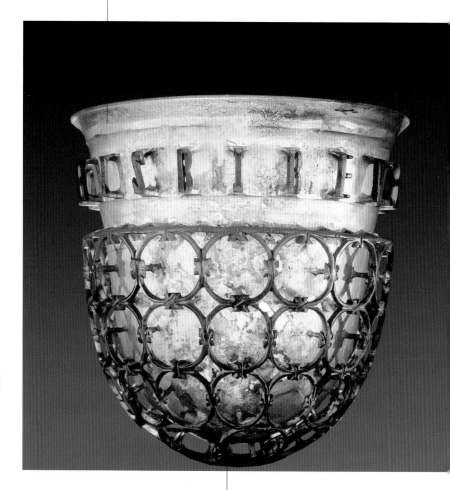

▲ Roman manufacture, Trivulzio Cup, 4th century A.D. Intaglio glass. Milan, Civiche Raccolte Archeologiche e Numismatiche.

The craftsman made the diatreta or "cage" and the sentence inscribed below the rim by carving out the glass with a scalpel and gradually emptying the carved areas.

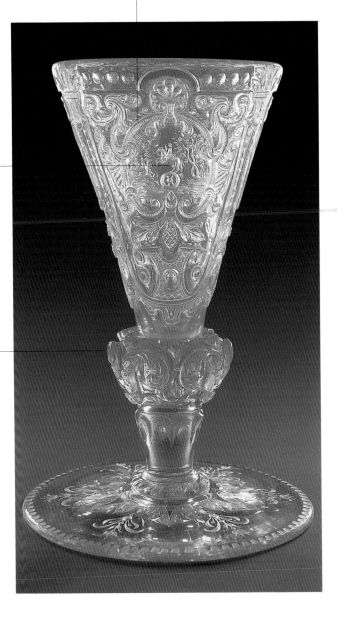

Some details of this
decoration were made
with a diamond point.

n this example,
he cut parts
vere polished.

Eighteenth-century
Silesian workshops
created outstanding
examples of
intaglio glass.

▶ Friedrich Winter, Chalice,
ca. 1700. Intaglio crystal.
Vienna, Wolf Collection.

Murrhine is a technique first devised by the ancient Romans; it uses as a central element small slices of colored glass canes.

Murrhine Glass

Raw Materials
Opaque and transparent colored glass

Tools and Supports
All those used in glass-making, including lamp work for small objects

Diffusion
From Alexandria (Egypt) in the 1st century B.C., this technique spread to the rest of the Roman world. Present in Venice since the 15th century, it spread in the 18th century to glassworks in France, Bohemia, and England, and in the 19th century to the United States.

Related Materials or Techniques
All heat-processing techniques

Notes of Interest
The term "murrhine" is derived from the *murrha* vases that Pompey carried to Rome from the Orient in 61 B.C. to be displayed in the temple of Jupiter on the Capitoline; they were made of a strange variety of fluorite, a stone scented by the resins used as binders in the cutting and processing phase.

The murrhine technique, also known as "millefiori" (thousand flowers) or mosaic glass, was perfected in Alexandria in the 1st century B.C. About two centuries later, it was imported into the Roman glassworks, which produced "mosaic" bowls. The first step in this process is to prepare glass canes, each of a different color, and fuse them together to produce a single, multicolored cane, called a murrina. This large cylinder is then heated and lengthened into a much longer, thinner cane that still maintains the original colors and composition. Once it has cooled, the cane is cut into small rounds and placed on a flat surface to form a disk held together by a glass ring, then reheated until the rounds fuse, bonding together. The resulting disk is cooled, then heated again and placed on a dome-shaped mold to shape it into a bowl. Varying the composition of the colored canes will result in murrhine works with all kinds of interior designs: stars, rosettes, even the silhouettes of animals or profile portraits. In Murano, starting in the 15th century, murrhine was also used to make objects of blown glass; in this case, the cane rounds placed next to one another were embedded in the molten mass. This technique spread from Venice to French glassworks and later to England and the United States. Paperweights filled with water were typical products of Bohemian and French production.

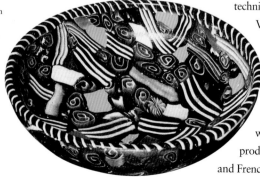

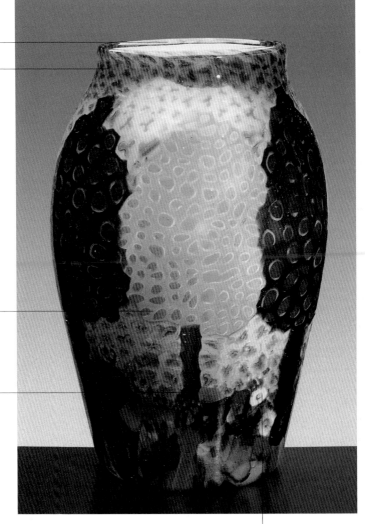

yer of lattimo
s encases the
rior of the vase.

murrina canes,
ed horizontally
bis composition,
e gathered and
edded in a layer
rystalline glass,
ch was then
wn into shape.
transparent
r is visible on the
erior of the vase.

e leafy
nches are
de of round
rrina canes,
iously colored.

e trunks are
de from a
tical glass-
e segment.

In this vase from 1920, the murrina canes were
arranged so as to create a landscape with trees and
flowers. The cane sections are clearly visible; here, a
white and yellow murrine has been shaped into a daisy.

Roman manufacture, Mosaic
wl, 1st century A.D. Murrhine
ss. Corning, Museum of Glass.

▲ Vittorio Zecchin, Barovier
Glassworks, Vase, 1920. Poly-
chrome murrhine and *lattimo*
glass. Private collection.

Filigree is a unique Venetian glassmaking technique that creates transparent objects run through with variously rolled or twisted strands.

Filigree Glass

In *filgrana* or "filigree" glassmaking, opaque glass canes, usually made of *lattimo* or colored glass, are embedded in clear glass. Instead of being used in sections, as in murrhine work, the entire length of the cane is used. Filigree glass, also known as *retortoli*, is a 16th-century invention of the Murano workshop of Bernardo and Filippo Serena. The process, registered in a document dated 1527, calls for preparing thin canes of crystalline glass containing spirals and strands of *lattimo* glass, either straight or twisted. The canes are placed on the stone marver, heated and gathered around a slightly blown mass of crystalline glass. The mass is rolled and "marbleized" on the stone until the canes are embedded in it; finally, the tips of the canes are joined and the excess is cut. Now the mass is ready to be blown again, either in free form or in a mold. As the glass thins out, the filigree design "swells," becoming light and delicate. This highly complex process yields airy decorative effects that do not disturb the neat, elegant forms of Renaissance glass.

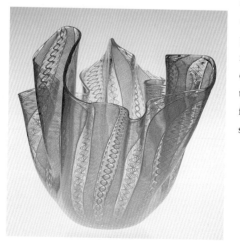

▶ Fulvio Bianconi, Venini Glassworks, Zanfirico-style "Handkerchief," 1949. *Retortoli* cane glass. Private collection.

In this large, ornamental plate, the cane segments containing twisted and braided strands of lattimo glass, swollen by the blowing process, are clearly visible. Each cane segment forms a section of the plate and presents a different motif.

Filigree plates have a sort of "navel" at the center bottom, which is visible: here the tips of the retortoli canes are joined together at the point where they were attached to the pontil rod; on the reverse of this "navel" is a slight depression.

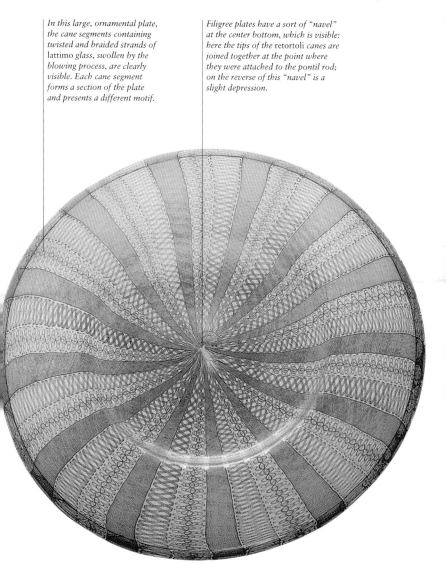

Murano manufactory, Plate, second half of the 16th century. *Retortoli* cane glass. Murano, Museo Vetrario.

A variant of filigree glass, reticello *is characterized by the regularity of the mesh pattern inside the object and the absence of gaps between the canes.*

Reticello *Work*

Raw Materials
Clear and colored glass

Tools and Supports
All those used in heat processing

Diffusion
From the Murano glass-works in the 16th century, *reticello* spread, starting in the following century, to many European glass-making centers.

Related Materials or Techniques
All the heat-processing techniques

Together with *retortoli* glass, another filigree process that resulted in extraordinary plates and artifacts was perfected in the cinquecento. *Reticello* is an even more complex technique that requires truly superior skills on the part of the glassmaker, who starts by preparing canes of crystalline glass containing just one, thin strand of *lattimo* or colored glass. The canes are placed on the marver; after they are heated, they are embedded in a partially blown mass of crystal glass. At this point, an assistant attaches a pontil to the opposite extremity of the mass and rotates it until a diagonal pattern appears. The mass is blown again and the mouth opened. Meanwhile, another identical mass, but with the canes facing in the opposite direction, is prepared and blown inside the first one, making sure that the walls adhere perfectly to each other, thus forming a mesh of slender diagonal strands. This done, the vitreous mass is shaped into plates, vases, pitchers, footed stands, and other objects.

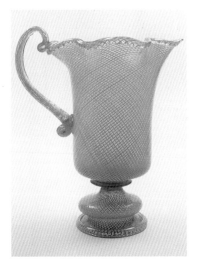

▶ Murano manufactory, Pitcher, end of the 16th century. *Reticello* glass. Murano, Museo Vetrario.

Each strand of lattimo glass is encased in a thin cane of clear glass. The cane segments are placed parallel to each other on the marver, a surface made of refractory stone.

The cane segments are gathered inside a molten mass of clear glass, which is then blown and rolled until the strands are all bent in the same direction.

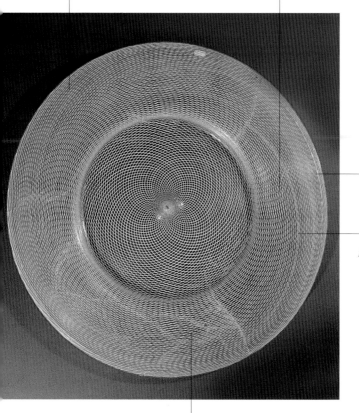

At the same time, another identical mass of glass, but with the canes facing in the opposite direction, is prepared and blown inside the first one after its mouth has been opened.

Once the reticello pattern is in place, the vitreous mass is blown once more, opened, and, as in this example, shaped into a plate.

Murano manufactory, Plate, second half of the 16th century. *reticello* glass. Bologna, Museo Civico Medievale.

Tiny bubbles are visible in each "stitch" of the mesh, for the air is trapped between the two layers of glass, although these artifacts are surprisingly thin.

Gold leaf is an ideal element for adding sparkle to the transparency of glass. Gold glass can be sgraffito-decorated, painted with enamels, or enriched with layers of clear glass.

Gold Glass

Raw Materials
Glass, gold leaf, greasy substances, enamels

Tools
Metalpoints for sgraffito, brushes, muffle kiln

Diffusion
This technique, practiced in pharaonic Egypt, was very popular in the Early Christian era. Rediscovered by Johann Kunckel, it was used by Bohemian craftsmen starting in the latter part of the 17th century and throughout the following century. Today it is still used to make decorative plates.

Related Materials or Techniques
Colored enamels, sgraffito, and glass grinding and polishing

Notes of Interest
Some 18th-century Bohemian drinking glasses decorated with *Zwischengoldglas* had double bottoms containing small objects such as ivory dice.

▶ *Portraits*, Roman or Byzantine medallion, 5th century A.D. Gilt blue glass with painted decoration. Brescia, Museo di Santa Giulia.

The terms "gold glass" and "golden bottom" refer to a type of decoration that was popular in the 3rd and 4th centuries A.D. for embellishing the bottoms of cups and drinking glasses, tableware, and luxury objects alike. The gold leaf encased between two layers of clear glass often bore inscriptions and was variously figured with portraits, scenes from the Old and the New Testament, legends, or pagan themes. The technique used at the time is still uncertain. Apparently, the gold leaf was applied to the outside, underneath the bottom of the object, then etched with thin metalpoints. The effect of sgraffito drawings on gold was heightened by filling some of the details with color. This decoration was then covered with a thin layer of clear glass that protected the gold from high temperatures; this done, the object was inserted and pressed into a second blown object that adhered to the decoration, and fused in the furnace. This delicate, complex technique fell from favor in later centuries until it was reintroduced by Johann Kunckel toward the end of the 17th century under the name of *Zwischengoldglas* (double-gilt glass). Bohemian craftsmen used the technique throughout the following century in applying gold to the bottom and the outside of glass objects.

Many of the late Roman glass bottoms that have survived were detached from their containers and walled into the lime used to seal burial niches in the Roman catacombs. For this reason, many of these fragile objects, which would otherwise have been lost, have survived.

The gold was applied to the outside of the object to be decorated and engraved with fine metalpoints. The decorated bowl or glass was then inserted and pressed into a second clear container and fused in a furnace.

The craquelé effect comes from the extreme sensitivity of the gold leaf to high heat, which is needed for the second melting.

It is thought that this type of object, before being placed in the furnace, was covered with a thin layer of ground glass having a melting temperature lower than that of gold leaf. The extra layer was apparently to protect the gold-leaf decoration from the heat during fusion; the complete process, however, is still not well understood.

"Traditio Legis," Roman medallion, mid- to late 4th century A.D. Gilt glass with sgraffito. Toledo Museum of Art (Ohio).

Gold Glass

This decorative technique was resurrected by Johann Kunckel in the latter part of the 17th century and took the name of *Zwischengoldglas*. It was used on potash-lead glass objects by Bohemian artists throughout the 18th century.

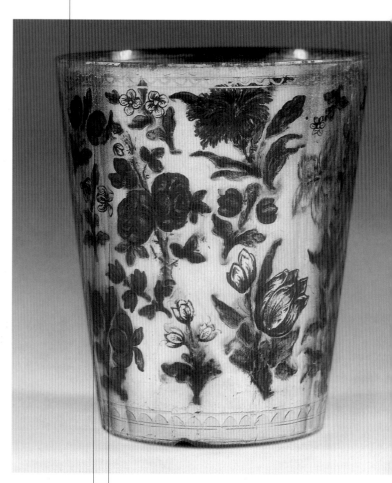

In the Bohemian technique, the gold leaf was applied with a greasy adhesive substance to the outside or the bottom of the glass. After being decorated, the gold was covered by a second identical object of blown glass that was fused to it, making a single object.

Lead-based glass has a much lower melting temperature than traditional soda-lime glass, thus allowing for more decorative freedom with gold leaf.

▲ Bohemian manufactory, Drinking Glass, 1720–30. *Zwischengoldglas* and enamel. Vienna, Wolf Collection.

On this small glass plate, the artist has made a modern adaptation of ancient techniques for decorating with gold. First he applied a coat of smaltite, grease, and oil of turpentine, which combine into a very sticky glue that is left to rest until, when touched lightly, it gives off a distinctive sound (known as "singing glass").

The plate was placed in a muffle kiln and fired at 530° C, a temperature at which the oils in the glue evaporate and the gold firmly fuses to the glass support.

The gold leaf, applied on top of the viscous layer, was etched with a needle and decorated with enamel.

▲ Marco Toso Borella, *Black King*, 2003. Painted gilt glass and sgraffito. Private collection.

Stained glass is a mosaic of multicolored glass panes; invented in the Romanesque period, it became the principal decorative element in Gothic cathedrals.

Stained Glass

The first step in making stained glass is the preparation of a sketch to lay out the images and color composition. This is followed by a cartoon made to the actual dimensions of the work. The cames, or grooved lead strips that will join the separate parts of the composition, are outlined on the cartoon. The latter is then transferred to a sheet of paper, which is used as a model. At this point, the cartoon is cut into its various segments to serve as guides for cutting the glass sections. There are two ways of preparing them: in the first, the vitreous mass, also known as "big drop," is blown into a bottle shape and cut into a cylinder, which is then cut open lengthwise and flattened; in the second, the mass, after being blown, is quickly rolled into a thin, large disk by two workers who

use two blowing irons simultaneously. The colored glass is then cut with red-hot irons (in the Middle Ages) or with a diamond point and marteline. For the leading, each section of colored glass is inserted into cames; since lead is a malleable metal, easily shaped, it is ideal for framing glass. The finished glass pane is applied to the window; large panes are further reinforced with an iron frame.

▶ German artist (Cologne), *Saint Stephen Preaching*, ca. 1300. Stained glass. London, Victoria & Albert Museum.

The making of stained-glass windows reached its zenith in the 13th century. In 1194 in France, the architects who began to rebuild Chartres Cathedral replaced the heavy bearing walls with slender pilasters, opening up large spaces which they filled with multicolored stained-glass windows.

Details such as hair, eyes, and drapery are outlined in grisaille, a ferrous oxide powder diluted in a solvent. Grisaille is applied with brush and water, vinegar, and a binder made of gum arabic or resin. Grisaille may be removed with metal-points or rough brushes to create subtle shading.

In Chartres Cathedral, the architect worked closely with the stained-glass artist, who tended to use very strong chromatic ranges.

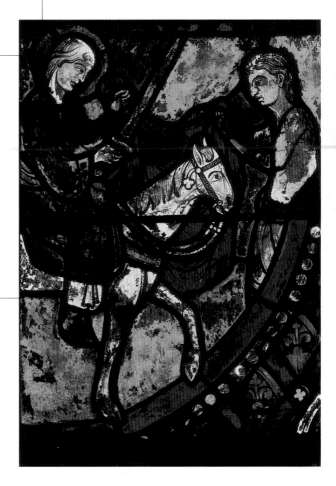

▲ *Saint Martin Dividing His Cloak with a Beggar* (detail), 1221–30. Stained glass. Chartres Cathedral, window in the south transept.

Stained Glass

In Italy, unlike France and England, it was customary for painters to prepare the cartoons for stained-glass windows. In this rose window, the composition recalls that of traditional frescos or paintings on wood.

Yellow with silver was used for the face of Jesus: a salt mixed with calcined yellow ocher, finely ground and diluted in water, the compound is applied to the areas to be made darker, and then fired. Thanks to this invention, some parts of the window consist of just a few panes of painted glass, brightened by luminous shadings with outstanding pictorial effects.

Fourteenth-century stained-glass windows were even larger than earlier ones, and used lighter, more luminous colors.

▲ Andrea di Bonaiuto, *Coronation of the Virgin*, 1365. Stained glass. Florence, Santa Maria Novella, rose window.

The panes were cut into rather large, regular segments; the different colors, instead of being made from variously colored pieces of glass, are painted on clear glass with transparent enamels.

Bertini's stained-glass windows belong to a 19th-century revival movement; the artist was active in Milan in the period when the stained-glass windows of the cathedral were being studied and restored.

The general effect is Gothic: the artist used elements of Gothic art interpreted in a purist style.

Glass painted with enamel does not allow the light to filter through as colored glass does: for this reason, this window is less luminous than the medieval ones.

Pompeo Bertini, *Dantesque Window*, 1853. Stained glass. Milan, Museo Poldi Pezzoli.

This cartoon was made in 1892 for a stained-glass window executed by Louis Comfort Tiffany in about 1895. Toulouse-Lautrec was inspired by a study he made on site in a Paris nightclub.

All the elements of the stained-glass window are present in this cartoon, the colors as well as the shape of each segment of glass.

▲ Henri de Toulouse-Lautrec, *Au Nouveau Cirque: La clownesse et les cinques plastrons*, ca. 1892. Preparatory cartoon for a stained-glass window. Philadelphia Museum of Art.

Louis Comfort Tiffany was the leading exponent of
Art Nouveau glassmaking in the United States. He had
an extraordinary success at the Universal Exposition
in Paris, where he introduced new kinds of opalescent,
rainbow-hued glass that were unknown in Europe.

is type of glass,
ed with tiny
riegations and
eckles, imitates
changing
vement and
t texture of
fabric.

Louis Comfort Tiffany, *Au Nouveau*
rque: Papa Chrysanthème, ca. 1895.
ined-glass window in favrile glass.
ris, Musée d'Orsay.

The sinewy, Japonais-inspired lines, typical
of the art of Toulouse-Lautrec, define the
movement of the lead-strip outlines.

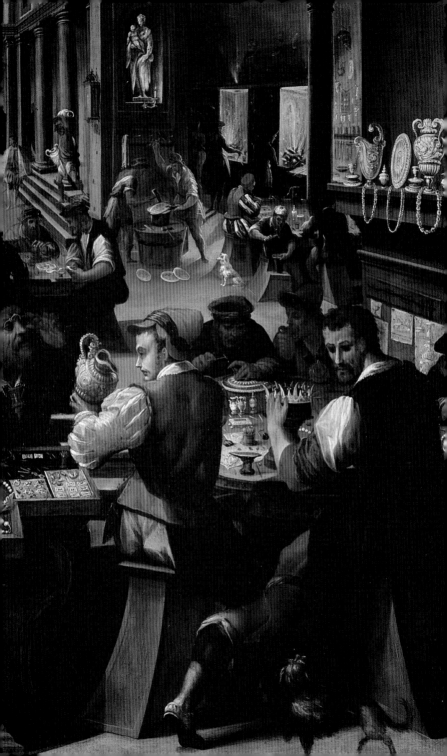

METALWORK
AND JEWELRY

Gold
Silver
Diamonds
Pearls
Gems and Semiprecious Stones
Rock Crystal
Amber
Coral
Unusual Materials
Incised Gems
Cameos
Repoussé (Embossing)
Chasing
Opus Interrasile
Casting
Filigree
Granulation
Enamel
Niello
Damascene

Alessandro Fei, *The Goldsmith's*
op (detail), 1570–72. Florence,
lazzo Vecchio, studiolo of
ancesco I de' Medici.

Gold

"*Moreover King Solomon made a great ivory throne, and overlaid it with the finest gold. . . . The like of it was never made in any kingdom*" (*1 Kings 10:18–20*).

Raw Materials
In its natural state, gold is alloyed with silver, tellurium, palladium, or small quantities of other rare materials. The carat of the gold alloy refers to the percentage of fine gold in it.

Tools
Sifters, furnace, crucibles, molds, wheels to grind the gold-bearing metals

Diffusion
Gold began to be processed between 3000 and 2000 B.C.

Related Materials or Techniques
Used in fine metalwork with all metals and all precious stones; in glass and maiolica, as decoration or component (such as in ruby glass); in sculpture; and in all the painting techniques

In all ages gold has been considered the most precious of metals because of its unique qualities: its brilliant yellow color and, in its original state, its incomparable permanence and malleability. This last quality makes it possible to make gold leaf less than one micron in thickness and a gold wire 3200 meters long with just one gram of gold. Furthermore, gold does not oxidize, and it is impervious to most acids. The metal is found in streams that carry the auriferous sand downstream; it is also found in rocks. In both cases, gold in its original state is not chemically pure but is alloyed with other metals, such as silver (with which it forms a natural alloy that was known to the ancient Romans as *electrum*), tellurium, palladium, and tiny quantities of other rare metals. In antiquity, auriferous deposits existed in Egypt, Ireland, Spain, the Austrian Alps, Macedonia, Anatolia, and some areas of the Italian Alps.

Gold becomes separated from alluvial sand through the action of water, which washes away the siliceous components, separating them from the gold fragments that are many times heavier. This procedure was also used with crushed and finely ground auriferous rocks. Silver and copper can be mixed with gold either by melting them together or in a solid state, and in all proportions.

The malleable, ductile quality of gold makes it the metal of choice for elaborate creations of great refinement: the handles of this bowl bear imaginary creatures decorated with tiny, perfect spheres, fashioned by means of granulation.

Gold is immune to corrosion by external agents or common acids; for this reason, the gold objects found in excavated tombs are in a perfect state of conservation and retain all their suggestive splendor.

ınerary Mask of Tutankhamon,
ıtian, 18th dynasty, ca. 1336–1327
Gold, semiprecious stones, and
ıels. Cairo, Archaeological Museum.

▲ Kotyle (Two-handled Cup), Etruscan, from the Bernardini Tomb, Palestrina, 675–650 B.C. Gold plate and granulated gold. Rome, Museo Nazionale Etrusco di Villa Giulia.

Silver shares with gold the quality of being ductile and malleable, which makes it suitable for stamping and punching for centuries it was used to coin money.

Silver

Raw Materials
Silver is alloyed with lead, sulfur, and other materials in small quantities.

Tools
Furnace, sifters, wheels to grind silver-bearing minerals, crucibles, and cupels

Diffusion
The exact time or place when silver began to be used is unknown. The earliest silver materials date from about 3000 B.C. Silver was rare in Europe until the 16th century, when deposits were discovered in South America.

Related Materials or Techniques
Metalwork: with all metals, precious and semiprecious stones, and with all techniques
Ceramic: for luster decoration
Painting: silver foil may be used as decoration instead of gold foil
Stained glass: silver yellow is used in windows to modify colors

Like gold, silver is only rarely found in its pure or crystalline state; usually it is extracted from metal-bearing minerals such as galena. In ancient times, this silver-bearing mineral was collected from alluvial deposits or mined underground. After being selected and crushed, the mineral is floated in running water, where its dense weight causes it to sink to the bottom while the waste is carried away by the water. To extract the silver, the mineral is placed in large melting pots set in furnaces. This first melting yields ingots of silver-bearing lead that are ready to be refined through a basic process called "cupellation," in which the ingots are kept for a certain length of time in the melting pot, or "cupel," until the silver sinks to the bottom. This system allows for the removal of pure lead from the surface; the gradual addition of more unrefined lead increases the volume of silver that is deposited at the bottom. When the cupel is sufficiently full of silver, the temperature is raised to the melting point for silver (960° C). Finally, a strong influx of air causes the uppermost layer of lead to oxidize and change into litharge, a sort of slag that is ultimately eliminated, allowing the natural brightness of the silver to shine through.

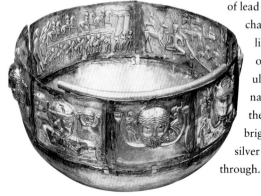

The figure in the center holds a large melting pot that contains the crushed minerals that will go into the furnace for the first melting.

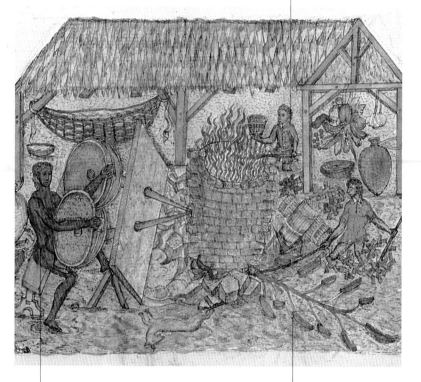

A slave operates the bellows to keep the fire going.

The silver-bearing mass of molten lead flows into the molds that will shape it into ingots.

Danish silversmith (Gundestrup), ʊldron, 1st century B.C Embossed er. Copenhagen, Nationalmuseet.

▲ French artist, *Furnace for Melting Silver*, second half of the 16th century. Watercolor drawing. New York, Pierpont Morgan Library.

Diamonds are the most precious and the hardest of all gems; whether simply polished or faceted in the brilliant cut, they have always been a symbol of luxury and wealth.

Diamonds

Raw Materials
Carbon

Tools
Diamond point and powders, mastic to set the stone to a supporting surface for cutting, measuring calipers, lathe and dop, metal clamp, cast-iron lap, cleaving mallet, steel wedges, box for collecting diamond powder, laser

Diffusion
From antiquity until the 18th century, India was the only producer of diamonds in the world; since then, mines have been discovered in Brazil, South Africa, Australia, and Russia.

Related Materials or Techniques
All the metalworking techniques

Notes of Interest
In 1978, a large natural diamond was used to make a porthole on the Pioneer space probe launched toward Venus, to protect the scientific instruments from adverse conditions.

▶ *The Regent*, 1701. Diamond weighing 136 carats. Paris, Musée du Louvre.

The diamond occupies a unique position in the history of mankind; for millennia, it was the most coveted and prized of all gemstones. Its purity, brilliance, and hardness make it a symbol of eternity and strength. Diamonds form at great depths in the earth by magmatic gases acting on carbon elements at enormous pressure and extremely high temperatures. The mineral thus formed in the abyssal rocks is moved toward the surface of the earth and dispersed along with other minerals by the pressure of magmatic movements. The diamond consists entirely of carbon, arrayed in a hexa-octahedron. In addition to the colorless diamonds, those tinged with yellow, green, blue, pink, or red are used as gemstones, while the opaque (*bort*) and black (*carbonado*) varieties are used industrially; recently the black diamond has been used in jewelry. In their rough state, diamonds appear opaque and not very attractive; proper cutting makes them glitter and sparkle, thanks to their high refractive power and the strong dispersion of light, which gives them their unique "fire." Ancient peoples did not know how to work diamonds and simply polished

them. The first cutting experiments began in the 15th century; the plain "rose" cut dates from about 1520; a century later, the "triple brilliant" cut with 58 facets was perfected after a long evolution in cutting techniques.

These diamonds are set in an "open" gold mount that leaves the backs of the stones free, enhancing their transparency.

This jewel is completed with enamels and colored gemstones (rubies and emeralds).

Some diamonds of this Indian jewel were cut in a flat rose cut known as the "Moghul cut."

Some diamonds are cut in the shape of a drop and are simply shaped and polished.

ndian jeweler (Rajasthan), Sarpench
nament for a turban, 17th or 18th
tury. Gold, diamonds, rubies, emer-
s. Private collection.

This etching depicts an
18th-century diamond-
cutting laboratory.

A worker prepares the
polishing wheel with a
layer of oil and diamond
powder.

A third workman is girdling
a diamond by rubbing it
against another diamond.

Another laborer is working the
pulley that turns the large
wheel and the grinding wheel.

▲ *A Diamond Cutter's Shop*, 1748–72.
Engraving from the *Encyclopédie* by
Diderot and d'Alembert, Paris, 1767.

▶ Johann Staff, *Order of the Golden
Fleece*, 1765. Gold, white diamonds
lined in pink. Munich, Schatzkamme
der Residenz.

These gems are rose diamonds lined with a pink-tinted foil to enhance their color. The use of foils at the bottom of the gemstone mountings was prevalent in the 16th century, and was even described by Benvenuto Cellini.

is extraordinary ndant made for aximilian III eph, Elector of varia, is an elo- ent example of velry from the th century, a riod known as the ge of a thousand es" because of the eat, widespread ssion for diamonds at, like the clothing bions of the era, nbolized wealth d vivacity.

e pendant is vided into three gments, each with eparate motif: m the topmost, a re, two flaming ngs are suspended, d from them, the olden Fleece.

According to an Indian legend, pearls are born from the embrace of seawater and moonlight inside the chamber formed by an open oyster.

Pearls

Raw Materials
Calcium carbonate and conchiolin

Tools
For fishing: ballast, leather fingerstalls to protect the fingers, and a basket
For cultivation: metal cages, tanks

Diffusion
The use of pearls is ancient but its origins are poorly understood.

Related Materials or Techniques
Gold, silver, enamels, precious stones, and all the jeweler's techniques

Notes of Interest
Julius Caesar sent a pearl valued at six million sesterces to the mother of Brutus. In the Nazar Bagh Palace in India is a rug made of pearls with borders encrusted in gemstones. The largest pearl in the world is the Pearl of Asia: weighing 600 carats, it is shaped like an eggplant and mounted with rose jade and pearls.

Pearl-producing oysters are a variety of lamellibranch bivalves of the *Meleagrina* genus; there are four major species of *aviculidae* (pearl oysters): *margaritifera, martensi, vulgaris,* and *californica.* The first inhabits the seas of New Guinea, New Caledonia, Australia, and Ceylon; the second and third species live in the seas of Japan, the Indian Ocean, the Red Sea, and the Persian Gulf; the fourth thrives in the seas of Central America. Normally, these mollusks are found in banks at a depth of about 15–20 meters. The body of the mollusk inside the shell is shrouded in a "mantle" formed by an epithelium that secretes a substance that hardens to form mother-of-pearl. Mother-of-pearl consists of very thin, transparent calcareous layers alternating with a protein known as conchiolin. When the mollusk opens its valves to get nourishment, any foreign body that enters it—most commonly a grain of sand—is surrounded by the secretion; this gradually forms the pearl. Pearls

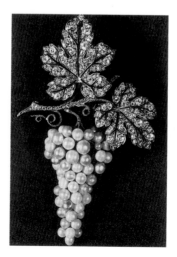

come in different shapes: round, button, pear, or irregular (known as gibbous or baroque). Colors vary from white to rose, yellow, gray, black, sometimes even green or purple, depending on the coloring pigments of the conchiolin. Until recently, pearls were fished by trained divers who could remain under water for up to eighty seconds; today most pearls are cultivated.

Queen Elizabeth I loved pearls so much that she literally covered herself with them, from her coiffure to the embroidery on her gowns.

This rich, heavy gown is embroidered with gemstones, solitaire pearls, and pearls mounted with gold or enamels. Not all the pearls worn by the queen were real: some, like the ones appliqued to this gown, were made of alabaster coated with mother-of-pearl powder (they were known as "Roman" pearls).

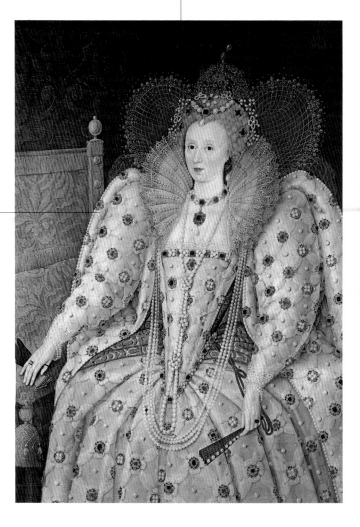

◄ Van Cleef and Arpels, Pin with Cluster of Grapes, 1895–1900. Gold, silver, diamonds, and pearls. Private collection.

▲ English school, *Elizabeth I of England*, ca. 1600. Florence, Palazzo Pitti.

Gemstone decorations were added to make this object even more valuable.

The neck and head of the ostrich are in gold and white enamel.

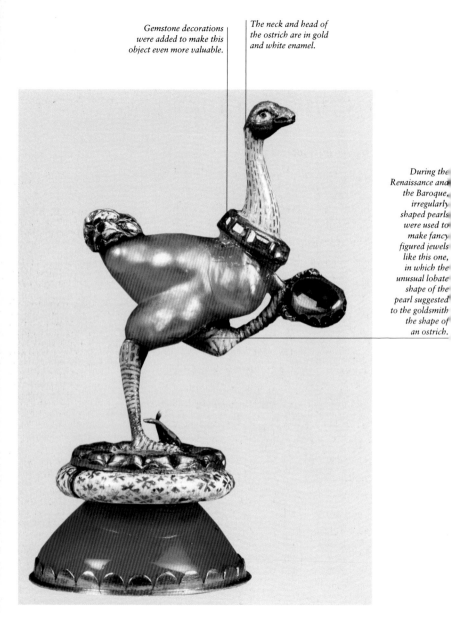

During the Renaissance and the Baroque, irregularly shaped pearls were used to make fancy figured jewels like this one, in which the unusual lobate shape of the pearl suggested to the goldsmith the shape of an ostrich.

▲ Flemish jeweler, *Ostrich*, 1570–80.
Gold, baroque pearl, enamels, precious
stones. Florence, Museo degli Argenti.

► German goldsmith, Cross of
Lothar, ca. 1000. Gold, precious
stones, cloisonné enamel, and
cameo. Aachen, cathedral treasury.

'Why do you need carved agates / So many lovely rubies, so many rich diamonds? / Your beauty alone is your ornament"
'Pierre de Ronsard, 16th century).

Precious and Semiprecious Stones

Some mineral substances are favored for use in jewels and ornaments due to structural characteristics such as color, transparency, brilliance, hardness, and rarity. These minerals are generally divided into three groups: precious (gems), semiprecious, and hard stones. The precious stones, of which the diamond is one, are very hard and sparkling; they include the ruby, the sapphire, and the emerald—all members of the corundum family. Semiprecious stones are not as rare as the former: they usually have a crystalline, transparent structure and include tourmaline, amethyst, topaz, and many more. Non-transparent minerals with a dense, variegated, or layered structure are usually classified in the hard stone family: they include chalcedony, onyx, malachite, agate, and noble stones such as turquoise and lapis lazuli. The use of precious stones has a long and fascinating history dating back to the 3rd millennium B.C. in the Indus Valley, home to many gems, including carnelian, steatite, agate, jasper, and amazonite; women there used them to fashion wide belts to wear on their naked bodies.

The techniques for piercing and polishing stones were born in Asia. Also noteworthy are the Egyptian jewels and the refined intaglio work of the Roman world. Gemstones imported from faraway places held a special place in medieval and Renaissance jewelry-making and continue to do so today.

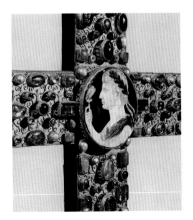

Raw Materials
Various

Tools
Points, chisels, grinding wheels, drills, diamond points, clamps, pincers, calipers

Diffusion
Since the 3rd millennium B.C.

Related Materials or Techniques
Gold, silver, platinum, pearls, and all the jeweler's skills. In painting, blue lapis lazuli powder is used. In antiquity, the powders of some stones were used for healing purposes: emerald powder was an antidote to poison, and aquamarine powder was used to treat sores.

Notes of Interest
The book of Exodus describes twelve precious stones, arranged in four rows of three, set into the breastplate of the high priest; they included sardonyx, topaz, jasper, carnelian, agate, and jade. Twelve stones were chosen as "reminders of the sons of Israel," the Twelve Tribes (Exodus 6–15).

This star-shaped pin, the work of a
northern Italian goldsmith, was
found inside the tomb of Cangrande
della Scala in Verona.

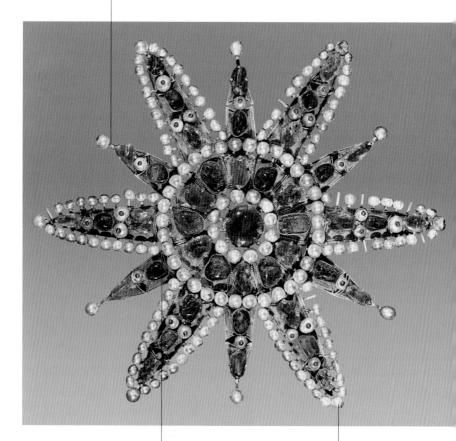

The star is covered entirely with
emeralds and amethysts cut in the
rounded cabochon style and set on
the gold support with bars and clips.

The precious stones
are surrounded by
pearls, each one set
on a single pin.

▲ North Italian goldsmith, Star-
shaped Pin, mid-14th century.
Gold, gemstones, and pearls.
Verona, Museo di Castelvecchio.

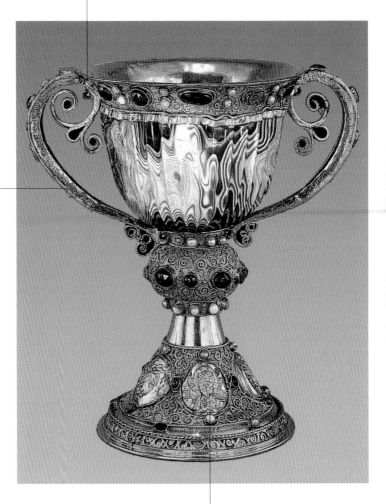

In addition to jewels for personal decoration, gems and hard stones were also used to make extraordinary sacred as well as secular objects that filled the treasuries of courts and cathedrals. In the 12th century, Abbot Suger of Saint-Denis owned a fabulous collection of precious sacred objects that symbolized the light and omnipotence of God.

The ribbed cup is made of Egyptian sardonyx and dates from the 2nd century B.C.

▲ French goldsmith, Chalice of Abbot Suger of Saint-Denis, 1137–40 (mounting), 2nd century B.C. (cup). Egyptian sardonyx, gold, and precious stones. Washington, D.C., National Gallery.

The gold mounting is decorated by very fine, filigreed scrolls that enclose chased medallions around the foot of the chalice.

This incense burner is made of nephrite, which looks softer than jadeite and has an almost "oily" appearance; jadeite is colder and more vitreous.

Jade is an important stone found primarily in China. There are two types of jade, outwardly similar but possessing different chemical structures: nephrite is the more common, jadeite the more prized and ancient.

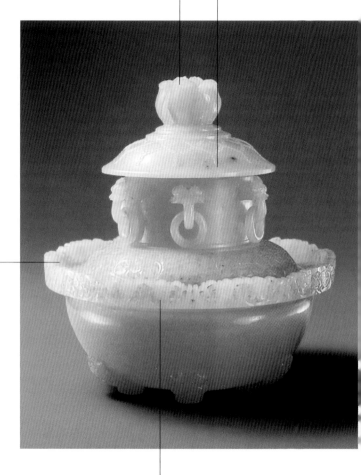

Nephrite is found in several colors: white, green, and black.

Jade is a very hard stone that requires a time-consuming process to shape it. Grinding wheels and drills are used, in addition to abrasive powders (quartz and garnet) mixed with oil or water to facilitate the cutting and fine polishing.

▲ Incense Burner, Chinese, Qing dynasty, second half of the 18th century. Nephrite. Taipei, National Museum.

This Indian necklace from the end of the 19th century was made using ancient techniques.

All the precious stones are set in a "night" mounting, meaning that it is closed in the back.

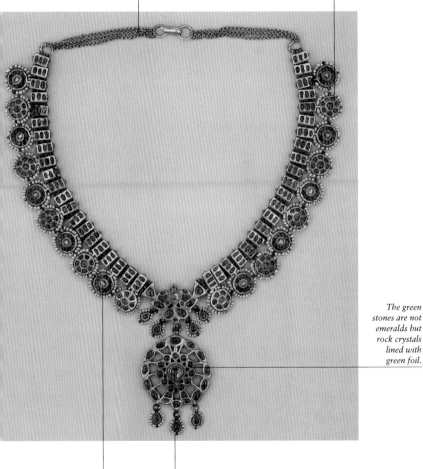

The green stones are not emeralds but rock crystals lined with green foil.

The rubies were simply polished, without facets, and left in their original shape.

Cabochon diamonds are set in the center of the round motifs.

▲ Indian goldsmith, Necklace, end of the 19th century. Gold, rubies, diamonds, and rock crystal. New York, Metropolitan Museum of Art.

"It was believed that nature generated it from pure water as a result of a deep, perennial frost" (Vannoccio Biringuccio, 1540).

Rock Crystal

Raw Materials
Quartz

Tools
Grinding wheels and rotating drills, chisels and small hammers, diamond point, diamond and corundum powder diluted in oil

Diffusion
Used in Europe since the earliest times until the end of the 17th century. The following artists were specialists who worked in rock crystal: Valerio Belli (1468–1546), Gian Giacomo Caraglio (16th century), Giovanni dei Bernardi (1496–1553), Annibale Fontana (1504–1587), and the Milanese workshops of the Saracchi (16th century) and the Miseroni (17th century).

Related Materials or Techniques
Gold, enamels, precious stones

► Ewer of Caliph Al-Aziz-Billah, 975–996 (ewer), 16th century (mount). Rock crystal and gilt silver. Venice, San Marco, treasury.

One of the most admired materials in antiquity was rock crystal. A colorless quartz, it was extracted from Alpine moraine deposits in the 16th century and therefore Biringuccio believed that such a transparent material could be produced only in the deep frost of glaciers. Rock crystal was used in ancient Egypt and the Roman world for cups, ewers, and other objects, and in the Carolingian age, for church furnishings. Vases, pouring vessels, and smooth or cut bowls were fashioned from rock crystal in the Islamic world; the finely cut artifacts from the Fatimid dynasty (10th–12th centuries) are noteworthy. In the 14th century, Venice became an important center for working and exporting rock crystal to all

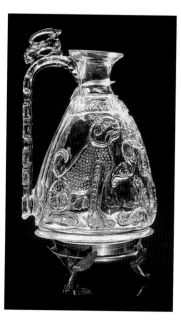

of Europe, especially Germany, where diamond-point decoration on it was perfected. The most brilliant periods of rock-crystal art were the Renaissance and the Baroque, particularly in Italy. This art slowly lost favor as lead-crystal glass became available. Created at the end of the 17th century specifically to imitate transparent rock crystal, lead crystal became the preferred material for expensive glassware and prized decorative objects.

This casket is decorated with more than twenty intaglio plates that narrate the story of Jesus.

This renowned casket, preserved in the Museo degli Argenti in Florence, was made for Pope Clement VII between 1525 and 1532.

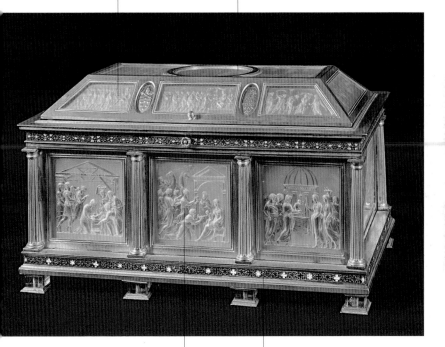

The technique employed by Valerio Belli to make these plates is similar to that used in cameo work: relief incisions are made with grinders or wheels of different sizes and hardness, with the help of abrasive powders such as diamond powder diluted in olive oil.

The cold purity of the crystal is perfectly suited to the severe Renaissance style. Here and in other works, Belli added a colorful note with the skillful use of colored enamels that enclose, as if in a frame, the architectural form of this box.

Valerio Belli, Casket, 1525–32.
Rock crystal, gilt silver, enamels.
Florence, Museo degli Argenti.

Amber is the most important organic substance used for jewelry. Its transparency and warm color make this resin perfect for jewelry and small sculptures.

Amber

Raw Materials
Fossil resin from coniferous plants

Tools
Blades, small drills, grinding wheels for intaglio, and lathes

Diffusion
From the Baltic seacoast, where it was collected land worked from time immemorial, it spread to all of Europe. Major resin-processing centers are in northeast Germany and in Poland.

Related Materials or Techniques
Gold, ivory, hard stones. Powdered amber dissolved in water was used as a varnish in paintings.

Like ivory and coral, amber is a natural, non-mineral material used in jewelry-making. The fossil resin of the conifer *Pinites sucinifera*, amber is found in lumpy blocks in lignite mines formed by primeval forests, especially along the Baltic seacoast. Amber also detaches itself naturally from the bottom of the sea and washes up on beaches. Amber is found in Myanmar and Romania, and in Sicily a fluorescent type of amber called simetite is found. The ancient Greeks called this substance *elektron* (shining thing); to the Romans it was known as *sucinum*, from *sucus* (juice). Amber's prized quality is its softness (1.5–3.0 on the Mohs scale); for this reason, it has been used since prehistoric times for jewels and arrowheads. For millennia, the use of amber was limited to the Baltic regions and to Continental Europe, being almost unknown in the Mediterranean basin. Even in the Middle Ages, the processing of this precious resin was the monopoly of the Baltic Germanic coastlands, and for a long time—until the 18th century—amber objects such as cups, tankards, reliquaries, veneered boxes, and finely shaped and carved statuettes came from Germanic lands or from Poland. In the 19th century, a technique for heat-stamping amber was discovered, making industrial production of amber objects easier, to the detriment of quality. Today, amber is used for fine jewelry as well as costume jewelry, though an artificial resin is mostly used for the latter.

▶ Northeast Germany, Fountain, ca. 1610. Amber and bronze. Florence, Museo degli Argenti.

Coral, the calcareous skeletons of marine animals, comes in many colors, from white and dark red to pale pink; its branches are dried and worked into jewelry and fine objects.

Coral

Coral consists of colonies of small polyps that secrete a calcareous substance, which forms the skeleton structure of the branches; when removed from the water, the branches dry and reach a hardness of 3.5–4.0 on the Mohs scale. Coral has been made into jewelry since antiquity (Mesopotamia and Egypt). Since remote times in India, a large producer of coral, it has been used for personal adornment. For the European market, coral has been fished from banks off the coasts of Sicily, Tunisia, and Libya. A special apparatus is needed to fish coral: it consists of two long beams mounted in the shape of a cross and loaded with ballast at the cross point. Iron hooks embedded in a tangle of nets are located at the ends of the beams. When this gear is lowered into the sea and pulled, the hooks break the coral branches, which are then caught in the nets.

Working coral is time-consuming; once the carving is done, the coral is polished with emery powders mixed with water. Dark red, red, pink, angelskin (pale pink, a highly prized color), and white coral are used in jewelry. A rare variety of blue coral is fished off the coast of Cameroon.

Raw Materials
Calcium carbonate and other minerals

Tools
Fishing gear, grinding wheels, drills, small chisels, blades, metalpoints, abrasive powders

Diffusion
All over the world. Coral is fished in the Red Sea and the Mediterranean, and off the coasts of Africa and Japan. In Italian waters, small quantities are found near Torre del Greco and Trapani, where the art of carving coral has flourished since the 16th century.

Related Materials or Techniques
All precious metals and stones used for jewelry

Notes of Interest
In Japan, until the end of the 19th century, coral was believed to be sacred and was not cut.

◀ Mirror, ca. 1550. Composition with coral, pearls, mother-of-pearl, and lapis lazuli. Innsbruck, Ambras Castle.

Coral

Some pieces of this matching set recall Roman
jewelry, such as the small heads carved in
relief. There are modern elements as well, such
as the rectangular links of the bracelet.
Together they form an unusual mixture of
styles typical of 19th-century eclectic taste.

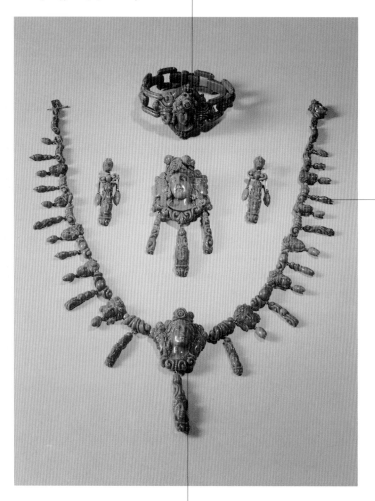

In the 19th
century, coral
enjoyed newfound
popularity, first as
jewelry of the
lower classes, later
also in important
parures, or jewelry
sets, such as this
one, crafted in
Torre del Greco,
near Naples.

▲ Torre del Greco jeweler, Parure,
1850–60. Mediterranean coral,
gold. Torre del Greco, Antonino
de Simone Collection.

Coral may be carved like any
other precious stone; however, it
is a labor-intensive process that
requires skilled craftsmanship.

In addition to fashioning precious materials, jewelers also made use of unusual materials that suggested faraway places and often reflected the taste of an age.

Unusual Materials

Since the birth of modern collecting in the 16th century, collectors have sought archeological and natural objects, paintings, and sculpture, as well as exotic pieces of the jeweler's art. These charming creations of gold and gems frame rare materials or objects, and include coral branches mounted with shells and pearls, or ostrich eggs, nautilus or coconut shells transformed into cups and set in fancy shapes and precious materials. Such objects were often housed in so-called *Wunderkammern*, "rooms of wonder," where objects were assembled to amaze the visitor and to satisfy the collector's curiosity and taste for beauty. Depending on the fashion of the time, unusual materials were incorporated into precious furnishings and personal ornaments alike: the earliest and best known material is ambergris, a strongly perfumed, blackish paste used in the 15th century to fashion beads for hair ornaments and long necklaces. Starting in the 17th century, materials such as iron, aluminum, grès, and lava stone, carved in relief, were added to elaborate jewelry. In the 19th century, human hair for necklaces, jet (petrified wood), and *uandong* (seeds of an Australian plant) were among the unusual materials associated with Victorian "mourning jewelry."

Raw Materials
Various materials

Tools
All the tools used in engraving and metalworking

Diffusion
Materials such as shells have been used decoratively since remotest antiquity, although a taste for the rare and curious has been documented only since the 16th century.

Notes of Interest
One unusual material found in some *Wunderkammern* is bezoar, a variegated, irregular "stone"; it is actually a gastric stone formed in the intestines of a particular kind of Asian goat. Some bezoars made into cups and mounted in gold are conserved at the Kunsthistorisches Museum, Vienna.

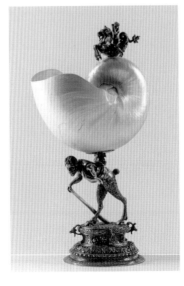

◀ Cornelis de Vriendt, Cup, 1548–77. Nautilus shell and gilt silver. Lugano, Thyssen-Bornemisza Foundation.

In this unique creation, ambergris was modeled into a small sculpture and dried, mounted in gold, and decorated with enamels and gemstones. This type of ornament was made in Italy, particularly in Lombardy, during the Renaissance.

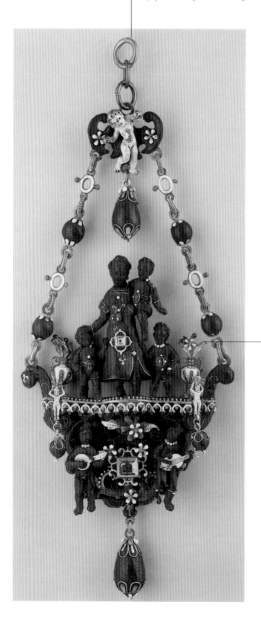

This pendant is a rare example of a perfumed jewel, being made of ambergris, a soft substance secreted by the sperm whale. Ambergris was usually shaped into beads to be used in long necklaces, a fact documented in many 15th- and 16th-century paintings.

◀ Italian jeweler, Pendant, end of the 16th century. Ambergris, gold, enamels, precious stones. New York, Metropolitan Museum of Art.

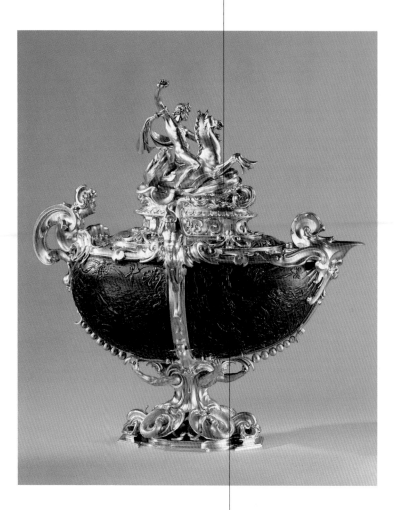

The elaborate figural mounting of cast silver transforms an empty coconut shell from the Seychelles Islands into an amazing, precious object.

The central portion of this decorative ewer is covered with delicately carved reliefs; their dark chocolate color provides a striking contrast to the rich gold and silver of the figural ornament.

▲ Anton Sweinberger, Decorative Ewer, 1602. Carved Seychelles coconut shell, cast silver, partially gilded. Vienna, Kunsthistorisches Museum.

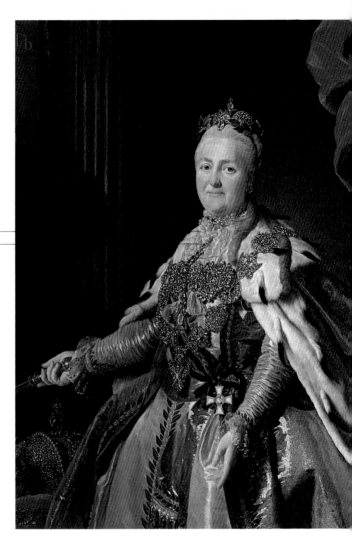

In this portrait of
Catherine the Great,
the Russian empress
is wearing a bulky
steel parure, or
jewelry set.

The steel was
worked into faceted
studs and polished;
the studs were then
set one next to the
other to heighten the
sparkle of the metal.

▲ Unknown artist, *Catherine of Russia*
(detail), 1780–90. Oil on canvas.
Vienna, Kunsthistorisches Museum.

These jewels have been crafted from jet, a kind of
petrified wood used in the 19th century to make
austere mourning jewels—the only ones that a
widow was allowed to wear for at least one year.
Here the jet was cut into small, classically inspired
medallions but was left opaque and unpolished.

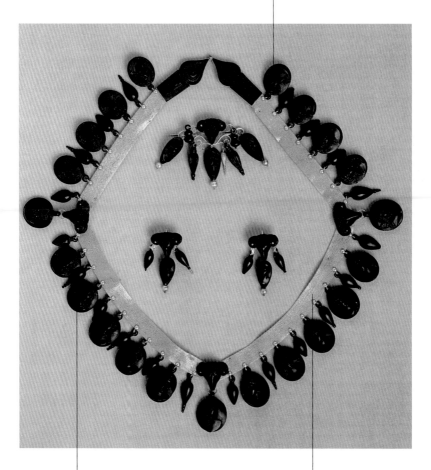

This jewelry set is an example of
"archaeological jewelry," inspired
by ancient pieces discovered in
contemporary excavations.

The pendants are
joined together by
a wide ribbon of
woven gold wire.

▲ Attributed to Fortunato Pio
Castellani, Parure, ca. 1850. Gold
and jet. Milan, Museo Poldi Pezzoli.

Incision is the most ancient of gem-decorating techniques. Incised gems were used as distinctive seals to mark documents in societies where few knew how to read or write.

Incised Gems

Raw Materials
Hard and semiprecious stones

Tools
Stone or metalpoints used as chisels; drill

Diffusion
From the 3rd millennium B.C. Incised gems in the classical style reappeared in the Renaissance, together with cameos; the gem collection of the Medici family, now conserved at the Museo degli Argenti in Florence, is noteworthy.

Related Materials or Techniques
In the Middle Ages, antique incised gems were set in jewelry of gold and precious stones. An example of this type is the Cross of Desiderius, conserved at the Santa Giulia Museum in Brescia.

Notes of Interest
The city of Ur, in Mesopotamia, was identified thanks to an inscription incised on a gem.

Incision is the earliest known technique for decorating gems: the surface of the stone is cut into different shapes using points made either of metal or hard stone; usually corundum or diamonds are used, since they are the highest on the Mohs hardness scale. The use of stone points to incise gems was known before the Iron Age. Until the Hellenistic period, incising was done in the negative, and the incised cut filled an important function: in addition to being decorative, it could be used as a seal to impress an image on clay or wax. Seals were either flat or cylindrical; in the latter case, the impression was made by rotating the cylinder to produce a horizontal impression. The high quality of the miniature work, usually done on very small stones, demonstrates the amazing skills of the ancient glyptic artisans. Incised gems were made in large quantities into the Hellenistic period and in Rome until the end of the empire.

The practice declined in the Middle Ages, but antique incised gems, as well as cameos and other mementos of ancient Rome, were preserved and inserted as valuable objects in the jewelry pieces of succeeding ages.

This handsome carnelian with the profile of Girolamo Savonarola was carved in relief.

The delicate, natural nuances of color, visible in the transparency of the stone, were used by the artist as points of light on the head and the drapery.

The definition of the profile is extremely delicate. This portrait was made on a stone only four centimeters high.

The drapery folds are defined by minute variations in depth and were carved with a rotina, a small cutting disk.

◄ *Head of an Empress*, A.D. 272. Intaglio on jasper, set in a gold ring. St. Petersburg, Hermitage.

▲ Giovanni delle Corniole, *Girolamo Savonarola*, ca. 1400. Intaglio on carnelian. Florence, Museo degli Argenti.

Cameos, invented by Alexandrian craftsmen in the Hellenistic period, consist of an image carved on a hard stone that has natural layers of different colors.

Cameos

Until the Hellenistic period, gem intaglio was done in the negative, even on stones that were not used as seals. Later, gems began to be cut in relief as skilled Greek artists exploited the stratified, multicolored structure of stones such as agate and sardonyx to achieve chromatic, nuanced effects between figure and ground, or face and hair, in elegant, suggestive scenes and portraits. Working on cameos is more difficult than carving other gems and requires a superior, mature technique: incisions are made with cutting or grinding wheels of different sizes and hardness appropriate to the type of the stone. Greek and Roman cameo portraits and mytho-logical scenes exhibit extraordinarily fine craftsmanship and realism; though minute in size, the images possess the same refined details as the larger sculptures of the time. Though cameo work faded out completely in the Middle Ages, ancient cameos were reused by setting them in contemporary jewelry, thus documenting the continuity of the great classical tradition.

This large (11.5 cm) "parade" cameo was made using an eleven-layered onyx.

With supreme skill, the Alexandrian artist took advantage of each contrasting layer of color to achieve unique polychrome effects.

A lighter layer that was removed to bare the underlying ones is visible around the border of the helmet.

The lightest tone, used for the faces, is an unusual, azure-tinged white; note how an extremely fine, transparent uppermost layer was left in place to color the lips of the foreground figure.

Note the extreme delicacy of the chromatic passage from the darker helmet to the cheek protector decorated by a light-brown sheaf of thunderbolts.

◄ Tazza Farnese, probably Alexandrian, 1st century A.D. Sardonyx cameo. Naples, Museo Archeologico Nazionale.

▲ Alexandrian artist, *Ptolemy II Philadelphus and Arsinoë II*, 278–270/269 B.C. Onyx cameo with eleven layers. Vienna, Kunsthistorisches Museum.

This is an example of a cameo carved on a complete shell. The large surface allowed the artist to create a very elaborate scene. Usually, shells were cut into oval shapes and used for small portraits, and sometimes for landscapes.

In 19th-century Torre del Greco, a flourishing craft specializing in coral and shell cameos developed at a time when they were especially prized as mementos of the Grand Tour, of which Italy was the highlight.

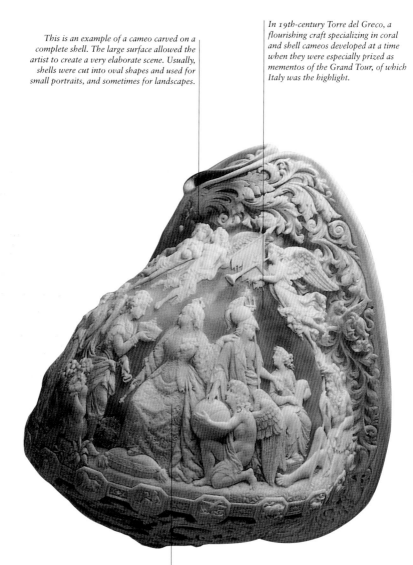

▲ Giovanni Sabbato, *Allegory of England's Naval Power, with Queen Victoria on the Imperial Throne,* 1873–83. Shell cameo. Torre del Greco, Museo Liverino.

Cameo work done on a shell can reach a high level of refinement; note, for example, the great accuracy in the details of the fabrics and jewels.

Repoussé (embossing) is one of the principal decorating techniques for working the reverse of metal sheets using hammers and rounded chisels; the finished design appears in relief.

Repoussé (Embossing)

Gold, silver, and copper are highly ductile metals: they can be modeled in relief by hammering from the reverse side of a cast metal sheet, a technique known as repoussé or embossing. The earliest known procedure involves beating a gold or silver sheet, placed on an anvil, with hammers; the work is very slow, but the craftsman can shape the metal as he pleases, stretching it into a plate or forming a deep or shallow bowl. Another ancient technique, used in Crete and Mycenae, as well as in the Middle Ages and much later by Benvenuto Cellini, used a kind of pitch consisting of brick powder, rosin, wax, and tallow, heated and mixed into a paste; this solid yet elastic compound was spread on a hemispherical stone, in turn placed on a leather pad so that it could be rotated. The metal sheet was laid on the pitch, which adhered to it, and was then shaped with different rods beaten with a hammer; once molded, the sheets could be mounted or soldered to other pieces. Embossing on mastic is a similar procedure: the sheets are beaten after fixing them to a wood support covered in mastic. One medieval technique used very soft, thick leather as the support for the metal sheet: the leather support gives the embossed figures soft, rounded outlines.

Raw Materials
Iron or steel rods of different shapes

Tools
Hammer and furnace to refire the metal sheets; anvil, pitch, tallow, leather, wood

Diffusion
It is not known when this technique was first used

Related Materials or Techniques
All metals; chisel, casting, *opus interrasile*, enamel, granulation, setting of gemstones, and all the goldsmith's techniques

◄ Bowl, Ugarit, 1400–1200 B.C. Embossed gold sheet, finished with chisel. Aleppo, National Museum.

Repoussé (Embossing)

Both cups were reinforced inside with a second, smooth sheet of gold that fitted perfectly inside the embossed one. The border of the inner sheet is higher and was rehammered on the rim of the outside sheet.

Using the pitch technique, the goldsmith can achieve reliefs that show minute details as well as soft, curving forms.

These reliefs were made with a small, pointed tool.

Small, chased details can be added to the repoussé sheet.

▲ The Vaphio Cups, Mycenaean, 16th century B.C. Repoussé gold sheet, finished with chisel. Athens, National Archaeological Museum.

These two cups from Vaphio were probably decorated using the pitch technique because the extraordinarily refined scenes of the capture and taming of a bull could not have been achieved with the free-form technique.

For these decorations, the artist used a chisel whose tip was decorated with small circular patterns.

The relief work was made on the back of the metal sheet using chiseling rods and hammer.

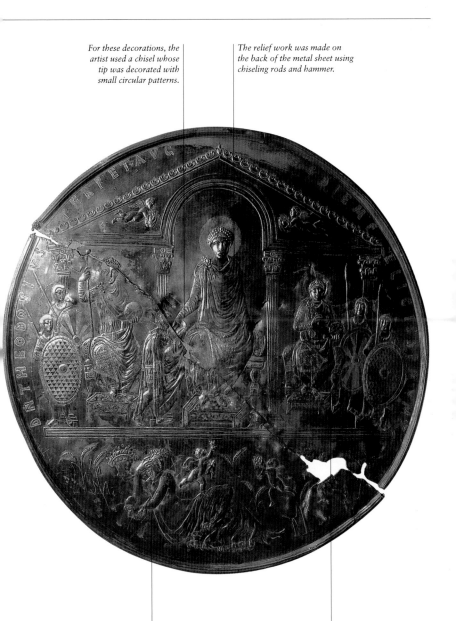

▲ *Missorium* of Theodosius I, Byzantine, end of the 4th century A.D. Madrid, Academia de la Historia.

This missorium was made using the technique in which the cast sheet is widened and stretched with a hammer. When the metal is beaten, it loses elasticity; to continue working it, the sheet must be reheated until it becomes incandescent (red hot).

The action of the hammer as it molds and decorates the sheet leaves light markings that project soft, muted highlights.

The sheet to be embossed is placed on a very soft, thick, pliable piece of leather. On this support the metal moves freely; the artist works mostly on the reverse of the metal, applying just a few finishing touches to the front of the sheet.

The reliefs on the rear side of the gold altar in Sant'Ambrogio, made by Vuolvinius for Archbishop Angilbertus (824–859), were embossed on leather, a somewhat rare technique.

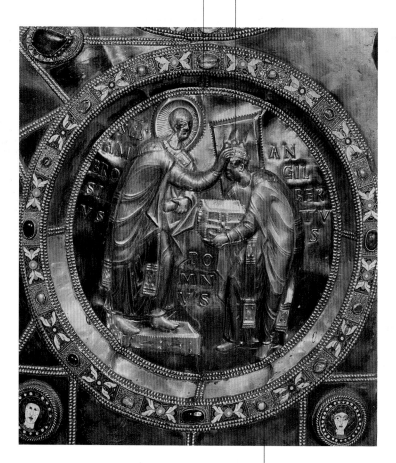

▲ Vuolvinius, *Saint Ambrose Crowning Archbishop Angilbertus*, detail from the gold altar, 9th century. Embossed gilt silver, enamels, precious stones. Milan, Basilica di Sant'Ambrogio.

Leather embossing creates a unique aesthetic result: very soft reliefs with rounded edges and an almost pictorial effect.

The chisel, a small metal scalpel (now usually made of steel) for incising metals and hard stones, is the tool used to carve out decorative forms and for all finishing work.

Chasing

Cast objects and sheets of precious and ordinary metals shaped by embossing may be decorated or finished in every detail with the chisel, a technique called "chasing." The tool, also used in embossing, is a rod that can be either square or round in section, with one head used for decorating and the opposite head for receiving the hammer's blows. Chisel rods and heads come in various shapes depending on their use: some are smooth rods with rounded heads, others have pointed heads or dotted ones, small circles or other patterns, or unusually rough textures that impart a grainy finish to the surface (called *sablé* or "sanded" work). In addition to being used on metal sheets, chisels are also used to put the finishing touches on cast pieces of all sizes. Using the chisel and the burin (the latter cuts the metal), the artist can correct small and large casting flaws and make carvings and incisions, including graphic touches on the surface, such as hair, drapery folds, and similar details. The chisel is also used to incise hard stones.

Raw Materials
Iron or steel rods of different shapes

Tools
Hammer and furnace to refire the metal sheets

Diffusion
The exact age when the chisel was first used in metalworking is unknown.

Related Materials or Techniques
All metals; embossing, casting, *opus interrasile*, enamel, granulation, setting of precious stones, and all the goldsmith's techniques

◄ Cup, Georgian, second half of the 18th century. Chased silver. Tbilisi, National Museum of Georgia.

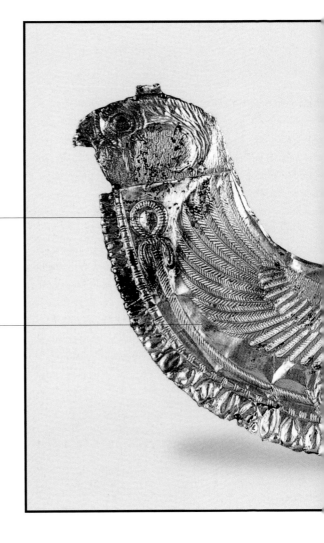

Even the ornamental
convex forms, made
after embossing,
were enhanced with
the chisel.

The feathers have
been precisely
defined with a
very thin chisel.

▲ Pectoral, Assyrian-Babylonian (Byblos),
18th century B.C. Chased and embossed
gold sheet. Paris, Musée du Louvre.

A single, large gold sheet was worked, embossed, and chased to make this extraordinary pectoral.

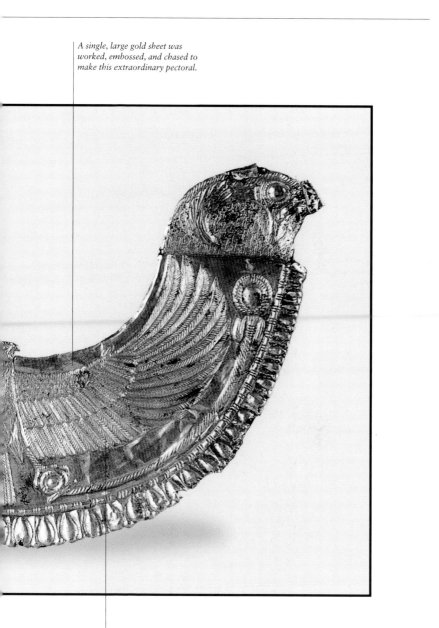

With the chisel, the artist can work on the reverse to make the reliefs and on the front of the sheet to finish the details.

This book cover, part of an evangeliary, was inserted in an elaborate mounting worked in filigree; it was originally set with gemstones.

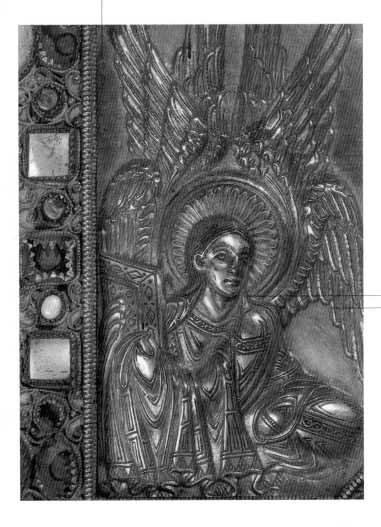

The lines of th
drapery, th
locks of hai
and all othe
the decorati
details wer
made with
pointed chise

The artis
enhanced a
the contours o
the embosse
image with th
chise

▲ Attributed to Roger of Helmars-
hausen, *Symbol of Saint Matthew*,
detail from the cover of the Helmars-
hausen Evangeliary, 12th century.
Gilt silver. Trier Cathedral, treasury.

A technique widely used in ancient Roman goldwork, opus interrasile *is a refined fretwork on metal that transforms a plain sheet of gold into delicate lace.*

Opus Interrasile

This Latin term, used by Pliny the Elder, is derived from the verb *interradere*, meaning "to scrape in between," which aptly describes the perforations made by the jeweler on sheets of precious metal. This technique produces delicate, complex openwork designs that resemble lace, lightening the look of goldwork that would otherwise seem too massive and heavy. Although it is a rather simple technique, great care and skill are required: on the gold sheet, the artist traces interlacing patterns, creating intersecting contact points, then perforates and removes all the areas that are not part of the pattern, using small, sharp burins and minute gouges and drills. Research done on ancient jewelry has revealed a surprising aspect of *opus interrasile:* the fretwork was often done using a "messy" method: examination of objects, especially on the reverse, through a magnifying lens, showed burrs and broken lines with irregular, chipped borders. These irregularities were not the result of an unskilled hand; rather, they were intentional: leaving the surface somewhat rough and "imperfectly" finished, the artist created micro-facets that heightened the play of light, adding movement and life to the gold.

Raw Materials
Gold or (more rarely) silver

Tools
Burins, very small scalpels, small hammers

Diffusion
On jewelry: from the 14th century B.C. in the Mediterranean area, and from the 6th century B.C. also among the Scythians and Sarmatians; and in Viking goldwork. Used frequently in Roman and Byzantine goldwork; also in medieval jewelry. The technique almost disappeared in the Renaissance. Imitations of ancient *opus interrasile* work (Castellani, Nibby, Canina) appeared in the 19th and early 20th centuries.

Related Materials or Techniques
Repoussé, chasing, filigree, mounting of gemstones and enamels

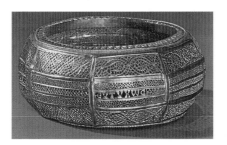

◀Bracelet, Roman, 4th century A.D. Gold. Berlin, Staatliche Museen.

The casting technique—using either the permanent form or the lost-wax method—allows the artist to create large or small full-figured metal objects shaped in a mold.

Casting

Raw Materials
Gold, silver, metals in general

Tools
Metal-melting furnace, crucibles. For permanent casting: stone, plaster of Paris; for lost-wax casting: wax, grease or tallow, fine clay. Chisels, burins, scrapers and other finishing tools

Diffusion
The earliest examples of cast-metal artifacts date from the Bronze Age

Related Materials or Techniques
All the goldsmithing and sculpting techniques

The principal casting techniques used in jewelry-making are permanent casting and lost-wax casting. The first is the more ancient, and less elaborate, of the two, and consists in using a mold, often double, worked on both parts. The material used most frequently for molds in antiquity was schist, although earthenware molds have also been found. The earliest surviving ceramic molds are from the Viking regions and date to the 5th–6th century A.D. Etruscan and Roman craftsmen also used iron molds that were less subject to wear and tear. The casting process that ensures a high degree of precision and refinement is the lost-wax method, an ancient technique that was passed from the bronze foundry to the goldsmith. Unlike the permanent molds, with the lost-wax technique, a model must be prepared for each new casting: a wax model of the object is prepared in all its details, then covered with a funnel-shaped wax mold with grooves that serve as draining vents and channels. The wax thus prepared is then covered with very fine clay; it is allowed to dry very slowly, then heated until all the wax that was partially absorbed by the clay layer melts and drains. At the time of casting, the clay mold is heated and a small crucible is used to fill it with molten metal. Once the metal has cooled, the mold is broken, and the object is ready to be finished.

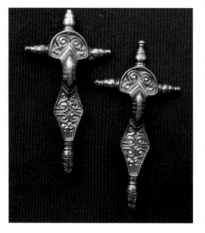

▶ Pair of Stirrup-shaped Fibulae, 455 A.D. Cast silver. Szekszárd (Hungary), Wosinsky Museum.

The details of the armor and the fabric decorations were finished with the chisel.

Wax is the ideal material with which to model small sculptures such as this one, for the artist can render all the meticulous and delicate gradations of the forms.

Each of the small crouching lions in the midsection of the comb was modeled and cast separately, then welded on.

This comb was found in the grave of a Scythian chieftain. Made entirely of gold using the lost-wax process, it consists of seven parts made separately and then welded together.

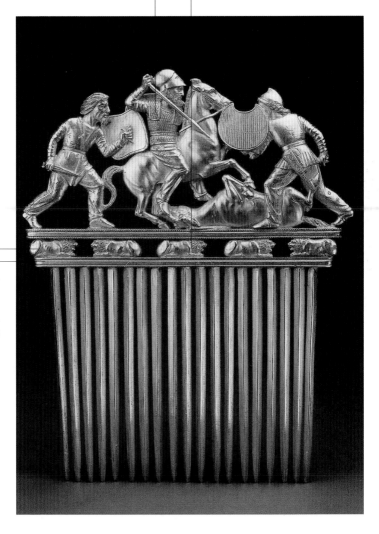

▲ *Battle Scene*, Scythian, comb, 430–390 B.C.. Cast gold. St. Petersburg, Hermitage.

Casting

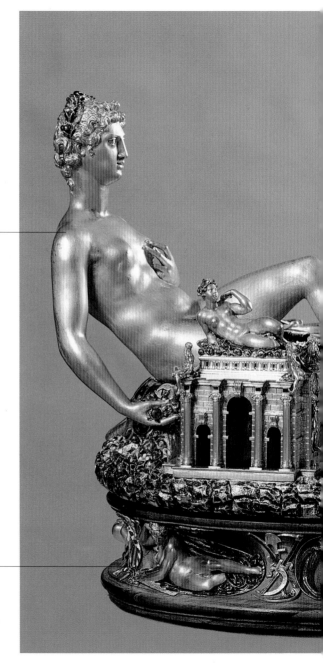

This small gold-work masterpiece embodies all the characteristics of monumental sculpture.

This sculpture has been mounted on a wood pedestal decorated with sea creatures and gods.

▶ Benvenuto Cellini, Saltcellar of Francis I, 1540–43. Cast gold, partially enameled, on a wood pedestal. Formerly in Vienna, Kunsthistorisches Museum.

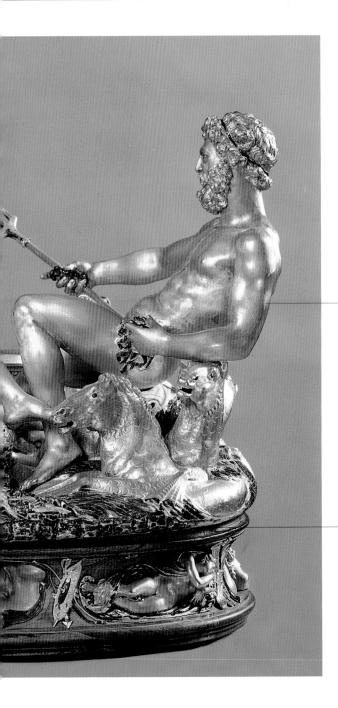

Each detail of
this sculptural
group was cast
using the lost-
wax process.

Cellini added color
to the sculpture by
applying light
touches of enamel.

The best-known filigree, still used in Europe, is a thin silver wire twisted into a sort of cord.

Filigree

Raw Materials
Gold and silver

Tools
Anvil, hammer, hard-stone or metal (iron, steel) dies

Diffusion
The earliest examples of gold-wire jewelry were made with thick wires in Asia ca. 2000–1500 B.C. They are conserved at the Musée du Louvre.

Related Materials or Techniques
Gold, silver, platinum, pearls, precious stones, and all the jeweler's techniques; spun gold is used to make plaited wire, chains, or *cloisons* to be filled with enamel. True filigree, made of silver, is the most widespread.

Notes of Interest
The Vikings used very thick wires, about 3 to 5 mm in diameter, twisting or braiding them with great skill. This heavy jewelry sometimes weighed more than a pound.

Since antiquity, humans have devised elaborate ways to make precious metals into thin wires. In the earliest method, the craftsman, using hammer and anvil, hammered and rotated a strip of gold or silver and shaped it into a progressively thinner cylinder until he made a very fine wire. This primitive technique was replaced by the use of dies. In both cases, the "spinning" was interrupted frequently in order to reheat the metal, making it ductile. Dies are made of very hard materials, such as agate, or more recently, iron. They have round, funnel-shaped smooth openings of decreasing diameter: the wider opening is for inserting the metal; the smaller one, for the extrusion of the wire. The gold or silver strip was shaped with anvil and hammer into a thin cylinder. One end was made even thinner with more hammering and repeated firings; holding the cylindrical rod with pincers, the craftsman inserted it into the die holes with the help of a lubricant, such as tallow or oil. In antiquity, the wire was pulled with short tugs; later, the pulling was done mechanically with a small winch, a less laborious method that made the wire more uniform. The filigree that is used today is made with extremely fine wires twisted together.

▶ Armlet, 1880–85. Gold with filigree ornament. Pforzheim, Schmuckmuseum.

Filigree decorations on medieval jewelry were often enriched with pearls and precious stones, here cut in the cabochon style.

This evangeliary cover is decorated with a dense filigree motif using wire made with special dies that produce a cord modeled as if it were formed by a row of minute pearls, an effect that recalls granulation.

The central panel, depicting the Baptism of Christ, is made of carved ivory.

Thin, filigree scrolls are closely mounted on the underlying gold sheet to form the frame for the central panel. Each curl is set with tiny pins.

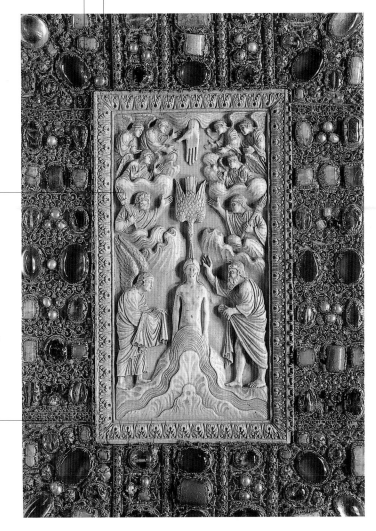

▲ Cover of an Evangeliary, 12th century. Gold, ivory, filigree, precious stones. Munich, Bayerische Staatsbibliothek.

Filigree

This elaborate alzatina *(footed plate) is made entirely of silver filigree; the intricate scroll design produces a gauzy lacework effect.*

Filigree made of thicker wire was used to make the object's frame, formed by heart-shaped motifs that radiate from the center.

Slender filigree scrolls made of plaited wire were welded inside each heart design.

The alzatina *is decorated with precious stones mounted inside settings and rosettes of wound filigree.*

▲ Italian manufactory, Footed Plate, 18th century. Silver filigree set with gold and precious stones. Milan, Castello Sforzesco, Civiche Raccolte d'Arte Applicata.

Since antiquity, one of the most fascinating and prestigious gold-working techniques has been granulation: minute spheres of equal diameter are applied to form geometric designs or decorations.

Granulation

Granulation is an elaborate process that requires an advanced knowledge of metallurgical principles. First, the precious metal granules are made using a very thin wire with a diameter of less than half a millimeter; the wire is cut into small equal segments that will form the granules. This "golden straw" is mixed with finely powdered coal and compressed in a crucible sealed all around with clay. The crucible is heated until the gold melts. As it melts, the gold absorbs part of the carbon contained in the fuel, which does not burn in the oxygen-free environment. This chemical reaction causes each gold segment to assume a spherical shape. After the crucible is removed from the heat and allowed to cool, the contents are washed: the granules are now covered with a dark film of gold carbide, which has a lower melting point than pure gold; the film is removed in the next step. Knowledge of the granule-welding technique was lost for ages: it requires the use of a special adhesive compound made of copper carbonate, water, and fish glue; applied to the sheet to be decorated, the adhesive keeps the granules in position. Reheating them in a closed muffle oven melts the copper in the glue and binds it with the gold. In the next step, the the gold is exposed to the air, enabling the carbon that formed a film on the granules to bind with oxygen and then dissipate. This allows the natural color and brightness of the gold to reappear.

Raw Materials
Gold

Tools
Ground coal, crucible with cover, casting furnace, muffle; glue: copper carbonate, water, and fish glue

Diffusion
The earliest granulated jewels are from the ancient Near East and date to a period between the second half of the 17th century and the 16th century B.C. This technique, also used in Egypt, was later perfected by Etruscan craftsmen. Slowly discarded in the Roman Age, it was almost forgotten until the 19th century, when several imitations were attempted. The Castellani family, for example, unaware of the ancient "self-welding" method of each tiny granule, made granulated jewels using larger granules soldered individually to the base.

◄ Castellani manufactory, *Head of Bacchus*, ca. 1860. Gold pendant with granulation. Private collection.

Granulation

The spheres on this disk are tiny and of almost identical diameter. The effect of these hundreds of granules welded to the small surface of the ornament is soft, almost velvety.

Etruscan and Hellenistic jewelry often combined granulation with filigree work, achieving lacelike effects; in this example, the filigree wires enclose the sections decorated with granules.

This earring has a diameter of 3.8 centimeters.

▲ Disk earring, Etruscan, ca. 520 B.C. Gold with filigree and granulation. London, British Museum.

▶ French manufactory, Ivy-leaf Pectoral-Pendant, 14th century. Gold and enamel. Cividale del Friuli, Museo Archeologico.

"TThis craft is extremely difficult with respect to firing, which is the last step after a laborious process, and often ruins and destroys it" (Benvenuto Cellini, 1566).

Enamel

This technique consists of spreading a vitreous paste on a metal base and fixing it by firing. Additives such as borax, soda, or magnesium produce greater hardness, stability, and elasticity. The vitreous paste, prepared in small cakes, is reduced to a powder, washed, and, when still damp, applied to a gold, silver, or copper base, then fired in a muffle kiln. The main difficulty lies in identifying the precise melting points of the different kinds of vitreous paste without reaching a temperature that could damage the metal base. The principal enameling types are: cloisonné, the most ancient, where the enamel paste is spread inside little "cells" (*cloisons*); champlevé, where the paste is laid inside grooves or hollowed-out spaces; *bas-relief translucid*, also known as *émail de baisse taille*, a method first perfected in Tuscany in the late 13th century; and "painted enamel," where the back of the copper or silver base is worked with a counter-enamel receiving the colors in successive layers and firings. Other kinds are encrusted enamel (*émail en ronde-bosse*), a technique for applying color to embossed metal sheets or small, precious sculptures, that first appeared about 1350, and the Flemish techniques of grisaille paint-

ing on enamel and *camaïeu d'or* that were used by the French painter Jean Fouquet on a series of monochrome medallions, originally mounted on the frame of the Melun Diptych, now divided between museums in Antwerp and Berlin.

Raw Materials
Vitreous paste colored with metallic oxides: cobalt and copper for blues and greens; manganese for purples and violets; iron for yellows and reds; tin, but also lead and antimony or calcium phosphate for white and to opacify the paste

Tools and Supports
Water, mortar and pestle to crush the vitreous paste, brushes, small silver spatulas, firing oven, preparatory drawings, gold, silver, or copper sheets or cast objects

Diffusion
The art of melting vitreous paste is very ancient; examples dating as early as Middle Kingdom Egypt (2100–1800 B.C.) have been found. The use of enamel has been widespread in all ages and in all of Europe and Asia.

Related Materials or Techniques
All the materials and techniques used in goldwork and jewelry-making

Enamel

In cloisonné work, the damp vitreous paste is laid inside little "cells" made with thin gold strips cut and curved to form small, enclosed "tubs."

The gold strips are so thin that they cannot be welded; therefore, most probably, resins were used to set them temporarily to the base. During firing, as the resins burned, the pressure of the enamels and the heat fix the strips to the base.

The cloisons in this highly refined Constantinopolitan enameled icon are so tiny that they evoke mosaic work.

▲ *Icon of Saint Michael*, Constantinople, end of the 9th–beginning of the 12th century. Gilded silver, *cloisonné* enamels, and precious stones. Venice, San Marco, treasury.

The areas that were to receive the vitreous paste were carefully hollowed out.

A drawing was etched on the plate using a thin point, then cut with chisels and burins.

The areas in gilded copper are of the same thickness as the original plate.

Finely ground and washed vitreous paste was applied inside the hollow spaces with a minuscule spatula; the plate was then placed inside a muffle oven and fired.

▲ Crucifixion, Lower Saxony or Westphalia, portable altar (upper plate), ca. 1150. Gilded copper with champlevé enamels. Paris, Musée du Louvre.

Enamel

The gold repoussé figurines of the betrothed couple are inserted in a nest-shaped mounting made of gold wire and decorated with pearls, precious stones (ruby and emerald), and an oak-leaf motif.

The enamel surface has been fused to form a uniform layer that covers the repoussé metal figurines, which were roughened to ensure that the vitreous paste would adhere.

This unusual pin was decorated with the encrusted enamel technique, typical of the late Gothic period.

With green enamel and tiny pearls, the craftsman can even make small mistletoe shoots.

▲ *Two Lovers*, Burgundy, Pin, 1430–40. Gold, enamel, and pearls. Vienna, Kunsthistorisches Museum.

The encrusted enamel technique allows the artist to create fanciful, refined work that resembles sculpture.

Gold-leaf cutouts made with dies in the shape of stars, leaves, and other designs are applied to the dark varnish while it is still damp, and they adhere firmly to this first vitreous layer.

Once the decorative elements are in place, the artist applies a second coat of varnish of the same or a different color, green or blue, leaving the gold decorations uncovered in whole or in part.

This technique imitates real enamel, but in reality special varnishes were used made of resin and linseed oil, boiled and mixed with colored pigments.

After the copper surface was given a rough texture to allow better adhesion for the enamel, it was coated with a dark varnish that is clearly visible here.

Starting in the second half of the quattrocento, a variant of the usual heat-applied enamel was created in Venice: cold-applied varnish enamel, also known as "Venetian enamel." The technique, which was developed north of the Alps, was brought to Venice by the many German goldsmiths who traveled there.

▲ Coffer with Lid, Venetian, 16th century. Enameled copper. Milan, Museo Poldi Pezzoli.

Enamel

Artists of the Pénicaud school in Limousin, France, used the
painted enamel technique: the copperplate was made slightly
convex (rounded outward) to make it resistant to misshaping,
then the drawing was engraved on the plate with a fine point
and covered with a thin layer of translucent enamel.

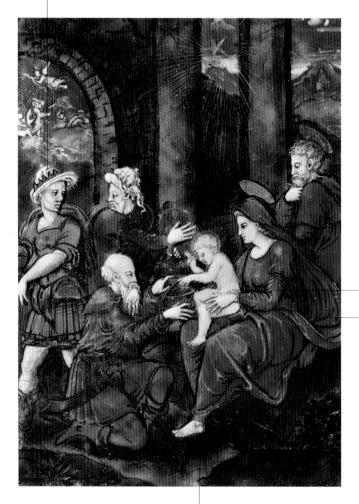

For faces and the
naked body of the
Christ child, the
artist used a special
technique: he first
applied a uniform
layer of very dark,
almost black, purple,
then added white
semi-translucent
enamel in thin
layers, letting the
dark background
show through and
creating shadows.
Finally, using thicker
brush strokes, he
covered the layer
with a milky
"flesh-rose" effect.

Using a palette of
increasingly rich
colors, the artist
created a true
painting, complete
with nuances and
gradations of tone.

Before applying the
final touches, the
plate was reinforced
on the back with a
generous coating of
counter-enamel.

▲ Jean Pénicaud III, *The Adoration of
the Magi,* ca. 1590. Enameled copper.
Florence, Museo del Bargello.

"Niello is nothing but a drawing outlined and painted on silver, done just as one paints or sketches lightly with a pen" (Giorgio Vasari, 1550).

Niello

Niello is a metalworking technique that includes elements of drawing and engraving. The artist incises a drawing on a metal plate, then pours into the grooves a black, shiny powder composed of three metals—silver, copper, and lead—with sulfur and borax added. The artist then fires the plate in the furnace. As the metal base heats, the niello melts and hardens, forming a shiny, ductile metal with colors ranging from dark brown to gray to intense black. In the final stage, the excess niello is scraped off and the object is polished. Niello flourished during the late Roman Empire and throughout the Middle Ages, and developed even further in the Renaissance. Niello on silver creates elegant graphic effects similar to prints from copper engravings. Vasari, a great champion of the primacy of drawing over the other arts, described the niello technique in his introduction to the *Lives*, and ascribed to Maso Finiguerra, a Florentine goldsmith, the idea of printing on paper an engraving made on a metal plate. This legendary attribution serves to underscore the fact that very often the "major arts" have more in common with the "minor arts" than we generally believe.

Raw Materials
Lead filings, silver, copper, sulfur, borax

Tools
Burins, firing oven, polishing abrasives

Related Materials or Techniques
Nielloed plates are often inserted in gold objects made using various techniques

Diffusion
Used since the late Roman Empire, continued through the Middle Ages and the Renaissance. Niello art spread throughout Europe, and especially to its northeastern regions.

Notes of Interest
Before qualifying as a master in Tula, Russia, the apprentice silversmith had to submit a niello-decorated silver plate that could be hammered until the surface area was doubled without cracking the niello.

◄ Spoon and Fork, Persian, 12th century. Engraved, nielloed silver. New York, Metropolitan Museum of Art.

Niello

A layer of niello covers the background, which was carefully hollowed out.

This plate is part of a portable altar made in northwestern Germany (Westphalia) by an exceptional goldsmith, perhaps Roger of Helmarshausen. Roger is identified by some scholars as the monk Theophilus, author of De diversibus artibus (1100–1120), the oldest medieval text on techniques of art.

The garment folds have dove-tailing corners filled with niello, creating a "bundle of strings" effect, proof of the smith's virtuosity.

Every minuscule detail of the scene was incised with the burin. The style is reminiscent of Carolingian miniatures.

▲ Attributed to Roger of Helmarshausen, Abdinghof Portable Altar Dedicated to Saints Felix and Blaise (detail), after 1115. Engraved, gilt, and nielloed copper. Paderborn, Erzbischöfliches Diözesanmuseum.

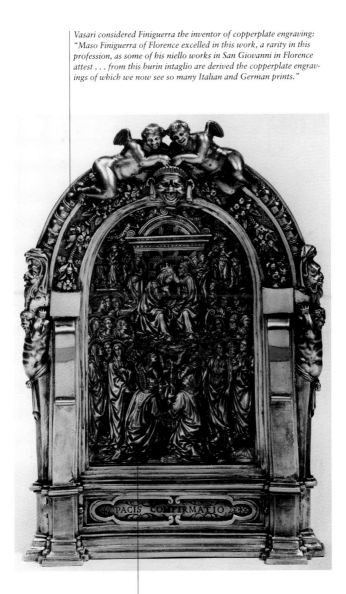

The artist used great painterly sensitivity in this engraving, heightened by the "brushstrokes" of black niello that form an elegant contrast to the silver plate.

▲ Maso Finiguerra, *Coronation of the Virgin*, 1452. Engraved, nielloed silver. Florence, Museo degli Argenti.

"We have seen steel objects incised like embroidery, also called damascene, because this fine craft is employed in Damascus and throughout the Levant" (Giorgio Vasari, 1550).

Damascene

Raw Materials
All metals

Tools and Supports
Points, burins, chisels, hammers, furnace to lrefire the metal sheets, smoothing and polishing abrasives

Diffusion
The earliest damascene works are from ca. 1500 B.C. The technique spread principally in the decoration of weapons, especially by Italian sword-makers; Milanese and Spanish craftsmen of the Renaissance and the 17th century were particularly prominent.

Related Materials or Techniques
Repoussé, chisel, casting

One of the oldest decorative techniques to be used on precious metals is damascene (also known as damascening), which consists of applying a sort of metal inlay of different colors to a metal base. The name is derived from a special process used by Islamic weapons-makers to forge swords. First, the artist traces the drawing onto the metal to be decorated. Using a thin point, he cuts deeply into the metal with wide burins and scalpel, making sure that the grooves are a bit wider at the bottom than on the surface. The incisions can be narrow or wide, allowing for the insertion of metal strips of various widths. The decoration may be made with round wires, ribbons, or foils cut in any shape, inserted in the grooves with chasing tools and small hammers. These decorations, which also appear on everyday objects, were typically used on weapons made in dark metals such as bronze, iron, or steel. Once the decoration was completed, the entire surface was carefully smoothed and polished. An unusual type of damascene called for immersing the blades in controlled acid bitings that bared the molecular structure of the metal, creating slight, irregular decorative streaks. Over time, however, the term took on a totally different meaning, referring to the light arabesque work of Spanish and Italian armorers during the Renaissance.

► Knife Scabbard, Mycenaean, 1500 B.C.. Bronze with gold and silver damascene and niello. Athens, National Archaeological Museum.

This handsome sword made in Milan by
Damiano da Nerve, a Spanish-born craftsman,
was decorated with delicate damascene work
using a technique similar to copper etching.

The hilt of this
sword is decorated
with elaborate
mythological and
hunting scenes:
here a boar is
chased by dogs
and hunter. On the
pommel Hercules
stands between
two palm trees.

The hollowed
parts of the design
were incised over
a varnish that
covered the metal
to be decorated;
the object was
then immersed in
an acid bath that
widened the fur-
rows into which
the gold foil was
to be inserted.

▲ Damiano da Nerve, Side Sword,
1550–60. Damascened bronze.
Vienna, Waffensammlung.

CONTEMPORARY
TECHNIQUES

Collage
Frottage
Dripping
Mixed Media

A collage is made by cutting pieces of paper and gluing them onto a paper or cardboard support. It is a technique used in Cubism and in almost all contemporary art movements.

Collage

Raw Materials
Colored or painted paper, newspaper pages, glue

Tools
All painting tools

Diffusion
Since the early 20th century, in almost all artistic schools: for example, Cubism, Futurism, Dadaism, Surrealism, Expressionism, Abstract Expressionism, Pop art

Related Materials or Techniques
Oil painting, gouache, tempera, drawing, mixed media

About 1910 or so, avant-garde artists adopted a new painting technique: collage, or *papiers collés*. Pieces of colored paper, newspaper, or photographic cutouts were glued to a support and arranged for different aesthetic effects. Often, the artist painted or drew on the paper. Collage originated in two very different artistic movements, Analytical Cubism (Picasso and Braque) and Italian Futurism. The use of paper cutouts to compose a work of art was perhaps the first, decisive "break" from traditional painting methods based on drawing and perspective. The Cubist painter was no longer interested in the three dimensions of Leon Battista Alberti's "window": he wanted to represent a space that "at a specific point in time soars toward the infinite in all directions" (Apollinaire, 1913). The two-dimensional cutout and glued paper was appropriately symbolic of changes taking place in the perception of reality since it represented fragments of reconstituted objects on the surface of the painting. Collage was also polemical: in the works of the Futurists; in its intent to erase any reference to art of the

► Kurt Schwitters, *Merz 299*, 1921. Collage and oil on cardboard. London, Marlborough Fine Art.

past, even from a technical point of view; in Dadaist collages; and especially in the work of artists such as John Heartfield, one of the German Expressionists. Among many great works of collage are elegant pieces by Matisse and Max Ernst, and the *décollages* by Mimmo Rotella in the 1960s, following on the wave of Pop art.

Ardengo Soffici painted a traditional subject—a still life with glass and bottle—though the composition itself is a total break with tradition: for instance, the objects are painted as synthetically as possible.

This collage is composed of newspaper cutouts and fragments of bus and train tickets. The artist has evoked waiting at a café table for a train or a streetcar.

The colors are muted, tending toward gray, the color of industrial civilization.

▲ Ardengo Soffici, *Still Life (Piccola velocità)*, 1913. Oil, tempera, and collage on cardboard. Milan, Civico Museo d'Arte Contemporanea.

Collage

Matisse executed this work by cutting out and painting the various elements of the composition, then temporarily attaching them to the support with pins; this allowed him to study the best arrangement.

Matisse followed an unusual method for his collages: instead of using colored paper or newspaper cutouts, he made them himself, using fine-quality watercolor paper that he painted with a single layer of gouache tempera. The strokes made with a flat brush are clearly visible.

The overall effect is perfectly two-dimensional and yet evokes space. The dense, luminous colors are typical of Matisse's palette.

▲ Henri Matisse, *The King's Sadness*, 1952. Collage. Paris, Musée National d'Art Moderne, Centre Georges Pompidou.

▶ Mimmo Rotella, *Europe by Night*, 1951. Torn cinema posters on canvas. Vienna, Museum Moderner Kunst, Stiftung Ludwig.

The artfully torn, overlaid posters evoke the passing of time, which is fast and spasmodic in the present, an age defined by artificial events.

Mimmo Rotella uses the décollage technique, that is, he uses torn posters underneath which one can see other poster fragments.

The large female figure, probably from a film poster, dominates the composition; a grid has been drawn over it, evoking the grids used by the great masters to reproduce drawings on a large scale.

> *"I made from the [floor] boards a series of drawings by placing on them . . . sheets of paper which I undertook to rub with black lead" (Max Ernst, Beyond Painting, 1948).*

Frottage

Tools and Supports
Tools: paper, canvas, pencils, oil colors, pastels.
Supports: wood, leaves, canvas, spatulas, metal grids and other rough-textured materials

Diffusion
Frottage and grattage are linked to Max Ernst and his work starting in 1925.

Related Materials or Techniques
Oil painting, gouache tempera

Notes of Interest
There is an authoritative precedent for frottage: Leonardo da Vinci, anticipating a future aesthetic, observed that a casual mark left on a wall could, in the mind of an artist, be transformed into a real image.

In 1925, Max Ernst developed a new technique, frottage, which is rubbing a pencil on a sheet of paper placed over an object. The result is a chiaroscuro drawing of the outline and projections of the object: the traced object produces a form that is abstract and concrete at the same time, a process known to the Surrealists as "automatic painting." With automatic painting, the artist works without reflecting on the subject being represented; thus, representation arises from the unconscious, with no apparent logic, and traces the mechanisms and images that live in our souls, in a process similar to that which creates dreams. From a technical point of view, frottage was used at first only to make drawings with colored pencils; later, Ernst also used it for oil paintings on canvas. To create the frottage marks, the artist uses worn pieces of wood or rough fabrics, leaves, or anything with veins or projections. A technique derived directly from frottage is *grattage*, which creates a sgraffito-like image: the artist begins by applying thick layers of color, which are then scratched with a spatula or with metal grids of different textures.

▶ Max Ernst, *Untitled*, 1925. Colored pencil on paper. Private collection.

The sky was painted with a heavy gray ground.

Traces of blue are visible on the sun's disk.

When they were almost dry, the upper layers of color were partially scraped using objects with lozenge-shaped reliefs and other patterns that allow the underlying colors to show through. A vivid red dominates the composition, evoking the color of the bricks.

▲ Max Ernst, *The Petrified City:*
Le Puy, near Auch, Gers, 1933.
Oil on paper with grattage.
Manchester, Art Gallery.

The area representing the petrified city was made with various grounds of contrasting colors, with the uppermost part very dark, almost black.

The dripping technique is typical of "action painting": the color drips from the brush of the painter, who moves quickly around the canvas, creating long, intricate color filaments.

Dripping

Tools
Brushes, canvases, oil colors, varnishes

Diffusion
Max Ernst was the first artist to use a form of dripping; later, it became a leading technique of American Abstract Expressionism and informal Expressionism. In 1952, Harold Rosenberg coined the term "action painting." Jackson Pollock, Willem de Kooning, Franz Kline, Marc Rothko, and others were part of this move-ment. European artists include Wols, Hans Hartung, Emilio Vedova, and Georges Mathieu.

Dripping is a technique of American Abstract Expressionism, born in post-World War II New York, home at that time of such artists such as Ernst, Mondrian, Léger, Tanguy, Hoffman, and the poet Breton. The presence of the Surrealists was particularly important as they introduced Americans to the theory of painting as an automatic transcription of the unconscious, to create works that would authentically represent the "ego" of the artist. For the Surrealists, automatic painting projected images that transfigured reality; for artists who utilized dripping, preexisting form was dismissed in order to arrive at casual, almost random, paintings made of lines, drops, or sprays of color. This method, known as "action painting," is a signature of the Abstract Expressionist school. The artist's utmost physical participation was required as he applied the paint to a large surface, moving swiftly across it with his entire body—even walking on it—and he painted as if in a trance to reach a pure state of automation in arranging and selecting the colors. Analogous to dripping, which creates long strings of liquid color, is *tachisme*, from the French *tache*, meaning stain, in which the colors form dense, casual stains on the canvas.

▶ Hans Namuth, *Jackson Pollock at Work*, ca. 1950. Photograph.

Full Fathom Five *is one of the first experiments made with the dripping technique.*

Some areas, such as the ones painted green, were applied directly with a large brush.

This painting has a dense, multicolored weave; the colors dripped last, oranges and yellows, light up the tangle of darker colors with an almost fiery effect.

For the dripping, Pollock used a very liquid oil color, dripping it over a canvas to which "casual" objects, such as buttons, nails, coins, and cigarettes, had been glued.

▶ Jackson Pollock, *Full Fathom Five*, 1947. Oil on canvas and mixed media. New York, Museum of Modern Art.

In contemporary art, when verisimilitude is no longer sought, mixed media takes on different uses and meanings; it gives polychromy to objects that would otherwise be monochrome.

Mixed Media

Composition
Any natural or man-made material

Tools
Any tool

Diffusion
The use of mixed media is an ancient technique practiced in all ages and civilizations. In contemporary art, it developed starting in the first decade of the 20th century.

The usual purpose behind the inclusion of different materials in a single composition, whether an ancient stone sculpture or an extraordinary artifact of metal and precious stones, was to make the work look more realistic. In contemporary art, this goal has often been discarded. Cubist collages contained, in addition to paper cutouts, fragments of fabric or other materials that completed the composition; in later movements—Dada, Surrealism, Pop art, "material art," hyper-realism, conceptualism—the materials acquired different meanings depending on the trend and the personality of the artist. It is difficult to synthesize in a few lines the use of mixed media in 20th-century art

► Vladimir Tatlin, *Blue Counter Relief*, 1914. Various woods, metal, leather, gesso on wood panel. Berlin, Berlinische Galerie.

because the materials can be used for their aesthetic-compositional qualities as well as for the tactile, evocative aspects of a lived, endured reality (for example, in Dadaism) or of a consumer society (as in some Pop art). Common to all mixed-media work is that the materials, used as freely as possible until they seem paradoxical, become the constitutive and fundamental elements of a new way of making poetic objects.

To evoke the Bois de Boulogne Park, Baj used upholstery fabric with a repetitive leaf pattern in the background.

The artist used fabric cutouts to represent the clumsy "generals," funny, headless shapes marching in the park.

These ironic figures are completed with everyday objects, such as buttons, braiding, medals, and mechanical toy pieces.

▲ EEnrico Baj, *Military Parade at the Bois de Boulogne*, 1963. Oil and mixed-media collage on canvas. Private collection.

371

Mixed Media

Pistoletto makes frequent use of the mirror as a surface on which to paint, for it reproduces reality by returning it to the viewer on an inverted, two-dimensional plane.

Through his or her reflected image, the viewer becomes part of the work of art.

The abstracting effect of the mirror is heightened by the images painted on onionskin paper and glued to it as if they were reflected images.

▲ Michelangelo Pistoletto, *Vietnam*, 1965. Painted onionskin paper on mirror-polished stainless steel. Houston, Rice Museum.

Mario Merz used a real object that normally goes unnoticed, a trench coat, charging this Dadaist ready-made article of clothing with artistic intention.

In "poor art," an Italian movement born around 1966, lowly materials were used to reach a negation of the form, intended as harmonious organization, which is always present in any artistic creation.

The rest of the composition consists of two neon tubes inserted in the trench coat. Note how the artist makes no effort to hide the electrical wires of the two lamps: they become part of the work.

▲ Mario Merz, *Trench Coat*, 1967. Trench coat, wax, neon tubes. Private collection.

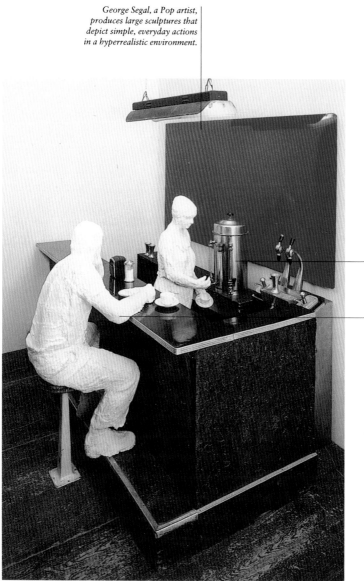

George Segal, a Pop artist, produces large sculptures that depict simple, everyday actions in a hyperrealistic environment.

The materials used for the "scene"—wood, plastic, and chrome—are actual everyday objects, making them more real than the men who are using them.

The human figures were made from thin pieces of canvas glued onto Masonite forms. The life-sized sculptures, without color, project a crystallization of reality that evokes the casts of ancient victims of the Vesuvian eruption on Pompeii and Herculaneum.

▲ George Segal, *The Dinner*, 1964–66. Wood, chrome finishes, plastic finishes, Masonite, neon, glass, paper. Minneapolis, Walker Art Center.

In this frame, the object "caught" in the fabric is a pair of pants. The work itself is outside any reference to traditional painting or sculpture, yet squarely inside a frame.

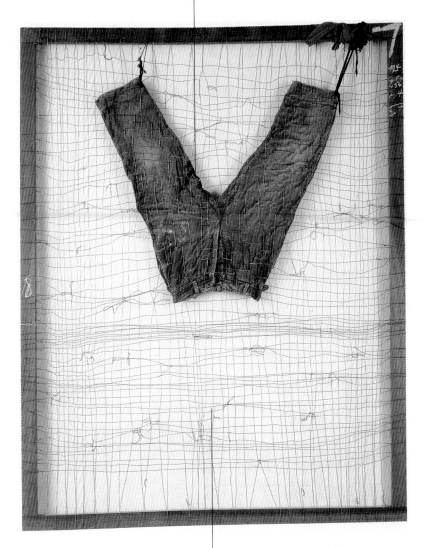

▲ Antoni Tápies, *Pants and Woven Wire*, 1973. Pants and iron wire. Washington, D.C., Smithsonian Institution, Hirshhorn Museum and Sculpture Garden.

The pants hanging by their cuffs from two plain ribbons are crossed by an irregular grid made of iron wire. The composition suggests the idea of weaving and the loom.

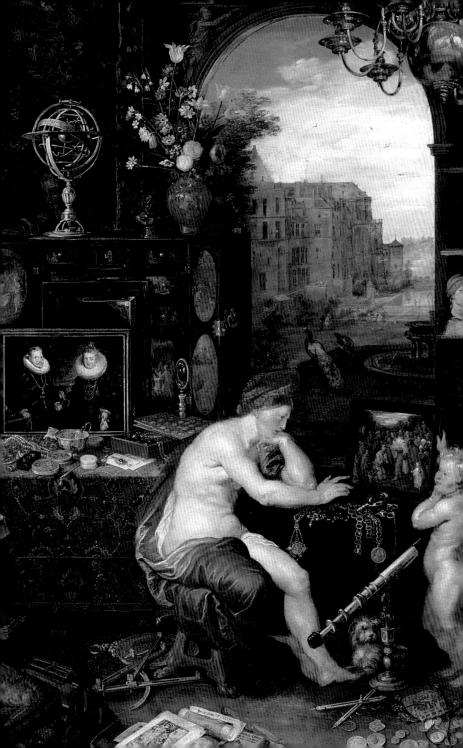

APPENDIXES

Index of Subjects

Essential Bibliography

**Primary Sources and
General Texts**

1st century A.D. Pliny the Elder. *Natural
History*, trans. H. Rackham (Cam-
bridge, Mass., 1967–75).

1100–1120. Theophilus, Presbyter. *On
Diverse Arts*, trans. J. Hawthorne
and C. S. Smith (Chicago, 1976).

1437. Cennini, C. *The Craftsman's
Handbook (Il libro dell'arte)*, trans.
Daniel V. Thompson Jr. (New
Haven, Conn., 1954).

1540. Biringuccio, V. *The Pirotechnia of
Vannoccio Biringuccio: The Classic
Sixteenth-Century Treatise on Met-
als and Metallurgy*, trans., and with
an introduction and notes by Cyril
Stanley Smith and Martha Teach
Gnudi (Mineola, N.Y., 2005).

1550. Vasari, G. *Lives of the Painters,
Sculptors and Architects*, trans. G.
de Vere (New York, 1996).

1972. Bologna, F. *Dalle arti minori
all'industrial design: Storia di una
ideologia* (Bari).

1973–81. Maltese, C., ed. *Le tecniche
artistiche* (Milan).

Drawing

1584. Borghini, R. *Il riposo* (Florence).

1681. Baldinucci, F. *Vocabolario
toscano dell'arte del disegno* (Flo-
rence).

1797. Milizia, F. *Dizionario delle belle
arti del disegno, estratto in gran
parte dall' enciclopedia metodica di
Francesco Milizia* (Bassano del
Grappa).

1956. Grassi, L. *Il disegno italiano del
Trecento al Seicento* (Rome).

1992. Petrioli, A., and G. C. Tofani Sci-
olla, eds. *Il disegno: Forme, tecniche,
e significati* (Turin).

Printing

1766. Papillon, J. M. *Traité historique
et pratique de la gravure* (Paris).

1819. Senefelder, A. *Lehrbuch der Stein-
drückere* (Munich). *The Invention of
Lithography*, trans. J. W. Muller
(1911; repr. New York, 2001).

1960. Solomon, F. *Il conoscitore di
stampe* (Turin).

1985. Bellini, P. *Storia dell'incisione
moderna* (Bergamo).

1998. Bellini, P. *Il manuale del conosci-
tore di stampe* (Milan).

2001. Mariani, G., ed. *Le tecniche di
incisione a rilievo: La xilografia*
(Rome).

2003. Mariani, G., ed. *Le tecniche
calcografiche di incisione diretta:
Bulino, puntasecca, maniera nera*
(Rome).

2003. Paoluzzi, M. C. *Stampa d'arte*
(Milan).

Painting

1435. Alberti, L. B. *Della pittura*, trans.
C. Grayson, rev. ed. (New York,
2004).

1587. Armenini, G. B. *On the True Pre-
cepts of the Art of Painting*, ed. and
trans. E. J. Olszewski (New York,
1977).

1681. Baldinucci, F. *Vocabolario
toscano dell'arte del disegno* (Flo-
rence).

1693. Pozzo, A. *Perspective in Architec-
ture and Painting* (1707; repr. New
York, 1989).

1730–34. Dionysius of Fourna, *"The
Painter's Manual" of Dionysius of
Fourna*, ed. and trans. Paul Hether-
ington (Redondo Beach, Calif.,
1974).

1847. Eastlake, C. L. *Methods and

Materials of Painting of the Great
Schools and Masters* (repr. New
York, 1960).

1958. Cagiano de Azavedo, M. "Tec-
niche della pittura parietale antica,"
*Bollettino dell'Istituto Centrale del
Restauro* 33.

1961. Procacci, U. *Sinopie e affreschi*
(Milan).

1983. Brusatini, M. *Storia dei colori*
(Turin).

1984. Forti, G. *Antiche ricette di pittura
murale: Affresco, stereocromia,
calce, tempera, olio, encausto*
(Verona).

1984. Mora, P., L. Mora, and P. Philip-
pot. *Conservation of Wall Paintings*
(Boston).

1990. Bensi, P. "La pellicola pittorica
nella pittura murale in Italia: Materi-
ali e tecniche esecutive dall'alto
medioevo al XIX secolo," in *Le pit-
ture murali*, ed. C. Danti, M. Mat-
teini, and A. Moles (Florence).

1990. Maltese, C., ed. *I supporti nelle
arti pittoriche* (Milan).

1993. Maltese, C., ed. *Preparazione e
finitura delle opere pittoriche*
(Milan).

1999. Paolini, C., and M. Faldi. *Glos-
sario delle tecniche pittoriche e del
restauro* (Florence).

2000. Bensi, P. "Appunti sulla tavolozza
del 'Quarto Stato'," in *Giuseppe Pel-
lizza da Volpedo, Quarto Stato*, ed.
A. Scotti (Milan).

Sculpture

1464. Alberti, L. B. *On Sculpture*, trans.
C. Grayson (London, 1972).

1504. Gaurico, P. *De sculptura*, Latin
text, trans. into Italian, with an
intro. and notes by P. Cutolo; essays